*To Tony + Graciela —
Thanks for the hospitality
Cheers!*

# WESTERN NORTH CAROLINA BEER

## A Mountain Brewing History

Anne Fitten Glenn

*Foreword by Ken Grossman*

AMERICAN PALATE

Published by American Palate
A Division of The History Press
Charleston, SC
www.historypress.com

Copyright © 2018 by Anne Fitten Glenn
All rights reserved

*Cover photo by Steve Yocom.*
*Back cover photos by Erin Adams Photography; courtesy of North Carolina Collection, Pack Memorial Public Library.*

First published 2018

Manufactured in the United States

ISBN 9781467139991

Library of Congress Control Number: 2018948030

*Notice*: The information in this book is true and complete to the best of our knowledge. It is offered without guarantee on the part of the author or The History Press. The author and The History Press disclaim all liability in connection with the use of this book.

All rights reserved. No part of this book may be reproduced or transmitted in any form whatsoever without prior written permission from the publisher except in the case of brief quotations embodied in critical articles and reviews.

*By the time you get a grasp on the enormity, complexity and staggering cultural and economical impact of the craft beer scene in Western North Carolina, it's already moved two steps ahead of you. It's a "catch me if you can" industry in these parts, with Anne Fitten Glenn seemingly the only one who can—and does—keep up.*
—Garret K. Woodward, arts and entertainment editor, Smoky Mountain News/Smoky Mountain Living

*Winston Churchill once said, "History will be kind to me, for I intend to write it." Luckily for the WNC brewing community, we have historian and writer Anne Fitten Glenn to take all of the spirit and toil of our local brewery revolution and pour it into a crushable, but full-bodied, book.*
—Mike Rangel, president and founder, Asheville Brewing Company

*The Western North Carolina beer world is constantly evolving, and Anne Fitten Glenn keeps up with every twist and turn. Her deep knowledge of the local beer scene, combined with a general sense of adventure and dedication to telling local stories, have made her an authority on beer in Asheville and beyond. She is the ultimate ambassador to the region's beer culture, and her new book demonstrates that on every page.*
—Jen Nathan Orris, contributing editor, Edible Asheville

*Anne Fitten Glenn has lots of experience writing about beer and breweries. Her engaging new book tells how Western North Carolina became such a key place for craft beer.*
—Tony Kiss, Carolina Beer Guy, Mountain Xpress

# CONTENTS

| | |
|---|---|
| Foreword, by Ken Grossman | 7 |
| Cheers and Toasts | 11 |
| Introduction | 15 |
| | |
| 1. Mountain Frontier-Style Beer and Booze | 21 |
| 2. The War on Beer | 37 |
| 3. The First Post-Prohibition Breweries | 46 |
| 4. The Surge Begins: The Early Twenty-First Century | 68 |
| 5. Expansion Breweries from the West | 86 |
| 6. Breweries of the Central Mountains | 95 |
| 7. Breweries of the Eastern Foothills | 112 |
| 8. High Country Breweries | 126 |
| 9. South by Southwest Mountain Breweries | 142 |
| 10. Breweries of the Western Mountains | 156 |
| 11. Six Years in Beer City, USA | 171 |
| 12. Beer's Pit Crew | 198 |
| | |
| Timeline of Western North Carolina Beer | 219 |
| Western North Carolina Breweries | 227 |
| Bibliography | 241 |
| Index | 247 |
| About the Author | 255 |

# FOREWORD

Sierra Nevada Brewing Company has called Western North Carolina—Mills River, specifically—its second home since 2012, when the company started construction on its brewery there. We started brewing in late 2013 and opened our facility to the public in 2014. It's been a great ride ever since.

Ironically, I didn't intend to build a brewery in the Asheville area. When we started the site selection process, it came up as an early, and obvious, contender. And why wouldn't it? A thriving beer scene, gorgeous scenery and plenty of the outdoorsy activities that our company and employees embrace. But the great local beer scene was precisely my concern—most of the breweries in Western North Carolina were fairly small with a regional reach and a loyal local following. The last thing I wanted to do was be seen as the behemoth, coming in and overshadowing the local brewers. I quickly took the Asheville area off the list.

As we neared our final selection after a year of research, Asheville came up again. All evidence pointed another way, but something told me to take a look. I made a series of visits with my family and with Sierra Nevada's leadership team—the consensus was that it would be a great second home for us. Still, the issue of our reception in the local beer community remained a concern. Rather than make assumptions, my son Brian and I met with the Asheville Brewers Alliance and spoke to members about the potential of opening a brewery in the area. We got a very warm welcome and were encouraged to join the community. There were a lot of questions, naturally,

# Foreword

but the meeting confirmed what I'd probably known for a while—Asheville was the place for us.

Aside from my philosophical concerns, the location we selected in Mills River certainly wasn't an obvious choice for a new brewery. Twenty minutes from downtown Asheville, it's somewhat removed from the center of the local beer universe. Located on almost two hundred acres of forest with French Broad River–front acreage, the site presented challenges—to say the least—when it came time to build the facility.

Still, the area suits Sierra Nevada perfectly. The property has excellent water for brewing. With careful tree removal, we were able to incorporate lumber milled from trees harvested onsite inside the brewery. We left as much of the property wooded and wild as we could, eventually planning to make areas available for hiking and mountain biking. Our riverfront property provides a scenic location for events.

Although I've been active in the Asheville beer community for fewer than ten years, I've seen enormous changes, the vast majority of which are for the better of breweries and beer drinkers. Like many states in the South, North Carolina's alcohol laws haven't entirely caught up to states in the West. Limits on distribution, sales hours and onsite brewery consumption were different from what Sierra Nevada was used to. Thanks to a united brewing community—brewers and drinkers alike—active industry organizations and interested legislators, we've seen positive changes that make it easier for us to do what we do in a responsible manner.

Ken Grossman, founder of Sierra Nevada Brewing Company, brewing in the early 1980s in Chico, California. *Courtesy of Sierra Nevada Brewing.*

The loosening of restrictions and growth of the craft beer industry nationwide is evident in the number of new breweries that have recently opened in the Asheville area. Breweries are now a major tourist draw for Western North Carolina, and they have a deep impact on the local economy. And yet, even with increased competition, the brewing community is still a supportive, collaborative, fun environment in which to operate.

# Foreword

Based on my long-held belief that a rising tide lifts all boats, Sierra Nevada started Beer Camp, which includes collaboration brewing as well as festivals that celebrate the craft industry's unique camaraderie. In 2014, we were pleased to invite brewers from the Asheville Brewers Alliance to collaborate on one of twelve beers featured in a twelve-pack and join us on the festival tour. Fittingly, Beer Camp kicked off in Chico, California, our original home, and ended in Mills River, when we opened the brewery to the public for the first time. It was a great way to welcome the community, and we, in turn, felt very welcomed by them.

As immersed as Sierra Nevada has become in Western North Carolina's beer community, I remain very aware there we're newcomers joining a long tradition of brewing in this part of the country. Anne Fitten Glenn is *the* beer historian of Western North Carolina. She has done in-depth research into that tradition, challenging our beliefs about the past and projecting a flourishing future. She understands that the area's brewing history is about more than just beer—major cultural shifts inevitably come when breweries establish themselves in formerly dry counties—and contrary to what beer drinkers in those counties may think, the changes have happened in a relatively short amount of time.

Grab a beer, ideally one made in Western North Carolina, and settle in for a story of malt, hops and determination.

Cheers,
Ken Grossman
Founder of Sierra Nevada Brewing Company

# CHEERS AND TOASTS

Writing can be a lonely craft, and yet, especially for a book like the one you're holding, it's impossible to do without a pit crew.

I'll begin by thanking everyone who has been a part of this process, no matter how small. I owe all y'all a beer (that's to cover my butt in case I've inadvertently left someone out).

I'd especially like to thank those who took the time to contribute to this book. Cheers to craft beer pioneer Ken Grossman, who wrote the lovely foreword. I always enjoy talking to Ken, because no matter how many questions I ask him, he always manages to ask me more. He's the epitome of humble. Plus, he created one of my favorite beers in the world—Sierra Nevada Pale Ale. Thank you, Ken.

Thanks also to amazing professional photographers and friends Steve Yocom and Erin Adams. Steve took the awe-inspiring cover shot, and Erin shared many of her beautiful beer and brewery photos with me. Erin and I work together for *Edible Asheville* magazine, and her photos always make my stories better.

Cheers to Kate Jenkins, acquisitions editor at The History Press. When Kate approached me in the fall of 2017 to discuss a volume on WNC beer, I said, "Let's do it," even knowing what the next six months would entail. Thanks, Kate, for your enthusiasm and for always answering my questions promptly. Thanks go out to everyone at The History Press and Arcadia Publishing who worked on this book. Thanks also to those of you who will help me sell it, especially the ever-persevering independent bookstores.

## Cheers and Toasts

To the librarians and historians who take time to point me down intriguing paths and help me uncover fascinating facts, thank you. In particular, I appreciate Gene Hyde, Ramsey Library head of special collections at University of North Carolina at Asheville, the Special Collections team at Belk Library at Appalachian State University and, always, the crew at the North Carolina Room at Asheville's Pack Library.

Please raise a pint to the vivacious Sally Tanner, who painstakingly helped put together the long list of breweries.

Cheers to everyone at Hatchworks Coworking. Y'all may be the only reason I showered during the final few months of writing. Thanks for providing me with a beautiful space in which to toil and copious caffeine.

Huge kudos to Courtenay Lane Morgan, who straightened out the crooked beer timeline and edited a bunch of stuff. She's my own personal cheerleader (not that either of us would ever consider being the kind that wear short skirts and wave pom-poms at male sports teams). I don't know how many times Courtenay said or texted, "You can do this!" But it was a lot, and it helped every single time.

Thanks also to Sean McNeal, who may be the only person other than my mom who has read almost every word I've written. I didn't ask him for as much editing on this book as I did on the first one, but he still pulled his weight. Plus, he's always down for a pint or an adventure or both.

Thanks also to friends who are always there for me, and for whom I am so grateful, especially (in alphabetical order) Billy Doubraski, Laura Lee Gentry, Megan Park, Gordon Smith, Rachael Smith, Alex Stevens and Lindsey Christmas Wilson. Also, thanks to my badass book club of twenty-plus years: Sheryl Aikman, Holly Jones, Mardi Letson, Beth Maczka, Beth Newman, Jeanine Siler-Jones, Susanne Walker-Wilson, Judith Whelchel and Tracy Whitehouse. I have the greatest friends ever.

Cheers to everyone in the now huge Western North Carolina beer family. Special thanks to all of you who talked to me, sent me photos and invited me behind the scenes of your lives and passions.

Special big hugs to everyone at Asheville Brewing Company. I've worked with this crew for the past three years, and they have given more to me than I have to them. They've paid me to give them advice, they've fed and cared for my kids and me and they've shared many pints of delicious craft beer with me. Particular thanks to Mike Rangel, one of the most creative visionaries I know, who has my back, as he's told me many times. I've got your back too, Mike.

I'd like to raise a glass to all my other beer industry friends, not just in WNC, but around the country, who've been there with me through all kinds of, let's say, interesting situations: Jason Caughman, Abigail Dickinson, Ray Dobens, Jo Doyle, Courtney King, Pete Langheinrich, Brandon Mountain, Allison Rangel, Jimi Rentz, Doug Riley, Tim Schaller, John Silver, George Stranahan, Scott Stuhr, Leah Tyrell and Nate Wall. I'm sure I've forgotten someone, and if that's you, I'll buy you a beer.

Big love to all my crazy extended southern family. To my mom, Lyn Glenn, who, despite having never consumed an entire beer in her life, has happily read almost every word I've ever written on the subject, and tells me I'm smart and pretty all the time. Thanks also to my dad, Bob Glenn, who, before he died, told me I should keep writing if that's what makes me happy, even if it's not a cash cow. Thanks also to my fun, smart, pretty sisters, Saunders Bohan and Amanda Brady.

This book is dedicated to my amazing offspring, Annabelle and Cador, who know more about beer than most middle-aged men. Annabelle, my rock, is the hardest-working person I know and already a better writer than her mom. Cador, my creative comedian, always makes me laugh when I need it and, as the kid still at home, is gracious enough to pretend to listen when I need to work through ideas. I love y'all so much.

# INTRODUCTION

The western part of the state of North Carolina is one of the best places in the world to drink locally brewed beer. I've lived here since 1997, and I've been writing about this region's craft beer for more than twelve years, so I'm clearly biased. But the triple whammy of Western North Carolina's natural beauty, increasingly sophisticated restaurant scene and prolific, diverse, high-quality breweries means you'd be hard pressed to disagree.

My first beer book, *Asheville Beer: An Intoxicating History of Mountain Brewing*, published in September 2012, profiles nineteen regional breweries in six counties. At the time, I thought the craft beer business might be hitting a plateau. Boy, was I wrong. Today, there are seventy-four operating breweries in eighteen Western North Carolina counties and at least another ten in planning. So, the number of WNC breweries quadrupled in six years. In the six months between turning in this manuscript and its publication, those numbers will change again.

While the growth of the industry nationwide is formidable, as there are currently more than six thousand craft breweries in the United States, the pace has been particularly explosive in this part of North Carolina. The City of Asheville's population of eighty-nine thousand and twenty-seven breweries give it one of the highest population to brewery per capita ratios in America.

This book serves as a companion volume to my first book and tells the stories of how Western North Carolina evolved from a mountainous frontier dotted with difficult-to-reach communities into a renowned international

## Introduction

Postcard, likely from the 1960s, showing some of WNC's famous attractions: Chimney Rock, Mount Mitchell, Biltmore, Tweetsie Railroad, Grandfather Mountain, Bridal Veil Falls, Blowing Rock, Looking Glass Falls and Jump Off Rock. *North Carolina Collection, Pack Memorial Public Library, Asheville, North Carolina.*

destination for craft beer drinkers. I discuss the rapid surge of breweries over the past several years while delving into the beery histories of some of the small towns outside of Asheville. Places such as Boone, Brevard and Hendersonville now have multiple breweries, rivaling the scene in Asheville of less than a decade ago.

This history of ales and lagers includes numerous formerly dry municipalities and counties revising their post-Prohibition regulations to welcome breweries—which attract community, jobs and dollars. Many of these spots only recently voted in alcoholic beverage sales, so there are first breweries popping up in tiny towns like Burnsville and Marion.

"There have been more changes in the beer business in the last eighteen months than in the past fifty years," said second-generation brewer Brian Grossman of Sierra Nevada Brewing Company. "The only thing that I will hang my hat on is that the brewing world will not look the same as it does today in a year or two years or five years. This business never gets boring."

When craft beer giants Sierra Nevada Brewing, New Belgium Brewing and Oskar Blues Brewery opened East Coast expansion facilities in Western North Carolina, it upped the ante in terms of quality, consistent beer and

# Introduction

access to ingredients and resources. This increased the area's attraction as a beer destination. In 2017, White Labs, a world leader in yeast production and fermentation science, opened new facilities in Asheville, partially because of the infrastructure created by the large expansion breweries. Western North Carolina beer's economic contributions continue to catch the attention of, not only the nation, but also of the world.

Additionally, this region is experiencing an agricultural renaissance hand-in-hand with the desire of many brewers to source ingredients locally. The number of support businesses, from hop farms to branding agencies to beverage-specializing attorneys, continues to pace the maturation of the industry. As the scene evolves, the number of folks looking for a piece of the action increases as well.

With opportunities come challenges, of course, in terms of buyouts from multinational beer conglomerates, increased competition, permitting woes and legal hurdles. Those are in addition to the challenges faced by any entrepreneur starting a business.

In terms of full disclosure, I have worked for a couple of the breweries featured in this book. I was full-time with Oskar Blues Brewery for almost three years, and I've consulted to Asheville Brewing Company for three years. Additionally, I served on the board of directors of the Asheville Brewers Alliance for almost five years. However, I've been a writer and journalist for much longer than I've worked with breweries, and I strive to be objective. My hope is that my time behind the mash tun has honed my knowledge and insights. That said, Western North Carolina has a complicated historic relationship with alcohol, and many people have opinions about it, including me.

Any and all mistakes herein are mine. I appreciate those who closely read my first book and contacted me about minor errors or discrepancies that I corrected in the reprints.

There are so many stories and people and businesses that should be in this book but aren't because I didn't have the time or the space to include them. Many folks have left their mark on Western North Carolina beer, and I apologize for not being able to talk to every one of you. I interviewed close to two hundred people, drove one thousand miles and had to get a new prescription for my glasses after months of too much screen time (not watching Netflix, although that's likely what I'll be doing by the time you're reading this—with a local beer in hand).

Additionally, history is more mutable than many people realize. When I was researching *Asheville Beer*, hardly any old newspapers were digitized.

# Introduction

Back when there were only a handful of WNC breweries and craft beer was called microbrew. *Photo by Anne Fitten Glenn.*

Today, numerous North Carolina newspapers are online at newspapers.com, some going back more than 150 years, with new content added weekly. This go-round, I spent much less time in the library stacks and much more time staring at a laptop (did I mention the new eyeglasses already?). Typing in keywords makes searching archives, newspaper articles and photographs much easier and helped me uncover some nuggets I didn't find the first time.

In *Asheville Beer*, I note that, as far as I knew, Western North Carolina's first brewery was Smoky Mountain Brewing of Waynesville, founded in 1993. Thanks to the magic of newspapers.com, I discovered stories from the 1870s referencing what were likely Asheville's first small breweries. As time marches on, other first breweries may be discovered and new information will be uncovered, possibly some that contradicts what I've written here. Please don't hold it against me.

It's often impossible to find secondary sources for ancient newspaper stories, so we'll have to trust the nineteenth-century editors until further information comes to light. Of course, drinking great beer and telling great stories go hand in hand, and I can't vouch for my interviewees' memories or levels of hyperbole. I'm a born and bred southerner and, therefore, a sucker for a good story.

## Introduction

While most of this book is chronological, because of the huge part of the state it covers, I often insert bits of history into the sections on specific towns or counties. History is everywhere.

This book isn't a guidebook, although it loosely can be used as such. As I discuss elsewhere, one of the hallmarks of this industry is speedy change.

Drink local. Drink responsibly. Cheers, y'all.

# 1
# MOUNTAIN FRONTIER-STYLE BEER AND BOOZE

Western North Carolina has a complicated history with alcohol. The wild saloon days of the late 1800s led to Prohibition, lingering dry counties and moonshine running, followed in the twenty-first century by the region's evolution into a renowned craft brewery destination. Only in the past few years have numerous towns outside of Asheville accepted a brewery in their midst. Despite some fears, many of these places have embraced the idea that beer production and sales can help reinvigorate communities.

But that's for later. Let's start at the beginning, or as close to it as we can, given the somewhat spotty historical record. Until the past fifty or so years, most newspaper articles lumped beer in with other alcoholic beverages, except when bars or saloons ran advertisements listing their goods. Most pre-Prohibition newspaper articles discuss the pros and cons (usually the latter) of whiskey, both illicit and legal. They rarely mention beer unless it's in relation to busting stills.

*Editor's note: Peculiarities of spelling and punctuation are preserved from the original documents.*

Making moonshine starts with boiling a mash using corn and water and then fermenting it. The resulting liquid basically is low-proof beer, which often was made for its own sake. People did, and some still do, drink the "beer." Thus, newspaper accounts of still busts throughout the region mention

the amount of beer discovered, as in this 1904 news item from Franklin: "Revenue officers J.B. Ensley and R.F. Henry captured an illicit still and about 400 gallons of beer and 50 gallons of low wines last Thursday on the Lyle Knob. The still was full of beer and a hot fire under it. It, no doubt, cut off a great deal of anticipated Christmas supplies."

While homemade corn liquor and fruit brandy were widespread in the Southern Appalachian Mountains in the early days, beer was here. However, its more potent relatives often overshadowed it.

## Where Is Western North Carolina?

To be clear, Western North Carolina (WNC) is not a defined region. Depending on whom you talk to or what you read, it encompasses between eleven and twenty-nine of the westernmost counties in the state. I've lived in Asheville since 1997, and most locals here don't include the exterior foothills or Hickory in WNC. Residents there may beg to differ. For this book, I asked a friend to draw an illustration of the twenty-three counties that straddle North Carolina's stretch of the Blue Ridge Mountains. Currently, eighteen of these counties are home to one or more breweries. To my surprise, every one of these counties, except Graham, either has an operating brewery, had one fairly recently or has one in planning.

North Carolina as a whole encompasses close to fifty-four thousand square miles, and WNC, at least within my parameters, includes more than a third of that. This is a long state. Folks crossing into North Carolina from Tennessee may not realize that they still have nine to eleven hours of driving to reach the state's coast. This volume attempts to cover the history of beer in an area bigger than some countries, so forgive me if I've missed anything along the way.

Originally, much of Western North Carolina was Native American country. Several of today's counties were part of the Cherokee Nation before treaties, many granted before the Revolutionary War, were broken. In the 1700s, much of the western part of North Carolina was called the "State of Buncombe." Also, the "State of Franklin" comprised part of the region. Both almost became their own states before North Carolina absorbed Buncombe and most of Franklin became East Tennessee. Today, Asheville is the seat of Buncombe County, which is considerably smaller than it was when the area was almost a state. Also, there was no clear western border early on, as maps only measured as far west as there were white settlers.

North Carolina's twenty-three westernmost counties and their county seats. *Illustration by Sean McNeal.*

If you're confused by the names of WNC's mountain ranges, that, too, is a little loose. The Blue Ridge Mountains are part of the Appalachian Mountain chain, and most references to the former are of the front range of the mountains that stretch through North Carolina and Virginia. The Blue Ridge Mountains often are called the Southern Appalachians as well. The Great Smoky Mountains are a sub range of the Blue Ridge Mountains and run down the North Carolina/Tennessee state border.

Now that we've gotten some geography out of the way, let's get back to what you're here for: beer.

## Western North Carolina's First Drinkers

The Mississippian, Cherokee and Catawba tribes were predominant in Western North Carolina for centuries before European settlers arrived. The archaeological remains of Joara, identified as the regional chiefdom settlement of the Mississippians, are near the town of Morganton in Burke County.

As far back as AD 900, settled communities here cultivated maize. As corn is, of course, a fermentable sugar and was used extensively later as the base for moonshine, it's likely that WNC's aboriginals knew how to brew a maize-based beer. There's evidence that the Cherokee made both corn

beer and fermented beverages from foraged fruits and berries. The resultant drinks likely were used for rituals.

Also near Morganton is the site of the oldest known non-coastal European settlement in America. The Spanish Fort San Juan was built in 1567 and occupied for eighteen months by men looking for interior routes to Mexican silver mines. They were, clearly, geographically challenged. The consumption of wine by sixteenth-century Spaniards was high, although it's not known if these early explorers carried that beverage this far inland. However, wherever Spaniards explored the Americas, they reported that the natives were masters at fermenting whatever was at hand, whether it be maize, cacti, wild fruit or even bark. The fort was abandoned after the Mississippians attacked the garrison, leaving only one survivor to tell the tale.

## The 1700s: Frontier Country

After the fall of Fort San Juan, it would be more than two hundred years before any Europeans attempted to resettle these mountains. In the mid-1700s, there was a great diaspora of Scots-Irish and German immigrants to America. Many who landed in the Northeast found land too expensive there and headed south. These immigrants slowly trickled into the mountains from cities such as Philadelphia and Charleston, settling first along the banks of the Yadkin and Catawba Rivers, including, famously, pioneer and explorer Daniel Boone.

Thus, the WNC towns of Morganton (1774) and Wilkesboro (1778) were among the first established. The Northern European frontier homesteaders brought a taste for peaty whiskey and warm, sweet beer with them. Many traveled with a copper pot among their few possessions. It wasn't until 1784 that the first family of European descent made the trek across Swannanoa Gap into the area that would later become Asheville.

In the 1700s, while imported beer, rum and brandy were popular in most of North Carolina, transportation of, really, anything, into the mountains was difficult, and it's doubtful that imported alcoholic beverages were readily available, if at all. Like the natives, early European settlers here made their own beer, cider, wine and mead from whatever fermentable fruits or vegetables they could find.

The families living in the hollers were subsistence survivors. Typically, women were in charge of beverage production in the home. They would use

persimmons, berries and even locust pods to make beer, wine and brandy. Given that wild ginger grows well in WNC, ginger beer likely was common. A recipe for table beer from the 1863 *Confederate Receipt Book* includes ginger: "To eight quarts of boiling water put a pound of treacle, a quarter of an ounce of ginger and two bay leaves, let this boil for a quarter of an hour, then cool, and work it with yeast as with other beer."

Of course, corn was cultivated both as livestock feed as well as for the production of small batches of corn-based beer and whiskey. These beverages were an important part of the barter system in the region, as cash was scarce. Corn liquor was one of the few items that Western North Carolinians could sell in order to raise cash to pay federal land taxes. In 1893, a tax collector announced in the *Brevard Hustler*: "I will sell on Nov 15th, in the town of Brevard, one lot of Corn Whiskey, to the highest bidder for cash, seized as the property of J.F. Henson's for taxes."

Referring to WNC's early settlers, Horace Kephart, author of *Our Southern Highlanders*, writes: "A still had been set up on nearly every farm. A horse could carry about sixteen gallons of liquor, which represented eight bushels of grain…and double that amount in value." Given the horrible state of the few roads across the mountains, it made more sense to send distilled corn to market than it did to send the raw ingredient.

Although the last wild buffalo disappeared from WNC in the late 1700s, Native Americans treaded the trails they trampled through the dense rhododendron on hunting trips. Over time, those trails morphed into rough roads, which became routes for moonshine runners, also known as blockaders. Today, beer trucks follow the paths of the buffalo up and down the mountains, along the ridgelines and through the river valleys of WNC.

Initially, the town of Asheville grew up around the Drover's Road and later the Buncombe Turnpike, which primarily were passages for livestock. The first inns and hotels in the region were built in the early 1800s for the drovers, including Sherrill's Inn in Fairview, which still stands today. In 1860, per one historical account: "Livestock, namely cattle, sheep, and hogs, was the principal crop of the region." Also of significance economically was the huge amount of corn needed to feed the stream of animals. Along the livestock roads, farmers flourished. Any leftover corn could be distilled into "mountain dew."

Transportation to and through these mountains continues to shape the region culturally and economically. As infrastructure improved and the first highways were built, they brought with them better access to goods and services. And, of course, they opened up more of the region to tourism.

Even today, a handful of WNC towns are accessible only via winding two-lane mountain roads. I mention this because, as I was struggling with how to organize this volume, I spent a lot of time looking at maps and following the roads from brewery to brewery on my computer screen.

Infrastructure has been both a boon and a challenge in these precipitous mountains, and it continues to impact distribution of goods today, including beer.

## That Good Old Mountain Dew

There are numerous histories of moonshining and illicit whiskey production in this area, so I'm not going to discuss that at length here. However, I do believe that the tradition of self-sufficiency that led WNC residents to make their own hooch has been a factor in the rise of the brewing business here. The liquid was such a part of the region's culture that the Asheville Moonshiners was the name of the first minor league baseball team. In a reflection of the evolution of revenue in the region, the team was renamed the Asheville Tourists during Prohibition.

Sheriff Jesse James Bailey busting a still in the Blue Ridge Mountains. Bailey was sheriff of Madison County (1920–22) and Buncombe County (1928–30), and he spent most of that time enforcing Prohibition laws. *North Carolina Collection, Pack Memorial Public Library, Asheville, North Carolina.*

One of the reasons the Southern Appalachians became a center of moonshine production is one of the same reasons the area has become a brewing mecca: access to good water and lots of it. Just as soft water, with a neutral pH, is great for making beer, it's also ideal for making good liquor. Additionally, the difficult-to-penetrate rhododendron thickets made excellent hiding places for stills.

Until the late 1800s, alcohol consumption was an important part of life in this part of the world, which had yet to hear much about the temperance movement arising in the big cities far away. Additionally, many of these spirits served as a base for homemade medicines and folk remedies. "Corn liquor is a great way to preserve medicinal plants," said Chris Bower, cofounder of Asheville's Eda Rhyne Distillery. "Part of the runs would go to grandma or grandpa or whomever was creating folk medicine for the family or the community. They would forage local plants and herbs that had medicinal value and preserve them in moonshine."

## The Early 1800s

North Carolina's first known commercial brewery was Single Brothers Brewery & Distillery, in the Moravian town of Salem, which produced beer from 1774 to 1813.

"Beer was a big part of life in the early days of Salem....Nearly all of the town's libations were made at Single Brothers' Brewery, including the beer served to out-of-town guests staying at Salem Tavern. Among the brewery's biggest fans was President George Washington, who reportedly praised the tavern's beer during his visit to Salem in 1791," wrote Kat Bodrie in *Winston-Salem Monthly*.

There's evidence that the community elders hoped that good beer would supplant "demon whiskey" and decrease local drunkenness without taking the drastic step of going completely dry.

While in today's miles, Winston-Salem is only about an hour's drive from the WNC town of Wilkesboro, there's no evidence that beer made it from the brewery to the town. However, Moravians originally settled Wilkesboro, so it's highly likely they were brewing beer there.

In 1822, Thomas Holmes opened a brewery in Salisbury, North Carolina, and even ran newspaper advertisements looking to purchase hops. While, like Winston-Salem, Salisbury isn't far from the mountains, back then,

getting heavy casks of beer up the muddy trails from the town would hardly have been worthwhile, and there's no evidence that Holmes's beer made it to the area. A year later, an article notes that the "successful" experiment by the "highly respectable and enterprising gentleman" had to suspend operations when his "principal worker, an experienced brewer, died."

Despite early stories to the contrary, hops sometimes were available for those who brewed at home. An 1860 ad in the *Asheville News* offers two hundred pounds of fresh hops for sale. An 1893 letter to the editor of the *Watauga Democrat* reads, "The hop industry is considerable in some sections of the State.…There is nearly as much beer drank here as there is water in the South." In full disclosure, the writer was decrying the lack of young men at church, but his comments are intriguing nonetheless.

## Western North Carolina's First Breweries (Probably)

In *Asheville Beer*, I wrote that I had no evidence of any pre-Prohibition breweries operating in WNC. I'm happy to report that newspapers.com has proved me wrong.

An 1872 *Asheville Weekly Citizen* article describes the town thus: "It contains ten stores with general assortments; two drug stores, one drug and book store, one family grocery, one jeweler's shop, two tailor's and two tin shops, with two bakeries and one small brewery." The population then was 1,600, making the brewery to population per capita rate higher then than in 2018.

Next, an 1875 notice in the same newspaper says that "Prof. Muller is now making an excellent article of lager beer at his brewery near town, which will be sold either wholesale or retail. We can endorse this beer for we have seen another fellow drink some who is a judge and who pronounced it betterish ash goode."

There are no further mentions of this brewery. Muller was a professor of music at Asheville Female College and a German immigrant. However, it seems that alcohol manufacturing has been a family affair in WNC since the very beginning.

Professor Muller's son, W.O. Muller, established a "liquor house" and bar in downtown Asheville in 1879. Contemporary newspaper advertisements assert that W.O. was a "distiller of pure 'Mountain Dew' Corn and Rye

Whiskies." W.O. did indeed own a distillery, although the only reason I know that is because he was indicted for tax evasion on his product in 1881. The distillery was located in Turnpike, North Carolina, which, as far as I can figure, was near Hominy Creek in West Asheville.

A distillery employee testified that he was told to pick up a barrel—on which the tax stamps had not been destroyed—from an Asheville bar. He then took the barrel to the distillery, refilled it and delivered the same barrel to a different Asheville saloon. He claimed the distillery manager, G.W. Cannon, instructed him to put his hat over the stamp so no one could see what he was doing. Another employee testified that he delivered a forty-gallon barrel of whiskey from the distillery to a bar without a tax-paid stamp, but Cannon told him the stamp would arrive the next day. Thus, it seems that adhering to the federal excise tax was not high on the agendas of even the legal liquor producers of the time.

W.O. ran numerous newspaper advertisements promoting Chas. Holter's Prospect Brewery of Philadelphia and his "Extra Quality 'Budweis' Lager Beer, brewed of the best Barley and Imported Bohemian Hops." In 1884, apparently having dealt with his tax situation, W.O. expanded his business, opening a second location, with a "Wholesale Liquor Business" and upstairs billiard hall and clubroom. He ran this business until 1894, when he sold the building on the courthouse steps. Its location, across from the old courthouse on the corner of South Main (now Biltmore Avenue) and West College, would suggest that it was a visible and profitable business.

In 1875, the *Asheville Weekly Citizen* published the new "Ordinances of the Town of Asheville," which ordained that any person engaging in the sale of "any distilled spirits, malt liquors, or intoxicating drinks of any kind" on Sunday would be fined ten dollars. Note that the offense of allowing a "Jackass to run at large within the town" would result in the same steep fine. Many years would pass before Sunday sales were allowed again in Asheville—but prohibited from 2:00 a.m. until noon because of morning religious services. However, the state passed the so-called Brunch Bill in 2017, which allowed Sunday sales to start at 10:00 a.m., subject to each town or county's approval.

There are a few more mentions of breweries in Asheville in the late 1800s. In June 1878, the newspaper ran a short item that reads: "The Deaver Brewery a short distance north of Asheville, has been resuscitated under the management of Mr. John Hildebrand, and the beer is all that the imbibers of this healthy beverage would have it. It is sold in casks to families at a price that places it within reach of all."

> HILDEBRAND BUCK BEER. — This very superior brand of Lager is now being manufactured in quantities to suit purchasers by Mr. J. S. Deaver, near Asheville. The brewery is located a short walk north of Camp Patton, in a delightfully cool place, where Mr. D... is preparing a beer garden for parties to walk to and enjoy a refreshing glass of excellent beer, porter or ale. It is a quiet retreat, no loafers or drunkards are allowed, and will be kept so that ladies can go with gentlemen with every assurance of being undisturbed and enjoying this healthful beverage. Very many now frequent the Deaver Beer Gardens.

An *Asheville Citizen* article from 1878 describing what may have been Asheville's first commercial brewery. *Newspapers.com.*

A few months later, there's an announcement that J.S. Deaver is brewing "Hildebrand Buck Beer" at his brewery just north of Asheville.

First of all, let's talk about the location. Camp Patton was a military encampment for both Confederate and Union soldiers—obviously not at the same time. Thomas Patton, a Civil War veteran and well-known Asheville citizen, completed a home on the property, which had belonged to his father, in 1869. The Patton-Parker House, as it would come to be known, still stands today at the corner of Charlotte and Chestnut Streets. Deaver Brewery or Beer Gardens likely would've been in the area between the Patton-Parker home, now owned by a local law firm, and the Manor Inn grounds, on which construction started in 1898. The location was considered outside of the city proper then.

Americans often referred to German-style "Bock," a sweet, strong lager, as "Buck" beer at the time. Hildebrand was the name of the brewery manager, who likely was the brewer.

The final mention of a brewery in the same area is an 1879 newspaper article titled "A Daring Robbery." In it, Rube Deaver reported walking to his brewery with an Atlanta man named Volmort (Not J.S. in this article, but Rube). Volmort, who came to town with "recommendations," said he was interested in renting the brewery. However, as they were walking back to town, the brewery owner discovered Volmort had removed Deaver's watch from his pocket and thrown it into a lot next to "the female college grounds." Deaver grabbed the man and started marching him to town, but when they reached College Street, "Volmort…made good his escape, shaking the dust (or, rather, the mud) of Asheville from his feet with a rapidity that would have done credit to a quarter horse. It is probably right to say he did not rent the brewery."

So, Deaver Beer Gardens was near the female college, where Professor Muller taught and near where he reportedly brewed beer. Was it the same brewery? It seems likely. It's possible that Professor Muller was the first brewer and then Hildebrand, the resuscitator, replaced him. My guess is that, given the small size of the city, most of these mentions, including

the one from 1872, refer to the same brewery. So, I think that, from at least 1872 until 1879, there was a small brewery on what's now Asheville's Charlotte Street.

I couldn't find anything else about a J.S. Deaver, although he's called Rube Deaver on second reference. There are a few mentions of a Rube Deaver through 1901, although no others in relation to a brewery or any other line of work. Additionally, there's nothing more about Mr. Hildebrand, although a John Hildebrand died on his farm in Chunn's Cove, outside of Asheville, in 1901. He was credited with being an Asheville pioneer, having moved to the area before the Civil War from Cleveland, Ohio. If it's the same person, Hildebrand would've been fifty-seven in 1878, which, back then, was a fairly advanced age to be running a brewery.

Finally, an 1880 *Asheville Weekly Citizen* ad mentions another local brewery making "pure Lager beer." A. Wernswag wrote, "I would respectfully inform the public that I have assumed the management of the Brewery of Featherston & Freck, and am now enabled to offer a first-rate article of Lager beer, equal to the best." The ad goes on to say, "Orders received at A. Frecks' and at the Brewery. I warrant this beer to keep good for several months in a cool place."

The ads appeared for about three months, after which there are no other mentions of the brewery or of A. Wernswag. Adolph Freck, however, was a German-born shoemaker whose shop was on South Main Street, where most of the city's saloons were located. Freck also attended the Association of Liquor Dealers' annual meeting and banquet in 1895, so shoes may not have been the only product he sold. Additionally, Freck's daughter was married to J.A. Marquardt, manager of Asheville's Bonanza saloon.

The final pre-Prohibition WNC brewery reference, at least from current digitized news stories, was a story big enough to be picked up by a Charlotte newspaper. In 1903, the *Asheville Weekly Citizen* announced plans for a brewery to be built in town, located on the French Broad near the Asheville cotton mills (near where Wedge Brewing at Foundation is today). The article mentions that the matter was in the hands of the Southern Railway and notes: "The enterprise is backed by large capital and it is proposed to erect a brewing plant thoroughly modern in its entire equipment with a capacity sufficient to supply the brewing demands of not only this immediate section, but the Carolinas, Virginia, Georgia, and East Tennessee." The article goes on: "There are no breweries in this section of the state."

It seems that nothing came of the plans, likely because of the railroad or pressure from the growing temperance movement or other issues. As Asheville citizens would vote to cease beer manufacture and sales six years later, it's probably a good thing that a large brewery didn't open there at the time.

## Wild, Wild Western North Carolina

The years between 1880 and 1900 ushered in tremendous change across WNC. The railroad inched its way deeper into the mountains, bringing people, goods and resources. The populations of many of the towns, and especially Asheville, swelled.

More people and more visitors pumped up the hospitality industry, which has continued to grow and spread since then. Lavish hotels and inns were built across the region to cater to tourists, many of whom visited for months in the summer to escape the heat of cities such as Atlanta and Charleston. Asheville's Battery Park Hotel was completed in 1889, and a year later, George Vanderbilt started construction on his magnificent home, Biltmore.

While Victorian-era travelers drank at hotels, working-class residents typically drank at the bars and saloons that popped up around the same time—well, men did, at least. It's difficult for me, a woman who works in this business, to imagine a world where women didn't drink in public. Some hotels had special rooms, hidden from the eyes of their male guests, where women were allowed to drink. Even in 1933, just after Prohibition ended, an Asheville newspaper article states: "Women drink beer in restaurants and from hotel service, or in their homes. Since the opening night here, no women have been served at the billiard parlor bars."

However, especially in rural parts of WNC, women were involved in home brewing and winemaking at the turn of the century and likely throughout Prohibition. An 1886 article from the Highlands newspaper notes: "Here, for instance, in a town of 2,000 inhabitants, one woman for years made her pin-money by the weekly brewing of yeast for her neighbors. She has gone out of the business now, her husband objecting; and the women are left lamenting the lost convenience." While that yeast was used for baking, it also, no doubt, was used for fermentation.

An ad in an Asheville newspaper, also from 1886, instructs: "Go to Bob Jones to get sweet mash corn whiskey made by the bare-footed girl on Bald

Mountain." There are numerous mentions of this "bare-footed girl," who produced superior corn liquor.

Saloons opened throughout WNC, although most were clustered in downtown Asheville. Per newspaper accounts, Thornton Ingle opened Blowing Rock's first "beer saloon" in July 1889. That opening provoked a flurry of angry letters in the *Watauga Democrat*, a newspaper serving both the towns of Boone and Blowing Rock. Most of the letters expressed delight that Boone hadn't allowed a beer saloon inside its town borders unlike its rowdier neighbor.

Throughout the 1880s and '90s, many bars advertised in local newspapers. As the temperance movement took hold, those advertisements lessened.

Newspaper ads for the Bonanza ran from 1886 to 1907, making it one of Asheville's longest lasting pre-Prohibition bars. The saloon and liquor store, located at 43 South Main Street, advertised, "Beer, Vaults, and Bottling Department in Basement." My guess is that the basement bottling operation was a place to transfer cask beer into bottles for to-go orders, like today's growlers. But there could have been brewing going on down there as well. The owner of the saloon, Frank Loughran, used his name to advertise several of his beverages, such as Frank Loughran's "Old Straight Cut" and

Billiard hall and saloon, circa 1890s, located on Asheville's "Saloon Row." Posters above the bar feature Henderson Brewing of Kentucky and Christian Moerlein Brewing of Cincinnati. The latter is still in existence today. *North Carolina Collection, Pack Memorial Public Library, Asheville, North Carolina.*

Frank Loughran's "Old Nectar." So, it's a good bet that, like W.O., Frank owned a distillery to help supply his bar.

"Vaults" were also used to keep beer cold. The advent of refrigeration was huge for the South. "Until recently New York and western brewers found a valuable market in the south, but since the invention of ice-machines new breweries have been built in all the chief centers of the southern states," proclaims an 1895 article in a Kansas newspaper.

Most of these saloons also sold product wholesale and offered home delivery. Growlers of the time were lidded buckets that could be filled and reused.

Per newspaper ads, after Prohibition was voted in, Bonanza manager Marquardt changed his career from saloon manager to tailor. Saloon owner Loughran, on the other hand, was a shrewd businessman who purchased lots of downtown property, including the Hotel Berkeley.

While we may think that partnerships and acquisitions of small businesses are specific to today's business world, we would be incorrect. In 1896, the Robert Portner Brewing Company of Alexandria, Virginia, purchased a $5,000 share in the Bonanza Wine and Liquor Company. Whether this was an investment or a bid to place beer there is unclear.

## The Sad Tale of the Alligator Bar

In September 1887, an Asheville newspaper featured a short article titled "Something New." It went on to say: "A six foot alligator, alive and splashing, adorns the basin that surrounds the fountain of Edel in the new Starnes building on North Main street. His alligatorship seems as much at home in his strange quarters as if he were in his native lagoon." A man named Sol Edel would soon open a saloon in the building, called, not surprisingly, the Alligator Bar.

Almost exactly two months later, the paper reports that

> *Mr. Edel's alligator which has been such an attraction to the Alligator bar, peacefully passed away Saturday night, and is now in the happy swamps where all good alligators go. Mr. Edel has ordered by telegraph another which has been forwarded, and which is twelve feet in length. This will be the largest alligator ever seen in the mountains.*

**THE - ALLIGATOR - BAR.**

Really Alive. 12 Feet Long.

DEALER IN

Pure Rye, Bourbon Brandies, Old Corn Whiskey,
AND ALL KINDS OF
WINES FOR MEDICAL PURPOSES.

Ales, Porters, and the celebrated Schlitz' Milwaukee Lager Beer. I keep the finest place and the finest goods and don't charge you no more than any one else. Come and give me a trial. I sell my goods on condition that if not satisfactory will refund money. There is also an elegant Bowling Alley attached, 70 ft. long.

**SOL EDEL,**
North Main Street, 127, Asheville, N. C.

An 1887 advertisement in the *Asheville Citizen* for the Alligator Bar. *Newspapers.com.*

Edel ran numerous ads for the bar from December 1887 through March 1888 advertising "Ales, Porters, and the celebrated Schlitz' Milwaukee Lager Beer." In addition to a large reptile, the bar contained an "elegant Bowling Alley." A later newspaper story mentions a shooting contest at the bar's shooting gallery.

However, all this was not enough to keep the Alligator Bar in business. In December 1888, Edel ran ads that he was selling, "at a great sacrifice," all of his goods, from corn whiskey to blackberry wine and cigars. There's no mention of what happened to gator number two. A separate item around the same time notes that Edel had sold two bears and a cage for fifteen dollars, indicating he may have had quite the menagerie.

There's no mention of Sol Edel or alligators in the local news until a decade later. In 1898, an article said that Edel committed suicide by shotgun in Texas. It goes on to say he was in Texas to face a murder charge, for which he was acquitted. Sadly, the piece concludes: "Edel left a letter to the coroner saying that he willingly took his life because he was not able to make a good honest living."

In the 1890 *Asheville City Directory*, an ad for Jas. H. Loughran's "White Man's Bar" claims "No free lunches served, or any kind of Wild Animals on exhibition to attract the attention of the lower trade." James Loughran was the brother of the aforementioned Frank. No doubt, in this ad, he was referring to the Alligator Bar. James also advertised extensively: "Whiskies, Wines and Brandies which have been recommended by leading physicians in the State for medicinal purposes." Apparently, this kind of medicine was only for white men who didn't cavort with wild animals.

"Blind Tiger" or "Blind Pig" bars often are mentioned as products of Prohibition. Even though sales were forbidden, drinking alcoholic beverages was not actually illegal. During that time, speakeasies would charge a fee

for the customer to see an exotic or unusual animal and then give them "free" whiskey. However, given the story of the Alligator Bar, using animals to attract customers was happening long before Prohibition. I'd love to know how someone got a twelve-foot gator from the low country into the mountains in the 1880s. The only options were via rail car or horse-drawn wagon, or possibly both. I don't imagine it was a fun trip, either for the poor animal or for whomever transported it.

Numerous saloons and bars, feeling the pressure of the temperance movement, closed in the first decade of the twentieth century. Many became groceries or mercantile businesses. Some proprietors left the area.

The war on alcohol in Western North Carolina had begun, and it would not end soon, if ever.

# 2
# THE WAR ON BEER

Prohibition lasted much longer in North Carolina than in most of the rest of America. The state was the first in the country to go dry via popular vote, in 1909. However, many Western North Carolina towns already had chosen abstinence by then.

While most of the nation lived through fourteen years of Prohibition, from 1919 to 1933, the Noble Experiment lasted for decades in WNC. Several counties are still dry today but contain wet pockets, typically in incorporated areas. The town of Robbinsville has been dry for more than 110 years. Even Asheville voted in Prohibition before the state did. There was no legal beer manufactured, transported or sold in Beer City for twenty-five years.

## Last Call

The Asheville vote, in 1907, was sparked, in part, by the violence on and around "Saloon Row" and the area behind it, often referred to then as "Hell's Half Acre." The latter term wasn't unique to Asheville, with numerous cities using that moniker, always for the most downtrodden areas, where the poorest and most desperate resided. In WNC's largest city, that was the area of South Main, now Biltmore, running from Patton Avenue down to where the Orange Peel is today and including the historically African American neighborhood behind it along Eagle and South Market Streets.

Tensions ran especially high in Asheville after a wanted man named Will Harris came to Asheville one November night in 1906, got drunk at the Buffalo Saloon, and then shot and killed five men, including two police officers. The next day, a posse tracked down and killed Harris near Fletcher. However, the Mecklenberg County sheriff who traveled to Asheville to identify the body wasn't positive the dead man was the desperado. Needless to say, townspeople were riled up, and the dry contingent used this horrifying trauma to push through its agenda several months later.

The reasons for American Prohibition are complex and multilayered. In the seventeenth and eighteenth centuries, drinking and drinking heavily was a daily part of life for many. In the mountains, every social event included corn whiskey—from barn raisings to bear hunts to political elections. As settlements developed into communities throughout Western North Carolina and more and more men started working away from their homesteads, it became normal for many of them to pop into a bar at the end of the day. Except for the fact that this norm is no longer gender-specific, today's world is not so different.

However, as women were not allowed in most saloons and billiard halls, they were stuck at home with the kids. Instead of heading home to help around the house, some men would arrive home late and drunk, having spent their cash on what was swishing around inside them. Not surprisingly, this made the females in their lives angry. While there were negative consequences of the temperance movement, one of the most positive changes it engendered was giving American women a voice. Women's right to vote, prison and education reform and multiple peace movements all arose from women getting organized around putting a halt to legal licentiousness.

Temperance also is tied to the Christian church, although different faiths supported it to differing degrees. Initially, the movement centered in big cities, mostly in the Northeast, and didn't much affect WNC, despite the area being a Protestant stronghold.

"While some mountain churches embraced the temperance movement, most, even the Baptists and the Methodists, only discouraged drunkenness and promoted moderation. In the antebellum period, it was common for deacons and elders in Smokies churches to drink alcohol or even produce it," writes author and University of North Carolina at Asheville history professor Daniel S. Pierce in *Corn from a Jar*.

However, that would change, as by the end of the nineteenth century, both of these churches adopted stringent teetotaling stances. The Southern Baptist Convention still promotes total abstinence. Pierce mentions that

A Mountain Brew History

A 1920s postcard of a black bear drinking soda at Point Lookout, a tourist attraction between Ridgecrest and Old Fort. *North Carolina Collection, Pack Memorial Public Library, Asheville, North Carolina.*

there still are more than one hundred Baptist churches in Buncombe County—which, believe it or not, means there probably are more Baptists than brewers.

In *Our Southern Highlanders*, published in 1913, Horace Kephart writes, "One might have expected that prohibition would be bitterly opposed in Appalachia, in view of that here the old-fashioned principle still prevails, in practice, that moderate drinking is neither a sin nor a disgrace, and that a man has the same right to make his own whiskey as his own soup, if he chooses."

Kephart also notes that when the area became dry, profits increased for the blockaders, as did the risks.

"Give the mountaineers a lawful chance to make decent livings where they are," Kephart suggests. "This means, first of all, decent roads whereby to market their farm produce without losing all profit in cost of transportation."

At the turn of the century, numerous U.S. newspapers rallied behind the temperance movement. At the time, some newspapers were unapologetically political and openly promoted their editors' agendas. In WNC, the *Franklin Press*, Brevard's *Sylvan Valley News* and Hendersonville's *French Broad Hustler* were bold proponents of Prohibition and editorialized profusely on the subject.

When the citizens of Brevard voted against opening a dispensary there in 1903, via a vote of 49 to 23, the editor of the *Sylvan Valley News* crowed, "The people of Brevard are decidedly against the legal sale of whiskey in the town." Dispensaries were the forerunners to today's state-run liquor stores in North Carolina. The editorial calls for the citizens of the town and county to put a stop to "nefarious" sales of illicit alcohol. The editor continues: "The legal sale of whiskey has received its quietus; let us give the same deadener to the blind tiger and hole-in-the-wall men."

That said, many of the most prominent advertisements in the same newspaper are for patent medicines, most of which were merely herbal delivery methods for alcohol, including Thedford's Black-Draught and Rocky Mountain Tea Nuggets. There also were numerous ads in many WNC newspapers for a "30-day Opium, Cocaine, and Whiskey treatment" in Atlanta, making it seem that many weren't battling the evils of only alcohol.

In 1911, the *Watauga Democrat* announced that, despite the loss of thousands of dollars, the editors had decided to no longer run advertisements for alcohol or "snake bite medicine." Yes, North Carolina was dry at the time, although—in a bit of a loophole—alcohol could still be delivered from other states.

# A Mountain Brew History

In WNC, Prohibition had the unintended effect of boosting illicit moonshine production and increasing the violence that sometimes accompanied its manufacture and distribution. It also sent many back to home brewing and wine making, which, while strictly illegal, was difficult to enforce. In *Historic Waynesville*, Louise Nelson writes that, in 1927, drugstores in the area sold moonshine by the drink with a doctor's prescription. This was common practice in drugstores across the state, unless it had been directly prohibited by a town's governing body. If you've ever wondered how Jay Gatsby of *The Great Gatsby* made so much money off of drugstores in the 1920s, now you know.

## No Hangovers for North Carolina

When Franklin D. Roosevelt signed the Twenty-First Amendment, which overturned the Eighteenth Amendment, North and South Carolina refused to ratify it.

"The Carolinas, only states to vote down the repeal amendment, awoke today without a hangover," was the lead in an *Associated Press* story published the day after repeal. "There was no public celebration, no spontaneous outbreak of revelry."

However, 3.2 percent beer slid under the North Carolina General Assembly's radar and made it to Asheville. On April 30, 1933, the first three thousand cases of legal bottled beer arrived in the city. The five registered wholesalers then scrambled to get them out to the more than one hundred retailers that had applied for sales licenses in the city and to the additional twenty-five licensees in the county. These businesses included grocery stores, restaurants, fountain counters (drugstores), hotels, coffee shops and lunch stands. Clearly, businesses and people were excited about low-alcohol beer.

An *Asheville Citizen-Times* article published a few months later proclaims that female beer drinkers were increasing, for a few intriguing reasons:

> *One is that all brands of beer being sold now taste better than home brew; however more potent the home product might be. The second reason cited is that many girls have been drinking liquor when they really did not care for the stuff. Then, too, the "very thin models" are hoping that beer will give them increasingly fashionable Mae West curves.*

Anheuser-Busch Brewery survived Prohibition by making a nonalcoholic malt beverage called Bevo. This truck, loaded with Bevo, made deliveries in the Rockingham, North Carolina area in the 1920s. *Rockingham Community College Foundation Inc., Historical Collections, Gerald B. James Library.*

Even after alcohol sales became legal in North Carolina, there was, and still is, a local option policy. This means every town and county in the state can decide whether or not to allow alcohol sales—and to what degree. Most places voted in sales of beer and wine first, followed—usually much later—by the introduction of an ABC store and, eventually, by approval of liquor-by-the-drink sales.

## Law and Order

WNC is still home to places that are completely dry, places that are moist and places that are semi-moist, so to speak. From the end of Prohibition until today, a veritable roller coaster of referendums, resolutions, votes and regulations has controlled alcoholic beverage manufacture and sales throughout the region. Many towns and counties have voted multiple times over the years, resulting in a confusing jumble of laws, separated only by lines on maps.

Because of local option, a county can be dry while some of its towns or incorporated areas are wet. Today, all of WNC's remaining dry counties contain a wet patch or two. Even the county that most consider the last completely dry one, Graham, now has alcohol sales in the tiny resort town of Fontana Dam. That's because of one of many weird laws that can supersede existing regulations. The so-called Blue Ridge Parkway rule allows alcohol sales within a mile and a half of a parkway entrance or exit ramp, and the "resort" law allows the same if there's a tennis court or golf course on the property. In other words, it's okay for the tourists passing through to imbibe, but heaven forbid that residents get the same privilege.

In 1937, the North Carolina General Assembly passed the Alcoholic Beverage Control statute, which allowed ABC stores to open in the state, under government control. There are seventeen control states in the nation, and North Carolina is one of the strangest. While beer and wine can be sold at grocery and convenience stores, all other liquors and spirits are sold only at ABC stores. Those are run by local ABC Boards, and those boards answer to the state ABC Commission, which sets all pricing for liquor. This is confusing for tourists when they learn that if they want to purchase a bottle of legal shine or whiskey they have to find an open ABC store.

Asheville voted no to having ABC stores in 1939, then yes in '47. Soon after, four ABC stores opened in the town. Many WNC towns still don't have ABC stores. There's an ABC store vote on the ballot in the Qualla Boundary in 2018, although the reservation has voted "no" multiple times in the past.

Additionally, the ABC Commission controls all permits and licenses for sales of alcoholic beverages in the state, including those for beer and wine. Therefore, state breweries are subject to extensive rules and regulations, including label and product approval, advertising and event restrictions and financial and inventory reporting. There's also a law enforcement arm of the ABC, the North Carolina Alcohol Law Enforcement Agency (ALE). Created in 1949, the ALE enforces alcoholic beverage control and lottery laws. The plainclothes ALE agents often bust licensees for serving alcohol to minors, but in recent years, they have cracked down on breweries, particularly in the areas of event permitting, cooperative advertising and drinking while on the clock (even if the brewery is closed).

## Post-Prohibition Turmoil

One of the first beer bars to open in Asheville after Prohibition was appropriately named "The Bar." Bernard Henderson and R.G. Carter opened it on Broadway Street in 1935. The Bar offered sandwiches, pool tables and a variety of ales and lagers, including Schlitz, Budweiser, Blue Ribbon Beer, Red Top (Cincinnati) and Hi-Bru and Oertel's '92 (both from Kentucky).

Clearly, some breweries got up and running quickly once Prohibition ended or back up and running after selling near beer and soft drinks for years. However, in WNC, it would take almost sixty years after Prohibition ended for a brewery to open in the region.

The Bar was raided a couple times in 1940 for having illegal liquor onsite and seems to have shut down soon after, having been "deemed a public nuisance" per a newspaper article. Another bar, Miller's Beer Tavern, did business at 6 Eagle Street in Asheville from about 1952 to 1964.

There were, for a while, after Prohibition, a few beer taverns and pool halls in Boone. However, pool tables were outlawed in the town after a man was killed in a fight over a game. From 1937 until 1960, pool tables

A delivery truck branded with the Red Top Beer label in Asheville. Red Top Brewing Company of Cincinnati brewed from the mid-1940s until the late 1950s. Note numerous signs touting both Red Top and Schlitz on tap. View is looking north on Broadway in downtown. *North Carolina Collection, Pack Memorial Public Library, Asheville, North Carolina.*

were illegal in Boone. Also in 1937, the United Dry Forces succeeded in overturning the sale of 3.2 percent beer there. That Christian group's goal was to prevent the repeal of local Prohibition laws. United Dry Forces had chapters throughout the South, although they seem to have predominated in North Carolina and Kansas.

In 1949, more than half of twenty-three WNC counties were completely dry, while the others allowed some beer and wine sales in certain areas. At that time, Asheville—which was a long drive for many—was the only place in all of WNC to have ABC stores.

Liquor by the drink was not made legal in North Carolina until 1978, although "brown-bagging" was allowed in many places starting in 1964. Thus, there were restaurants where you could take your own wine or liquor in with you. I remember doing so at Balsam Mountain Inn in Jackson County as recently as 2010.

Much of the twentieth century was one of turmoil for WNC, as it was for the world. Prohibition, while it felt like a big deal to some, was a mere blip in a century that would see two world wars, the Great Depression, the civil rights movement, assassinations of its greatest leaders and almost incomprehensible leaps in technology.

In some ways, the economic ups and downs were good for WNC. The lack of development helped preserve much of the region, including many historic buildings and early architecture. The movement to create national parks and protect mountain forests, spearheaded, in part, by Horace Kephart, also kept overdevelopment at bay.

In the 1990s, the mix of longtime mountain natives and the influx of new creative-class residents helped spark a cultural and economic renaissance in WNC. The former wanted to revitalize the towns that had fallen into disrepair. The latter, when they learned they could choose to live anywhere, chose WNC for its charm, natural beauty and potential. There would be, and still are, conflicts between the old and the new, and the work continues, especially in towns that see value in preserving their history and not becoming Anywhere, USA. However, it's from all this that the beer industry and many other small family-owned-and-operated businesses have risen and are shining.

As more and more formerly dry municipalities welcome breweries, these businesses are mostly seen as a force for good.

# 3
# THE FIRST POST-PROHIBITION BREWERIES

While Asheville has, for more than a decade, claimed the title of Beer City, USA, Western North Carolina's biggest city was not home to the first or even the second post-Prohibition brewery. Those honors go to Boone and to Haywood County.

The 1990s was a decade of significant change throughout WNC. Bill Clinton was president, Jim Hunt was North Carolina's longtime governor and Asheville was just beginning to become what *Rolling Stone* magazine would call in 2000 "America's new freak capital." The city paid off years of Depression-era debt in the '70s, but it would take a couple more decades for the mostly derelict downtown to begin to rise from the ashes. Outside of Asheville, most of WNC was still sleepy and rural, although this was the decade when many communities began exploring how to attract both tourists and new citizens.

Boone's Tumbleweed Grille and Cottonwood Brewery was the first post-Prohibition brewery in the region, as far as I can tell, followed closely by Smoky Mountain Brewery, near Waynesville. While neither brewery survives today, Winston-Salem's Foothills Brewing purchased the Cottonwood brand and still brews some of its ales. The region's third twentieth-century brewery, started in 1994, Highland Brewing Company, is the oldest continuous production brewery in the WNC region and still mostly owned and managed by its founding family.

This chapter tells the stories of these first three breweries and includes some history and updates on the other WNC breweries that opened before 2000: Green Man Brewery, Asheville Brewing, Catawba Brewing and

French Broad River Brewery (while French Broad officially opened in 2001, it grew from the same roots as Green Man, so I include it in this chapter). For more historic stories of all of the aforementioned breweries, with the exception of Cottonwood, consult my book *Asheville Beer*.

## Tumbleweed Grille and Cottonwood Grille and Brewery

The first in-house beer was poured at Tumbleweed Grille in February 1992. The owner of the southwestern-style restaurant near Appalachian State University, Bart Conway, had read about brewpubs and was intrigued.

"As he contemplated starting his own brewpub, I think it's fair to say, Bart didn't know the difference between malt and hops," wrote Kinney Baughman in the *Newsletter of the Ann Arbor Brewer's Guild* in 1994. Kinney would become Tumbleweed's head brewer soon after it opened.

"He talked another guy in town into brewing the first few batches with a used gas stove and a ten-gallon enamel pot," said Kinney when I talked to him at his ASU office, where he now works in IT support. "It was foul. They couldn't give it away."

At that time, Kinney was running a business called BrewCo out of his house and teaching philosophy classes at ASU. A longtime home brewer, he had invented an upside-down brewing system soon after home brewing was legalized. Called the Brew Cap, he successfully sold it, in addition to a countertop wort chiller, to home brewers for fourteen years.

When Tumbleweed's first brewer left after a few months, Bart asked Kinney if he would brew for him. He initially turned him down, but after pulling in another home brewer, Burton Moomaw, the two decided to share brewing duties. Burton only stayed for a couple of months, but he helped get the brewing operations ironed out. Burton, now an acupuncturist, still lives in Boone.

Kinney then dove into his home brew recipe collection, and with some slightly updated brewing equipment, he said, "We were soon able to start selling beer instead of giving it away."

Here's his story of how Bart acquired brewing equipment:

> *Being the good mountain man that he is, Bart is an inveterate horse trader. With his own beer online, beer was a hot topic of conversation at the*

*restaurant. During the course of one of these rap sessions, he scrounged a thirty-gallon stainless-steel pot that had been used in the restaurant of one of the country clubs close by. Now he needed a gas burner. This came up in conversation with the guy who sold the restaurant after dinner mints. He knew of a 350,000 BTU burner that wasn't being used and gave it to Bart. The moral of the story here is that for a couple of free meals, the brewery now had a stainless-steel pot and a gas ring.*

Kinney later upgraded to a four-barrel pot that came from a cough drop manufacturer in Ohio he found via an online chat room. He traded a couple of kegs of beer for it. He noted that the chat room, Home Brewers Digest, was one of the internet's first listservs.

After a cease-and-desist letter arrived from a chain of midwestern restaurants, Bart changed the name of the business from Tumbleweed Grille to Cottonwood Grille and Brewery.

"We brewed the first IPA, the first wheat, the first pumpkin, the first Belgians and the first spiced beers in Boone," said Kinney.

And all this happened on a jerry-rigged system. The brewing operations were in an apartment behind the restaurant. Kinney brewed in a bedroom that he'd plumbed out. He built a refrigeration unit for fermentation and a walk-in cooler made from particleboard and home building insulation in the living room. He brewed in one-barrel containers on dollies that he would roll between the rooms. The beer was decanted into five-gallon Coca-Cola kegs, and Kinney would walk the kegs down to the restaurant whenever beer was needed for one of the four taps.

"One of the first commercial sour beers to be brewed in America postprohibition was by Kinney of Cottonwood Grille and Brewery in 1995," writes Michael Tonsmeire in *American Sour Ales*. "The brewery released two sour beers, Belgian Amber Framboise and Black Framboise, created by blending clean beers with a batch accidentally contaminated with the lactic acid bacteria Pediococcus."

America's first commercial sour beer truly was an accident. Kinney said that he was brewing at Cottonwood and realized he was out of kegs. So he grabbed a couple from his basement that he'd previously used for home brewing. He said they had a few inches of old beer in them, but he scrubbed them out with bleach and water. (This was before brewing sanitizer was de rigueur.)

*About a month later, certain kegs were tart....But I realized they tasted like the beers I'd been drinking in Belgium* [where he played basketball in

# A Mountain Brew History

1979 for an international league]. *So I started experimenting. I got some fruit concentrates and started blending. I would run those beers down to the restaurant and they would sell in about a week. When those beers showed up, I really got a religious following.*

Kinney submitted the Belgian Amber Framboise to the Great American Beer Festival competition that year and came home with a bronze medal.

"There was no sour beer category at that time, so I put the Amber Framboise in the Belgian beer category," Kinney said. "I wasn't even paying attention, and then this guy said, 'Kinney, they just called your name out.' We didn't need an airplane to fly home from that trip."

He added: "After we won that medal, we got a huge amount of press. We were about the smallest brewery in the country to come home with a medal that year."

Kinney noted that many North Carolina brewing pioneers helped him out back in the day, including Uli Bennewitz, who opened Weeping Radish, the state's first brewpub, in 1986, and John McDermott, who opened Highland Brewing with Oscar Wong.

Beer bottles from Boone's Tumbleweed Grille and Cottonwood Brewery, WNC's first post-Prohibition brewery and the sixth North Carolina brewery to open in the twentieth century. *Photo by Kinney Baughman.*

Boone brewpub Lost Province invited brewing legend Kinney Baughman to reproduce one of his old recipes, Cottonwood Brewery's Black Bear Stout. Pictured here are Andy Mason (*left*) and Baughman. *Photo by Ken Ketchie.*

Cottonwood was the sixth brewery to open in North Carolina in the late twentieth century, and while the original brewpub is long gone, its legacy remains in the Cottonwood Ales brand.

Kinney returned to work at the university after a couple of years, and in 1997, Bart sold a majority stake in the business. The new ownership moved the brewery to Howard Street and hired Don Richardson as head brewer, but the new location didn't pan out. Bart would open Canyons Restaurant and Bar in nearby Blowing Rock, and Richardson moved with the brand to Carolina Beer and Beverage in Mooresville in 2000. Richardson opened his own brewery, Quest Brewing, in Greenville, South Carolina, in 2013.

In 2011, Foothills Brewing acquired Carolina Beer and Beverage's brands, including the Cottonwood ales, many of which are still in production.

In 2017, Kinney got back on the brew deck at Boone's Lost Province Brewing Company. To celebrate its 200th brew, he remade one of the recipes from his Cottonwood days, Black Bear Stout.

"Kinney is a brewing legend. We had been trying to get him to brew with us for a while, and we were excited when it worked out," said Andy Mason, Lost Province co-owner and brewer.

"That old Cottonwood was one of the best brewpubs ever. We had a great kitchen and great beer. On Friday and Saturday nights, we would have lines out the door. It was a great one/two combination and loads of fun," Kinney reminisced.

## SMOKY MOUNTAIN BREWERY

The town of Waynesville, thirty-eight miles west of Asheville, started evolving into the happening town it is today in the '90s. Folkmoot USA, a renowned international folk festival, originated there in 1994, and today it brings thousands of people from all over the world to the area annually. However, closure of the Dayco rubber plant, which employed up to one thousand people at its height and was in operation from 1941 until 1996, was a setback to the town.

Smoky Mountain Brewery got its start in a home basement near Waynesville. Rich and Gloria Prochaska and Gloria's brother, Matt Hunt, had been home brewers for a while when they decided to apply for production and sales licenses for their beer. More than two years later, the partners started selling an amber-style ale, in bottles and on draft, around Waynesville and Asheville. Smoky Mountain had a great run, said Rich Prochaska, but after about a couple of years, they were wiped out by the amount of work required and closed the brewery to move on to other things. Prochaska now co-owns Vino de Vaso Wine Market in Arden, which opened in 2008.

Beer bottle label from Haywood County's Smoky Mountain Brewery, one of WNC's first post-Prohibition breweries. *Collection of T.J. Piper.*

Like Cottonwood, Smoky Mountain opened with simple equipment and brewed, kegged and bottled beer by hand. After a couple of years, the Smoky Mountain crew was producing and selling up to one thousand cases of beer a month throughout North Carolina and across the border into western Virginia. At the time, that was remarkable.

## What Is a Craft Brewer?

To be called *craft*, an American brewery must be small, independent and traditional, per the Brewers Association (BA), the trade organization representing the American craft beer industry.

Per the BA's definition, a craft brewer is:

- Small—annual production of six million barrels or fewer.
- Independent—less than 25 percent of the brewery owned or controlled (or equivalent economic interest) by a beverage alcohol industry member that is not itself a craft brewer.
- Traditional—a brewer that has a majority of its total beverage alcohol volume in beers whose flavors derive from traditional or innovative brewing ingredients and their fermentation.

This definition isn't perfect, and it invites some controversy. Additionally, it has changed since it first was penned in 2005, and it likely will change again. However, it's what we have now to differentiate craft beer from mass-produced big beer.

The term *small* is relative, as six million is not a small number, unless we're talking microbes or Trump investments. A beer barrel equals 31 fluid gallons. Barrelage is how American breweries measure production volume and capacity.

Six million barrels is a huge amount of beer. Only a handful of American craft breweries produce even one million or more barrels a year. The five largest craft breweries, in 2017, were Yuengling, Boston Beer, Sierra Nevada, New Belgium and Duvel Moortgat. Yuengling's production that year was about half of the BA's cap, so these breweries, and the rest of the six-thousand-plus American craft breweries, have plenty of growing room.

For comparison purposes, Western North Carolina's largest homegrown brewery, Highland Brewing, brewed 45,000 barrels of beer in 2017. The world's largest beer company, Anheuser-Busch InBev (AB), produced somewhere in the realm of 420 million barrels that same year. (AB measures volume by hectoliters instead of barrels, so that's my calculation.)

The BA stakes a great deal on the *independent* portion of this definition. In 2017, the organization released an independent craft brewer seal for BA-certified breweries to display, if desired, on beer packaging, websites and other marketing materials, as well as in taprooms. Within eight months of its release, the BA reported that more than three thousand breweries had signed up to use the seal.

According to Julia Hertz, BA craft beer program director, in a press release, "One of the main goals of the certified mark is to ensure that beer from small and independent US craft brewers continues to be top of mind despite the flood of acquired beer brands now making their way into the market."

The ongoing conflict between big beer and craft has heated up in recent years, as large breweries have recognized that craft beer is legitimate competition. Even so, only five companies controlled 51 percent of the world's beer market share by volume in 2017: AB InBev, SABMiller, Heineken, Carlsberg and China Resources Enterprise.

"What's funny about this craft beer industry is we don't compete against each other, we compete with AB InBev and the other big guys who come in and suck all the oxygen out of the room. We all hang out together and drink beer together and support each other," said Jonathan Ayers, co-owner of Triskelion Brewing Company in Hendersonville.

A recent Nielsen research group consumer survey reports that a third of craft beer buyers prefer beer that's not mass-produced. Thus, in an increasingly crowded market, having the BA seal on a six-pack on the grocery store shelf could influence a consumer's purchase.

One of AB InBev's responses to the fast-growing craft market has been to purchase, so far, ten American craft breweries, including Asheville-based Wicked Weed Brewing in 2017. This wave of acquisitions has increased tensions between big beer and craft. It has angered and confused many craft beer drinkers. The level of passion that craft beer consumers bring to this industry is unique, and there was an outpouring of shock and distress when Wicked Weed sold.

"I can understand why Wicked Weed sold to AB InBev, assuming it was the business plan of the Wicked Weed founders all along," said beer

drinker Ben Erlandson. "I must say that I don't think I can ever drink another Wicked Weed beer again. I'll wait a while and give it another go, but the past few times I've tried one of their tasty sours or hoppy ales, there's been something missing that I just can't put my finger on."

Yet Wicked Weed continues to grow and expand distribution and to attract tourists, many of whom either don't know or don't care who owns the business. Many of those beer-loving visitors also spend money at locally owned breweries. A number of brewery owners have told me that "business is business." I'm fairly certain many of them have a magic number that, if offered, might entice them to turn over the keys to their brewery to big beer too.

After AB InBev purchased Wicked Weed, both the BA and the Asheville Brewers Alliance (ABA) downgraded the brewery to associate membership. The ABA is the trade organization representing WNC craft beer and follows the national group's lead on membership.

A couple other WNC breweries have big beer or private equity investment ownership. Via the Craft Brew Alliance group, AB InBev owns an undisclosed minority stake in Boone's Appalachian Mountain Brewery. That brewery retains full voting membership in both trade organizations because big beer's stake is less than 25 percent (self-reported). In 2015, Oskar Blues Brewery sold a majority stake to Fireman's Capital, a private equity firm based in Boston. However, as Fireman's is not itself an alcohol industry member, Oskar Blues retains its trade group membership as well.

The primary reason for the differentiation between private equity and straight out financing from big beer rises from concerns about market share and competition for shelf space. While AB InBev and MillerCoors produce more than 70 percent of the beer sold in the United States, craft breweries are slowly whittling that percentage point down.

Beer drinker Trevor Sharp said he hasn't purchased any Wicked Weed beer since the buyout; however, he struggles with the ownership issue at times: "It's made me more aware of where my money is going, and I try to direct my spending away from the big breweries. But Goose Island [owned by AB InBev] is a tricky one. I try not to buy too much Bourbon County Brand Stout."

The third piece of the BA's definition, *traditional*, can be difficult to parse. If the majority of a brewery's beers contain corn or rice as opposed to malted barley, wheat or rye, that brewery is not considered traditional. This is another shot at mass-produced beer, which sometimes uses nontraditional ingredients and whose brewing processes are highly automated. Most of the

larger craft breweries are now automated as well, although the BA doesn't directly address that part of the brewing process.

Flavored malt beverages are not considered beers, the organization adds. That said, having both *traditional* and *innovative* refer to ingredients is somewhat contradictory.

One piece of the puzzle that beer consumers may not be aware of is that many wholesalers either are aligned with or partially owned by AB InBev or MillerCoors. Numerous small craft breweries distribute their product via these wholesalers, as their options may be limited. These distributors also are concurrently selling both big beer and craft beer brands.

Perhaps surprisingly, some of the seemingly restrictive North Carolina ABC rules and regulations protect small brewers from what big beer money could bring to the table. For example, a brewery can't (legally) pay a retailer to put its beers on draft. Nor can it put branded T-shirts on bartenders or pay for advertising for a venue that sells its beer.

## Highland Brewing Company

The man many call the godfather of Asheville beer, Oscar Wong, started Highland Brewing Company as a retirement hobby. He's still at it, almost twenty-five years later, although his daughter, Leah Wong Ashburn, who took over as company president in 2015, said, "Dad's acting more retired. He plays handball now on Tuesdays and Thursdays."

There have been lots of changes over the past several years for Asheville's oldest brewery. The brewery started in the basement of Barley's Taproom downtown in 1994 with repurposed dairy tanks for fermentation. In 2017, Highland was WNC's largest homegrown brewery.

When I asked Oscar what it's been like to pass the torch to his daughter, he said, "It's heartwarming. I'd hoped it would happen for quite a few years, especially since I turned her down initially. I couldn't afford her, and the company still can't."

Leah, who previously was a sales representative for a yearbook publishing company in Charlotte, responded: "I'm glad you said heartwarming instead of it's been a heart attack, Dad. It's been thrilling and an honor. It's been terrifying at times. Dad was so unusual in that he was able to let go and say, 'Do it your way.' Even when I didn't know what my way was."

Discussing the early years in Barley's basement, Oscar noted that "it was rather interesting, because we had drug pushers in the back alley. But it was cheap. Dealing with the regulatory folks was tough. And acceptance by people in general was tough."

He added, "However, Asheville was very accepting in the sense that, at the time, it was still a backwater town. There were a couple of top-notch restaurants and a kind of eclectic collection of people who had moved into the area who were willing to try new things."

"Giving away samples was the only way you could get people to try our beer," Oscar said. "I had a little five-gallon keg in my trunk. It was totally illegal on all counts, but I think the statue of limitations is over."

Former Highland head brewer John Lyda, now the brewing, distillation and fermentation instructor at the Craft Beverage Institute at Asheville-Buncombe Technical College, reminisced about Highland's early days.

"We were always scrambling to find raw ingredients," Lyda said. "There were not nearly as many options for hops or malt. Craft brewers were so small that growers weren't even concentrating on growing hops for craft brewers. There weren't a lot of aroma hops—we mostly had to use bittering hops that farmers were growing for the big breweries."

He added, "I think Asheville Brewing beat us to brewing Asheville's first IPA. Kashmir was the first one that Highland did. It was an English IPA because, at that time, I couldn't get any U.S. hops."

Asheville native Lyda started working at Highland under John McDermott, Highland's first brewer, in the summer of 1994. His goal was to gain three years of professional experience so he could attend Siebel Institute's world-famous brewing education program, which he did.

"I was going to come back from Siebel and start a brewpub with a friend in the restaurant business. I had my eye on the Two Moons Brew & View location [now Asheville Pizza & Brewing]. When I came back, Oscar said, 'Let's give you partial ownership and make you brew master, otherwise we're going to shut this thing down.'" Lyda brewed at Highland for twenty-two years.

McDermott now owns an Asheville-based custom furniture and woodworking business and still home brews, according to Lyda.

Highland Brewing underwent a major rebranding in early 2018 and dropped the image of the Scottish Highlander, which resulted in some customer pushback.

"We were hearing from our own team and others that our look was dated," Leah said. "We did multiple surveys and engaged with an amazing

branding company. We're still Highland, but when you see us, it's a quicker and clearer message now."

Oscar commented that the new logo feels contemporary and dynamic, and he recognizes that there's been a generational change from 1994.

"You have to be open to change. It's a necessity in this industry," Leah added. "We changed up our beer lineup as well. Half of our eight year-round beers are less than three years old. We're not doing what we've always done."

Oscar said he's most proud that Highland currently is the largest independent family-owned brewery in the Southeast.

Leah added that Highland is in the top 1 percent of craft breweries in the country in terms of size, and she's excited to be at the helm of the third-largest solar craft brewery in the United States. Currently, Highland beer is sold in seven southeastern states. The brewery recently cut distribution to Alabama and Ohio, citing a disparity between the expense of being there and sales, especially in chain grocery stores.

"Our taproom is now a major investment," Leah said. "We started as a distributing brewery. That was our model at the time, and we still see that as a great way to grow, but we've recognized it's important to bring people here."

To that end, Highland has increased its taproom programming significantly. According to Leah, 10 percent of the brewery's production volume is sold onsite. Additionally, there's an outdoor stage and bar area next to the brewery that has pulled in some big acts, including Nathaniel Rateliff & the Night Sweats, Band of Horses and St. Paul and the Broken Bones.

"Our biggest struggle is the proliferation of breweries, which causes customer confusion and competition for shelf space and tap handles. There were six hundred breweries when we opened, and now there are six thousand," Leah noted.

Biltmore Brewing Company contract brews two in-house brands at Highland Brewing. The beers, Cedric's Brown and Cedric's Pale Ale, are sold only at Cedric's Tavern at the Biltmore Estate.

## Blue Rooster Restaurant and Brewpub

Asheville's first brewpub was open for business for less than two years, from 1996 to 1998. Oscar Wong; Frank Smith, owner of Hunter Banks outdoor store; and former Asheville mayor Lou Bissette partnered in Blue Rooster Restaurant and Brewpub. The brewing concept was, interestingly, one that's

being used by one of Asheville's newest breweries, Zillicoah Beer, today. Highland Brewing, which was directly next door, sold wort to Blue Rooster, which had a couple thirty-barrel fermentation tanks in the middle of the restaurant. Highland brew master John McDermott then would ferment the beer for the brewpub. Renowned local chef Mark Rosenstein was the man behind the menu and an original owner, but even that combined firepower wasn't enough to keep Blue Rooster in business for long.

"It probably would've been less expensive if they'd bought a brew house," Lyda said. "Table turnover wasn't high enough, so we ended up dumping a lot of beer down the drain because it would go bad before it sold."

The building had housed a paint supply store and needed extensive renovations. That part of Biltmore Avenue was beginning to see renovations of some of its historic buildings, although the building next door offered an impressive storefront display of porcelain toilets and bathtubs at the time.

The building at 48 Biltmore Avenue has been home to restaurants ever since. After Blue Rooster closed, the space housed the Golden Horn, Thidodeaux Jones Creole Kitchen, the Raven Grill, Ed Boudreaux's Bayou Bar-B-Que and, most recently, the Chestnut Restaurant. Not surprisingly, the location got a reputation for being cursed. When Joe Scully opened Chestnut there in 2014, he hired a spiritual cleaning crew to come in and sweep out troubled spirits, according to an *Asheville Citizen-Times* article.

In 1997, Jack of the Wood started in-house brewing, as did Two Moons Brew & View, both of which are brewpubs. (The BA defines a brewpub as a brewery/restaurant that sells 25 percent or more of its beer onsite.) So, in a very short time, Asheville went from zero to three brewpubs, as customers became interested in the combination of craft beer and pub food. Sadly, there wasn't enough interest to keep Blue Rooster afloat, although by the time it closed, Highland Brewing's business was increasing, so Oscar returned full-time to his basement brewery.

## Green Man Brewery

Asheville's second brewery ultimately would evolve into two breweries, both of which are still making beer today. In 1997, Jonas Rembert and Andy Dahm started Benefit Brewing in the back corner of Jack of the Wood pub. The business partners brewed a line of Green Man beers, which they sold to the Irish pub to put on tap. After a couple of years, they sold the brewery

to Joe and Joan Eckert, Jack of the Wood's owners. The Eckerts changed the name to Green Man Brewery. Rembert and Dahm then started French Broad Brewing in its current location behind Biltmore Village. Benefit Brewing remains French Broad Brewing's corporate name, and it was sold to Paul and Sarah Casey in 2017. So, in a way, you could say Green Man and French Broad share the title of Asheville's second brewery.

In 2005, Green Man moved brewing operations to a warehouse on Buxton Avenue, in the area now known as Asheville's South Slope. The production space and taproom, called Dirty Jack's, isn't so dirty anymore. However, it's still a low-key local hangout. In 2010, the Eckerts sold Dirty's to Dennis and Wendy Thies, who moved to the area from Florida a couple years beforehand. Current head brewer John Stuart, who started in 2007, stayed on when ownership changed. Mike Karnowski, former Green Man assistant brewer, initiated the brewery's sour program, producing what were likely the first commercial sours in Asheville.

The Thieses have greatly expanded the business, primarily by building a three-story, twenty-two-thousand-square-foot brewery, packaging hall and taproom on the land next door to Dirty's. The Green Mansion opened, true to the brewery's mascot, on Saint Patrick's Day 2015. Currently, Green Man beers are distributed in seven southeastern states, with more to come.

The Green Mansion, Green Man's expansion brewery and taproom next to Dirty Jack's. *Courtesy of Green Man Brewery.*

"We decided to expand when we saw a need for a larger space for our packaging equipment. We found a fantastic combination bottling and kegging line and needed the perfect place for it to fit," said Elizabeth Nestler, Green Man relations director.

In addition to the business, the new ownership also inherited sponsorship of multiple adult league soccer teams, and Dirty Jack's continues to be a popular soccer match–viewing venue.

"Two of the bartenders here were English and South African and big into the sport," said Clayton Elliott, local soccer player. "We convinced Dennis to open at 7:30 in the morning for a match between those two countries, and three hundred bloody people showed up. Then three TV crews showed up too. How they got wind of that, I have no idea."

Clayton said that beer has been sponsoring soccer in Asheville at least since 2005.

## Asheville Brewing Company

Asheville's third craft brewery opened in 1998 as a mash-up pizza joint, second-run movie theater and brewpub, all wrapped up in a family-friendly space. Asheville Pizza & Brewing Company, in neighborhood-centric North Asheville, has had a loyal local following since day one. The downtown brewpub, Asheville Brewing Company, anchors the South Slope's unofficial brewery district.

The second location opened in 2006 when the only other South Slope brewery was Dirty Jack's. Today there are nine breweries, a sake bar, a cider maker, a distillery, a craft beer bottle shop and a slew of bars and restaurants within about five blocks—and that's heading away from downtown.

Former spouses Mike Rangel and Leigh Oder purchased Two Moons Brew & View in 1998. They renovated it and reopened it as Asheville Pizza & Brewing. Current head of brewing operations Doug Riley was already brewing there and became a co-owner in the transition. He had been brewing in Portland, Oregon, and said, somewhat ironically, that at that time, there weren't many brewing opportunities in Oregon. Riley developed the recipe for Shiva IPA in 1997. I'm fairly certain Shiva is both the oldest IPA in continuous production in Asheville and the first Asheville IPA in a can. As Mike said, "You can't spell Asheville without Shiva."

# A Mountain Brew History

Andy Dahm (*left*), co-founder and former co-owner of French Broad Brewery, and Mike Rangel, co-founder and president of Asheville Brewing Company, cheer Asheville's first win of the Beer City, USA title in 2009. *Photo by Anne Fitten Glenn.*

"As a small craft brewer, we wanted to make a mark in the new craft beer renaissance—we felt that our IPA was our strongest beer at that time," Doug said. "People thought we were crazy to make our first can an IPA in a world of canned pale ales. But we like being a little bit different. And we wanted to can a beer drinker's beer."

Initially, every drop of beer that Doug made in the "beer closet" at APBC was sold onsite. "Highland laid the groundwork, and people in Asheville were ready for craft beer in the early '90s," he said.

For a long time, the only beers he brewed were Shiva and Ninja Porter, but he said he could barely keep up with those. Especially as, long before Netflix was available, APBC would show the *Simpsons* and *South Park* weekly.

"The theater would be packed," Doug said. "People would be sitting on the floor, and we'd completely sell out of beer."

Currently, the business has seven local owner/managers, all of whom work full-time there.

Asheville Brewing installed Western North Carolina's first in-house canning line in 2011. The North Asheville's original 7-barrel system joined

the downtown brewery's 15-barrel, consolidating all brewing operations under one roof in 2016. The brew crew produced 5,200 barrels of beer in 2017, up from 1,200 barrels in 2011. Asheville Brewing Company's beers are sold throughout Western North Carolina.

In 2014, with its Ninja Porter, Asheville Brewing became the first homegrown WNC brewery to win a gold medal in the prestigious World Beer Cup. Ninja medaled again in 2018. The competition, billed as the "Olympics of beer," takes place every two years.

"We were psyched," said head brewer Pete Langheinrich. "I mean, we think it's a great porter. After our two IPAs, Shiva and Perfect Day, it's our number-three seller, and it has been for years."

"It's been an incredible ride," said Mike.

> *The American dream is to own your own business and work for something you can be proud of and help others along the way. What's most gratifying is to be able to leave a mark on a city that's like no other. To be a mover and a shaker in this amazing town has been a dream come true.*

## CATAWBA BREWING COMPANY

Catawba Brewing got its start in the tiny basement of an antique mall in the town of Glen Alpine in Burke County in 1999. Almost twenty years later, the business owns production facilities and taprooms in Morganton, Asheville, Charlotte and Charleston, South Carolina. Spouses Billy and Jetta Pyatt, with Billy's brother, Scott Pyatt, started the brewery.

Catawba added Palmetto Brewery, South Carolina's oldest brewery, to its family of breweries in late 2017. Catawba is one of the fastest-growing homegrown WNC breweries at present, jumping from 4,200 barrels to 8,200 in the past three years, and with Palmetto, the company expects to produce around 55,000 barrels in 2018. That will make them WNC's largest homegrown brewery, surpassing Highland Brewing. Currently, Catawba beers are available in seven southeastern states, with more states to come.

"We are thirty-three times the size we were in 2012," Billy Pyatt said. "But we really believe that getting our start in a small town has allowed us to grow so quickly. We're about to become one of the largest southeastern breweries—all because we were able to build out from our small town."

## A Mountain Brew History

Scott and Billy Pyatt, founders and co-owners of Catawba Brewing, cleaning tanks for their new brewery in 1999. The arm coming out of the metal box belongs to the brothers' cousin Greg Pyatt. *Courtesy of Catawba Brewing Company.*

Soon after they started brewing in Glen Alpine, the Pyatts moved the brewery to Morganton in order to open a taproom. Scott and Billy grew up in Marion, and Billy said Morganton was familiar and comfortable for them.

"Early on, we were just having fun and doing something we wanted to do," he said.

> *For Scott to be able to get one thousand barrels out of that tiny building in Glen Alpine was amazing. Burke was a dry county then, so we couldn't have a bar or taproom. We just brewed the beer and put it out there and waited to see what would happen. We were lucky to have anyone drink our beer. We also were lucky to have time to hone our craft. It's not like that anymore.*

Scott has been head brewer since day one, while Billy and Jetta worked for the brewery part time while living and working in Hickory. Billy retired from his day job in 2012, and Jetta did so a couple years later.

"When we got that eight thousand square feet in Morganton, we thought we'd never fill it up," Billy said, laughing. "We only opened the taproom

one night a week initially, on Friday night. Jetta and I would drive up from Hickory after work, and we'd work all night and then be exhausted. Eventually, we opened on Saturday nights as well, but by that time, we could afford to pay for help."

Billy notes that even as recently as 2012, there wasn't much happening in downtown Morganton, but it has grown significantly in the past few years: "There's Fonta Flora Brewery, there's two or three independent restaurants and there's the new campus for the North Carolina School of Science and Mathematics."

Until a rebrand in 2012, the brewery was called Catawba Valley Brewing. Billy said they dropped the "valley" because it made the name too long to say, but he noted: "The name really anchors us here. It's an Indian tribe. It's a rhododendron that grows on the high peaks. But mostly it's a river."

Since Billy and Jetta "retired," things have been hopping at Catawba. The brewery started canning its beers in 2013 with small hand canners, then added fermentation, then moved to a larger canning line. The thirty-barrel tanks that were in Ed Boudreaux's restaurant, which originally had been Blue Rooster's tanks, still see daily use at Catawba.

"Those are still our work tanks," Billy said. "It took some work for Scott and I to get them out of that building. We had to build an indoor crane."

In 2014, Catawba opened a small taproom behind Biltmore Village and attempted to build its second brewery and taproom on property across from French Broad Brewery. Billy said they were stymied by restrictions on the land, which is in a flood plain, and they never could come to agreement with the city on plans. Then they found a building on Banks Avenue, on the South Slope, and opened a taproom, venue space and seven-barrel brew house in 2015. The brewery shares an entryway with now world-famous Buxton Hall Barbecue.

The Catawba team opened a huge new brewery and taproom in Charlotte in late 2016 in an old Kellogg's bakery warehouse where Famous Amos cookies were made until 2016. The Charlotte Catawba brewery is large enough to house two open fermenters behind plate glass. Next came the purchase of Palmetto Brewery, which, per Billy, has a similar culture to that of Catawba.

The three Pyatts manage the day-to-day operations of the growing Catawba beer empire, although Billy said that they're now up to eighty-plus employees and acting like a "real company." He emphasizes that as natives of WNC, he and Scott care deeply about supporting the region and, in particular, its people.

A MOUNTAIN BREW HISTORY

"We grew up in Marion, and in the '70s and '80s, we watched all the jobs there disappear. It's near and dear to my heart to create jobs. It gives me so much visceral reward to create not just jobs but careers," Billy said.

## French Broad River Brewery

Even though Asheville's French Broad River Brewery was founded in 2001, the brewery has its roots in Andy Dahm and Jonas Rembert's first brewery, which opened in the back of Jack of the Wood Pub in 1997. That brewery, Benefit Brewing, remains the corporate name of French Broad, which Sarah and Paul Casey purchased in 2017.

French Broad River Brewery does not overlook the river for which it is named, although several other WNC breweries do, including Sierra Nevada, New Belgium, Zillicoah and Mad Co. However, its location behind Biltmore Village, not far from the conjunctions of the Swannanoa and the French Broad Rivers, puts it in one of the city's most flood-prone areas.

This part of town is becoming Asheville's next South Slope—perhaps it will soon be called the Biltmore Brewing District, said Paul. In addition to French Broad, nearby are one of Catawba's taprooms, Burial Beers's new production brewery and American beer bar and Hillman Beer's production brewery and taproom. Not far are Sweeten Creek Brewing and Brewery Cursus Keme.

French Broad can claim one of the oldest brewery taprooms in the area, as it opened in 2004, as soon as it was legal for a brewery to do so in North Carolina without being a brewpub.

Current co-owner Paul, who worked in the pharmaceutical industry for twenty-two years, was intrigued with the idea of owning a brewery and started searching online for breweries for sale. He said he was looking at a brewery on the Outer Banks when one in Asheville appeared. It was, of course, French Broad.

"I like that it is one of the original breweries here and has a good product and an interesting story to tell," Paul said. "The river it's named for runs through the heart of Asheville, and beer is part of the heart of Asheville. There's something to be said for age and history."

He adds that as he didn't have experience in the business, he wanted to find a brewery that employed talented, skilled people. After meeting the French Broad crew, he felt that was the case. Most of the people who were there

before the sale stayed on, including head brewer Aaron Wilson. Wilson has been with the brewery since 2008 and before that worked for Andy Dahm's other former business, Asheville Brewers Supply, a home brew shop.

One of the first things that the Caseys did was rebrand. The brewery's name originally contained the word *river*, but it had been dropped. Paul put it back.

"The beer has a good footprint in Asheville but less of a footprint elsewhere in the state. Putting the river back in gives us a better and easier story to tell outside of Asheville," he said.

"Plus no one will ever ask me again if I'm the French Broad at a beer festival," Aaron added.

While the Caseys continue to live in Chapel Hill, where their three children are in school, both are at the brewery regularly. Sarah has taken over as brand manager.

The Caseys want to increase production and distribution. To that end, they recently expanded the brewery into the building next door, which they also purchased. That building was home to Toy Boats Community Arts Space for six years, and some of the artists and performers were

Aaron Wilson, head brewer at Asheville's French Broad River Brewery, on the brew deck. *Courtesy of French Broad River Brewery.*

angry about being displaced sooner than planned, according to an *Asheville Citizen-Times* article.

"Taprooms are destinations in Asheville because of their cool vibe, and each one has its own thing," Paul said. "We have a vibe and a feel and our current space is just a little too small, so we accelerated our plans to move next door and create a bigger destination for both locals and for tourists. It still will be rustic and industrial but with an expanded bar area and stage."

Taproom capacity will go from twenty-five to two hundred, a huge leap, and there will be more room to add fermentation. Expect more seasonals and one-offs, per Aaron.

"While we've traditionally been a European-style beer house, as times have changed and the move has been toward more hoppy beers, we've tried to keep up," he said. "Our main focus is on being a consistent packaging brewery first and foremost, though."

Production in 2017 was 2,400 barrels, distributed regionally as well as downstate and in East Tennessee.

Aaron noted:

> *I was a beer drinker first. So I brew for that beer drinker sitting on the other side of the bar—that person who maybe has been dreaming about having a beer all day. If that person sits down for a beer and it's off or a little different, they'll be disappointed. I've been that person, and I don't want to do that to anyone.*

# 4
# THE SURGE BEGINS

## The Early Twenty-First Century

The first dozen or so years of the twenty-first century saw more breweries opening in small previously dry Western North Carolina towns, as well as additions to the burgeoning Asheville beer scene.

These breweries benefited from the paths smoothed by the post-Prohibition beer pioneers. North Carolina's General Assembly revised several archaic blue laws in the first decade of the 2000s, including raising the maximum alcohol by volume level for commercial malt beverages. Numerous towns and counties held alcohol sales referendums, and for the first time in more than one hundred years, more of WNC was wet than dry. Increasing appreciation for drinking local made brewery entrepreneurship more attractive.

The Beer City, USA poll, beer festivals and tours, Asheville Beer Week, beer tourism, and local agriculture all contributed to the expanding craft beer–centric world of WNC.

This chapter gives updates on most of the breweries covered in my *Asheville Beer* book. The majority of the breweries that opened their doors during these exciting and transitional years are still at it, although a few have closed, and several have changed ownership. Almost all of them have grown.

*The Pop the Cap movement pushed the North Carolina legislature to increase the allowable alcohol by volume for commercial beer from 6 percent to 15 percent. Courtesy of Fullsteam Brewery.*

# A Mountain Brew History

## Southern Appalachian Brewery

A barn in tiny Rosman, near Brevard, was Southern Appalachian Brewery's first home. Husband and wife Andy and Kelly Cubbin purchased the brewery from the founders in 2006 and moved it to a warehouse in Fletcher, just outside of Asheville. Then, in 2011, the Cubbins moved the brewery to its current home on the edge of downtown Hendersonville.

Initially, town, county and state laws restricted Hendersonville's first brewery from selling its own product. The brewery opened as a private membership club. Soon after opening, House Bill 98 passed, which allowed breweries to sell their product from the manufacturing site. Then, after a year of lobbying, Kelly and Andy helped persuade Henderson County to hold a special alcohol-sales referendum. The citizens approved on- and off-premise sales of malt beverages.

Andy has been head brewer since day one, and Kelly is the taproom and marketing manager. About 85 percent of Southern Appalachian's beer is sold onsite in the taproom, which attracts a regular clientele. The remainder of the 1,200 barrels produced in 2017 was distributed throughout WNC and in Greensboro.

Husband-and-wife team Andy and Kelly Cubbin, owners of Southern Appalachian Brewery, Hendersonville's first brewery. *Courtesy of Southern Appalachian Brewery.*

Southern Appalachian expanded its barrel-aging program after the Cubbins purchased the brewery building along with an adjacent courtyard and warehouse. Like pretty much everyone else in craft beer today, Kelly said they have plans to can some of their beers. Regular food trucks and live music, including a new outdoor stage, round out the Southern Appalachian experience.

"We started our business to make great beer, help the community, be charitable and provide jobs. It humbles us that strangers continue to pull us aside to thank us for what we have done for the community," said Kelly.

## Pisgah Brewing Company

When the Sierra Nevada Brewing team went out on the town not long after that brewery opened in Mills River, at every account they visited they would ask for a pale ale. And at every account, they were handed a Pisgah Pale Ale. That's the story that Benton Wharton, Pisgah Brewing's general manager, heard from a friend who works for Sierra Nevada.

"That's something that we're daily reminded of—that Pisgah Pale Ale is the most important thing we do week to week. We are humbled by that, and we'll never forget it," he said.

Black Mountain's first brewery opened in 2005, and its eponymous flagship, Pisgah Pale Ale, has consistently been one of WNC's best-selling beers.

Pisgah was co-founded by Jason Caughman and Dave Quinn, with Dave's mother as a silent partner. Jason and Dave ran the brewery together for a few years, and then Jason managed it for three years while Dave traveled. Dave came back, Jason left and now Dave manages the business. Jason moved to Charleston, South Carolina, and opened Lo-Fi Brewing there.

After self-distributing for more than ten years, Pisgah struck a deal with Skyland Distributing, although the brewery still self-distributes in Buncombe County. Currently, Pisgah beers are available as far as Charlotte and in Charleston.

"Our challenge is to keep a core brand like Pisgah Pale relevant forever," Dave said. "I made a decision that I wanted to be the local working man's pale ale. I want to be the $8.87 six-pack on the shelf every day. The market wants to go up, but I want to be the last to go up."

The brewery recently finished a large expansion, adding a new thirty-barrel brew house in a building across from the taproom. That will increase

production capacity by around 1,500 barrels from 4,500 barrels in 2017. The brewery also added a canning line after using mobile canning for several months.

Pisgah has both an indoor stage in the taproom and a large outdoor stage in the meadow next door. Big-name shows at the outdoor stage have included Jason Isbell, Michael Franti, Lucinda Williams, Bruce Hornsby and Umphrey's McGee.

"Music is a huge part of who we are. We like to support and nurture music the way we support and nurture craft beer," Benton said.

Dave added: "When we have a sold-out show we increase the population of Black Mountain by like 20 percent. We add around 2,500 people out here for several hours."

When Jason and Dave first discovered the empty warehouse on the edge of Black Mountain, they knew it would be perfect for a brewery. After presenting to the town's governing council on a couple of occasions, they were granted permits to brew and sell their beer.

"When we went to the Black Mountain zoning guy, he flipped open his three-ring binder, and he looked through the industrial section. After a few minutes, he said, 'No. Breweries aren't listed for permitted use,'" Jason said. "It made more work for us to get permits, but the town was supportive. They just had never had anyone want to start a brewery there before then."

Pisgah was one of the first breweries in the country to use mostly organic ingredients in its beer, which the brewery touted on its logo and packaging. However, when the federal government changed the rules for labeling food products as organic, Pisgah had to remove that word from promotional materials.

"Our beer is still 95 or 98 percent organic," Dave said. "We just can't put the stamp on the can. All our grain is organic, but in order to go with all organic hops, we'd have to increase prices and we'd have to change suppliers. We have long-standing relationships with local farmers, and we didn't want to lose those."

If hop bines are sprayed with any kind of pesticide once they flower, they are no longer considered organic, per the Federal Department of Agriculture.

The industrial park where the brewery opened once housed the Drexel Heritage Furniture plant. Now, in addition to Pisgah, Oak & Grist Distillery and Black Mountain Ciderworks & Meadery share the grounds.

"It feels great to be innovators on this side of the world and also to see it grow here," Dave said.

In 1998, a disgruntled Drexel employee shot and killed two workers there and injured three others. The plant reopened for a short time before closing for good. Needless to say, the site has a reputation for being haunted.

"It is for real haunted," Dave said.

> *I was in there one morning super duper early, like 5:15 a.m., to start a brew, and I went into grain storage, and sometimes a bird will get in there, and you have to shoo it out. Then out of the corner of my eye I saw a big bird flying really fast. It was a crow. I was like, "What's a crow doing in here?" Then it flew straight into the wall and disappeared. I was standing there with goose bumps just like I am now. And that wasn't the first time something weird like that happened.*

Dave added that, given the live music and the happy people drinking beer, he thinks the ghosts must be having fun.

## WEDGE BREWING COMPANY

Wedge Brewing's eclectic brewery and taproom in Asheville's funky River Arts District (RAD) has been creating beer magic since 2008. In early 2017, owner and co-founder Tim Schaller added a second Wedge brewery and taproom a mile down the road at the old tannery site now called Foundation.

While Tim initially was wary about expansion, he said when he saw the building that the second Wedge now occupies, he knew it could be something special. He also wanted to help preserve the property's gritty, blue-collar history, just as he has done at the original location.

Hans Rees & Sons constructed the historic building in 1898 as part of the company's leather tannery. That business, headquartered in New York City, utilized thirty buildings on more than twenty-two acres between the French Broad River and the Southern Railway. At one point, it was the largest tannery in the nation, and it was one of Asheville's largest and longest running manufacturers, employing four hundred at one point. The tannery lasted until 1955, despite losing buildings to fires and floods, as well as workers, processes and products to mechanization and modernization.

Until recently, the warehouse buildings on the property were mostly derelict, although some were used as artist studios and storage facilities. 12 Bones Smokehouse moved into the building adjacent to Wedge's second

# A Mountain Brew History

Head brewer Carl Melissas, wearing the Great American Beer Festival gold medal won by Wedge Brewing for German-style Märzen in 2017. *Courtesy of Wedge Brewing.*

home, and in late 2017, Summit Coffee Company opened in the building across the alley, following extensive renovations on what once was the tannery's shower building. That building is divided in half by a brick wall, as, at that time, there were separate shower rooms for white and "colored" workers.

The Foundation area as a whole has attracted graffiti artists for years, and for the past two, it has been the site of an organized artist event to expand on this heritage.

The original Wedge was co-founded by metal artist John Payne. Payne died just before the brewery opened, but Tim has strived to stay true to their shared dream of making the brewery a community hub and gathering place for, as he put it, "Folks sitting around drinking good beer and telling good tales."

"The community part is big for us and has been since day one," Tim said. "We've been lucky to be accepted by and created by this community, and we feel a responsibility to our community because of that. And it's important to us to make good beer."

Longtime head brewer Carl Melissas remains hands-on in the original thirty-barrel brew house. The brewery's 2017 win of a Great American Beer Festival gold medal for German-style Märzen only increased his renown as a master of German- and Belgian-style beers. Foundation head brewer Ian Leightner is a whiz at creating low ABV and lager beers, per Tim.

As part of the original Wedge's summer birthday, Tim shows the iconic 1958 moonshining movie *Thunder Road*, parts of which were filmed in the neighborhood. The movie is projected on the side of a panel truck, and neighbors bring lawn chairs for the sundown showing.

## Oyster House Brewing Company

Billy Klingel started out with a home brewing system on wheels behind the bar at Asheville's The Lobster Trap Restaurant in 2009. He's come a long way since then, opening his own brewery and restaurant in West Asheville

Oyster House Brewing Company of West Asheville is famous for its oyster stout. *Courtesy of Oyster House Brewing.*

in 2013. Oyster House Brewing, across the street from the hugely popular Sunny Point Restaurant, has been a welcome addition to the neighborhood where Billy and his family have lived since 2001. The restaurant offers a variety of seafood and non-seafood dishes and, of course, fresh oysters.

"If you start by brewing an Oyster Stout, you gotta sell oysters, and then you gotta have something for people who don't like oysters, and then boom, all of the sudden, you've got a full restaurant," Billy said.

He said his biggest challenge to opening wasn't scaling up production but waiting for permit approvals. "I had a month of standing here drinking beer and staring at the walls and waiting for permits from the city to come through. I had quit my job downtown. I had a pregnant wife, an almost four-year-old daughter and no income. Then my boy was born two months after we opened," Billy said, laughing.

He's no longer brewing on a SabCo Brew Magic but on a five-barrel brew house. Billy doesn't brew much anymore, as two years ago he hired Philip Shepard as head brewer, formerly of Wedge Brewing.

Most of the five hundred barrels of beer produced in 2017 were sold in-house, although Billy still supplies The Lobster Trap with a couple kegs a week of his famous Moonstone Oyster Stout. He also keeps an old-fashioned hand-pumped cask engine behind the bar and always has cask beer available.

"The restaurant and brewery business isn't easy, but we have a great community that supports us, and the people who work for me are delightful," Billy said. "I think of this as an extension of my home. Our whole mantra is laid back and friendly. I'm totally biased, of course."

## Lexington Avenue Brewing Company

The patio at Lexington Avenue Brewery, better known as LAB, is one of the top people-watching spots in Asheville. While Lex Ave, as the locals call it, once was slightly seedy and off the beaten path, it's now a central corridor for tourist traffic. The gastro-pub, started in 2010 by business partners Mike Healy and Steve Wilmans, sits at Lex Ave ground zero.

It's almost always crowded, and almost every drop of beer brewed on the fifteen-barrel system is sold on site, per head brewer Jonathan Chassner. He and assistant brewer Bruce Duncan brewed around seven hundred barrels in 2017.

Jonathan Chassner (*left*) and Bruce Duncan, brewers at Asheville's Lexington Avenue Brewery, on the brew deck. *Courtesy of Lexington Avenue Brewery.*

"We believe we have better quality control of our product if we keep it all in house," Jon said. "We have no plans to sell outside, other than a couple taps at Barley's. Grocery store shelves are scary."

Jon, who has been with LAB for several years, also is a co-owner of Zillicoah Brewery in Woodfin, making him the only WNC brewer I'm aware of who works for two different breweries simultaneously. LAB owners Mike and Steve are co-owners of Zillicoah as well.

In 2012, the owners had planned to expand LAB into the building next door. They got pretty far with renovations before giving up. Per Jon, having a production-sized brewery in a historic downtown building proved to be a logistical nightmare. Among other issues, the brewery would have needed to build an explosion-proof, fireproof room just in order to mill grain.

LAB's house beers are an even split between American and Belgian styles, with the occasional German style thrown in, Jon said. LAB's original head brewer, Ben Pierson, brewed lots of German-style beers, but Jon focuses on the new wave of American IPAs and big, fruity Belgian brews.

"We push the envelope and innovate while respecting and paying homage to tradition," he said. "This facility isn't set up for barrels or wild and sour beers or lagers. We have to produce ales, but we want to always be doing something new with those."

## NANTAHALA BREWING COMPANY

Nantahala Brewing was the first brewery in Bryson City and one of the first breweries in the far corner of WNC, opening in 2010. The brewery sits next to the historic train depot that is home to the Great Smoky Mountain Railroad. The railroad offers scenic tours of the region, including the highly popular Polar Express during the winter holidays. The railroad brings the tourists, and the nearest watering hole just happens to be the brewery, mere steps from the depot. It's housed in a large Quonset hut that was once used by the U.S. government to house supplies when Fontana Dam was constructed to electrify the region.

"Just for the forty-five days of Polar Express, more than ninety-two thousand people came to town," said Nantahala co-founder and president Joe Rowland. "This place was packed like it's the middle of July."

While the town's population is less than 1,500, more than half a million visitors come through annually, often on their way to Great Smoky Mountains National Park.

Joe started the brewery with three other partners, although he's down to one other for now. Original partners and brewers Chris and Christina Collier returned to their day jobs in Atlanta after a few years of commuting. Another founding partner, Mike Marsden, now owns Valley River Brewery, with locations in Murphy and Haysville. Joe plans to buy out Greenville businessman Ken Smith.

In late 2016, Joe opened a second taproom and restaurant in Bryson City called The Warehouse at Nantahala Brewing. The brewpub, just half a mile from the production facility, fills a new niche in the town.

"It's a real farm-to-table restaurant that this community really needed," Joe said. "We're working with Darnell Farms, which is a third-generation family farm that sits on the Tuckasegee River."

Then, in early 2018, Joe purchased a property in downtown Sylva, where Nantahala will open another taproom, possibly by the end of 2018. It will house a pilot system, a small kitchen and a music venue.

Joe Rowland, co-founder and president of Nantahala Brewing Company in Bryson City, enjoying the fruit of his team's labor. *Courtesy of Nantahala Brewing Company.*

He said the new property is on the same river as Innovation Brewing and on the same train tracks as Nantahala's original Bryson City locale. He's excited to reach more Western North Carolinians, noting that Jackson County has more than forty-five thousand residents, plus fourteen thousand college students and twenty-five thousand Harrah's Casino employees.

Additionally, Nantahala has a taproom in West Asheville, which opened in the summer of 2018. Joe also is looking at locations in East Tennessee.

The brewery added fermenters to its 10-barrel brew house in 2017, and while barrelage was around 5,500 that year, capacity is now 14,000 barrels. Nantahala currently distributes in North Carolina, Tennessee and North Georgia. Joe plans to expand distribution to the rest of Georgia and potentially into South Carolina. More than 80 percent of Nantahala beer is sold outside of the two Bryson City locations, he said.

## The Thirsty Monk Pub and Brewery

The Thirsty Monk, an Asheville-based pub and brewery with multiple locations, has been brewing since 2012. Barry Bialik founded Thirsty Monk Belgian beer bar in 2008, and he has expanded the brand significantly in the decade since.

Head brewer Norm Penn initially ran a one-barrel brew house at the Monk's second pub in South Asheville. That location, now called Brother Joe's Coffee Pub, currently has a three-and-a-half-barrel system. However, in 2017, the Monk announced the purchase of both a brewery in Denver, Colorado, and a beer bar in Portland, Oregon. The Denver brewery, formerly Deep Draft Brewing, has a twelve-barrel brew house. Head brewer there, Brian Grace, started shipping regular batches of beer from Denver to Asheville Monk locations as well as to Bazi Bierbrasserie, the Portland bar, in 2018.

For more than a year, the Monk contract brewed some of its recipes at French Broad River Brewery. Bialik contracted to purchase that brewery in 2016, but the deal fell through.

"Barry often says there were a million moving parts to it, and when we started negotiating, we only had about ten pieces of a one-thousand-piece jigsaw," said Joanna Postlethwaite, Thirsty Monk head beer buyer and marketing coordinator. "At the same time, other opportunities in other states came up, and his choice was to explore other options."

Thirsty Monk brewer Chris Whaley engaging in quality control at Brother Joe's Coffee Pub. *Courtesy of Thirsty Monk Pub & Brewery.*

The Monk also contracted to purchase Waynesville's former brewery and restaurant Tipping Point Tavern, but that didn't happen either.

"We went out there and had a great time learning about their system. It was the same situation as French Broad. When we had two options in hand, we decided to go further afield," Joanna said. "Denver seemed to be a great strategic move for us. Asheville has a hugely renowned craft beer market, and we want to take that brand there. And we are still aspiring to get Thompson Street up and running."

Bialik owns a warehouse on Thompson Street, behind Biltmore Village, where he has said he wants to expand brewing operations.

"While we will explore packaging options, I don't think we will necessarily will be a distributing brewery," Joanna said. "We are more focused on having Monks across the country. We'd like to build the Monks and then brew the beer to fill them."

In addition to the downtown, South Asheville and Biltmore Park brewpubs, the Monk had a fourth pub location at Reynolds Village in North Asheville for a couple of years before closing it. That space is now a test kitchen for a culinary food box program that the Monk team is developing with Josh Weeks, former chef at Corner Kitchen in Biltmore Village.

Bialik recently purchased the building adjoining the Biltmore Park Monk, and per Joanna, will likely expand into barrel-aging at that location.

"Although the Monk is traveling far, we remain very committed to Asheville and to supporting our community here," Joanna said.

## Frog Level Brewing Company

Frog Level Brewing became Waynesville and Haywood County's first twenty-first-century brewery in late 2011, following in the footsteps of Smoky Mountain Brewery. Clark Williams, founder and owner, initially kept his day job and brewed on the side, but after only a few months, demand was high enough for him to start brewing full-time. Now he has a head brewer, Matt Norman, and his daughter, Celeste Underwood, works as chief operating officer.

The brewery is named for the former swamplands along Richland Creek, which were built up as an industrial district after railroad tracks and a train depot were built there in the 1880s. Locals called the area "Frog Level" because when it flooded, the frogs would move to a higher level. The brewery taproom has a deck overlooking the creek, and Frog Level is now a designated historic district.

In 2017, Clark expanded from a three-barrel to a seven-barrel brew house and added fermentation tanks, which increased production capacity significantly, to around three hundred barrels. Also, after working with mobile canning for a while, the brewery purchased its own canning system, as well as adding 1,400 square feet to accommodate both extra customer seating and brewing operations.

Frog Level started with limited self-distribution, but with the addition of twelve-ounce cans, the brewery has picked up wholesale distribution throughout WNC and into Charlotte. While Clark said 70 percent of his beers still are sold from the taproom, he's looking forward to expanding his sales footprint over the next few years.

The quirkily named flagship beers, such as Tadpole Porter and Catcher in the Rye IPA, sell well; however, Clark said the brewery now makes lots more specialty and one-off beers, and he works to source local ingredients for those.

"I buy all the hops they grow from Heidi Dunkelburg's H&K Hops Farm. I can buy whole leaf dried from them," he said. "I send samples to ASU for testing. They're great hops."

Frog Level Brewing Company founder Clark Williams and his daughter, Celeste Underwood, chief operating officer for the Waynesville brewery and taproom. *Courtesy of Frog Level Brewing.*

The brewery added pub chow in 2018. As with many other breweries that started as out as tasting rooms only, Clark recognizes that food options keep customers in seats longer, as well as mitigating the effects of alcohol.

"We are military-owned and family-operated and true to the English style of brewing. As our tagline has always said—we're distinct in our attitude and our ingredients," Clark said.

When asked about the increase in tourist traffic in the area, he said the breweries definitely bring folks to Waynesville: "We have a lot more tourists now coming to see our breweries. I invite them to try all of the nearby breweries."

## BearWaters Brewing Company

First it had to change its name, and then it had to change towns.

In 2012, Headwaters Brewing Company became Haywood County's second modern-day brewery, opening a small taproom with a nano system in Waynesville. Several months later, Pennsylvania's Victory Brewing Company served the new brewery a cease and desist over the name, as Victory makes a beer called Headwaters Pale Ale.

While trademark skirmishes in the beer industry have reached fairly epic proportions in recent years, back then it was less common, and it provoked a good deal of industry concern. Headwaters founder and president Kevin Sandefur hired a marketing consultant who came up with the idea to change two letters in the name. Thus, Headwaters became BearWaters. Luckily, the logo already was a bear, so no change was necessary there.

Early in 2017, Sandefur and his newly added co-owner, Art O'Neil, learned that the Waynesville building they were leasing had been sold. It would soon be bulldozed to make way for a Publix grocery store.

The business partners already had a fifteen-barrel brew house in storage, so it seemed like a good time to look for a bigger space. They found it, not in Waynesville, but down the road in Canton. In the summer of 2017, BearWaters reopened in an historic downtown building on the Pigeon River, becoming Canton's first brewery.

"There's always that first tinge of anxiety when people hear there's going to be a brewery in their small town," said Kevin. "They wonder if it will be a dive bar. They want to know if there will be empty beer cans all over the street or drunk people wandering around downtown late at night."

BearWaters Brewing Company moved locations from Waynesville to Canton and built this deck overlooking the Pigeon River. *Courtesy of BearWaters Brewing.*

BearWaters allayed those concerns by renovating a piece of property that was on the verge of demolition, including a separately owned restaurant onsite, and making the business family-friendly.

"We've quickly become a community center for the town," Kevin said. "People from here who don't even drink have come in and thanked us for opening here. I think they're glad to see some revitalization in a downtown that has had some stigma over the years because of the [paper] plant."

He's gives credit to the town's leadership, especially former town manager Seth Hendler-Voss and current town manager Jason Burrell, who actively recruited the brewery.

"It was like we both got a second chance. It's a great boost to Canton's economy," Kevin said. "Local realtors will come by and buy cans of beer as a gift for people looking to buy in the area. Having a proven business downtown has helped instill a sense of confidence for other businesses looking at Canton."

In 2017, BearWaters received further validation when the brewery brought home a bronze medal from Great American Beer Festival for Smells like Money, a Belgian strong ale. The beer's name is a play on words referencing Canton's paper mill and, according to Kevin, an ode to the town's blue-collar pride.

"The response has been really overwhelming," said Sean Coughlin, one of BearWaters' two head brewers with Justin Tate. "It's really great because our regulars from Waynesville still visit, and we get lots of Canton residents who are so excited that they are here, and we're close enough to Asheville to get beer tourists from there."

## Brevard Brewing Company

The Land of the Waterfalls didn't have a brewery until the spring of 2012, when Brevard Brewing opened on Brevard's Main Street. As of early 2018, there would be four breweries in the small town, including Colorado-based Oskar Blues Brewery.

Brevard Brewing remains the only downtown brewery. Founder and brewer Kyle Williams owns the production brewery, taproom and the building they're housed in.

He said there were no issues to opening Brevard's first brewery: "Other restaurants and bars paved the way. Falls Landing was the first to get

Founder, owner and Brevard Brewing Company brewer Kyle Williams. *Courtesy of Brevard Brewing.*

liquor. When that happened, there were police cars parked outside and protesters, and this is a fine-dining restaurant."

Falls Landing Restaurant, across the street from the brewery, opened in 1993 and still feeds folks today. Much of Transylvania County still does not allow liquor sales, and beer and wine sales were only approved in some areas of the unincorporated county as recently as 2014.

However, the town has embraced craft beer. "I have a really strong local following. We see some of the same people almost every night," Kyle said. "If you walk into any restaurant downtown, you'll see three or more of my taps."

Kyle estimates that 65 percent of his product is sold via his wholesaler, Budweiser of Asheville, although he still self-distributes within Transylvania County. After purchasing a canning line and additional fermentation for his thirty-barrel system in 2018, he expects his output to increase quickly. With expansion will come change. "I'm planning on getting a staff and being a brewer/owner instead of a full-time grunt," he said.

Brevard Brewing specializes in lagers. The pilsner, lager and dunkel are bestsellers and are available in cans. "As far as I know, no one else focuses predominantly on lagers. My lineup is almost all lagers," Kyle added.

# 5
# EXPANSION BREWERIES FROM THE WEST

The original American diaspora saw immigrants moving from East to West, from the early cities settled by those who had crossed the Atlantic Ocean to the western frontier lands. Craft brewing, in the twenty-first century, mostly moved the other direction—from West to East.

Craft brewery pioneers included Fritz Maytag of Anchor Brewing Company, Jack McAuliffe of New Albion Brewing Company and Ken Grossman of Sierra Nevada Brewing Company. These breweries all started in California. While Jim Koch opened Boston Beer Company in the Northeast, the early '80s and '90s saw most craft breweries popping up in the states of California, Oregon and Colorado. The Southeast was slow to join the small brewery resurgence, mostly because of antiquated blue laws, a cultural preference for "working-class American" beer and, duh, the Bible Belt.

In early 2012, not one, not two, but three large American craft breweries headquartered out West announced that they would build East Coast expansion breweries in WNC. It was a heady time for local beer drinkers and those working in (and writing about) the industry.

First up was Colorado's Oskar Blues Brewery. That brewery opened its expansion facility in Brevard in late 2012. California-based Sierra Nevada Brewing Company and Colorado-based New Belgium Brewing Company then opened massive production facilities in Mills River and Asheville, respectively.

# A Mountain Brew History

The Brewers Association ranks all three breweries in the top ten U.S. craft brewing companies by production volume, with Sierra Nevada at number three, New Belgium at four and Oskar Blues Brewing Holding Company at nine in 2017.

## Oskar Blues Brewery

Oskar Blues has climbed in the BA rankings significantly since opening in Brevard, when it was listed as the twenty-ninth-largest American craft brewery. In 2015, the company sold a majority stake to Fireman's Capital, a private equity firm. This enabled the fast-growing business to purchase Michigan's Perrin Brewing Company and Florida's Cigar City Brewing and open a third Oskar Blues brewery in Austin, Texas.

Because Fireman's Capital is not itself a multinational conglomerate brewer, such as AB InBev, the Brewers Association and the Asheville Brewers Alliance still consider Oskar Blues a craft brewer. The holding company for these three beer brands plus Utah-based Wasatch Brewery and Squatters Craft Beers became the Canarchy Craft Brewery Collective in 2017. Total production volume for the Canarchy brands in 2017 was 350,000 barrels.

Oskar Blues famously chose Brevard for the simple reason that the brewery's sole owner at the time, Dale Katechis, is an avid mountain biker. Some of the best single track on the East Coast is in the area of Pisgah Forest nestled above Brevard as well as in nearby DuPont State Forest. Soon after opening the new brewery, Dale purchased a former dairy farm on the edge of DuPont, where Oskar Blues hosts special events and beer-soaked music festivals. Rechristened REEB Ranch, after Dale's custom-made bike business, REEB Cycles, the farm's new name is the word *beer* spelled backward.

Although Oskar Blues was the last of the three breweries to announce they'd expand in WNC, it was the first to open. While the Sierra Nevada and New Belgium facilities were built from scratch, Oskar Blues set up shop in a large industrial warehouse that was formerly home to a roof truss manufacturing plant. Thus, renovations were minimal, and after a scramble to assemble brewing equipment, including a large canning line, the first Brevard Dale's Pale Ale was brewed on 12/12/2012.

By 2017, production was up to 112,000 barrels in Brevard, which was half of Oskar Blues's total volume that year. Cigar City's Jai Alai IPA was

80 percent of Brevard's volume, said Aaron Baker, Oskar Blues Brevard marketing manager. The original warehouse has grown significantly as well, with the addition of another building to house fermentation tanks and offices. Capacity is around 200,000 barrels a year at this location, Aaron said.

"Brevard is so different now. I think back to when I was in college here, and there was only one place to go out at night," said Aaron, who attended Brevard College.

> *Brevard used to be just a day trip for people on their way to Asheville. But now you can make a whole vacation of Brevard with Pisgah, DuPont, breweries and restaurants. There's been skepticism from locals if this could be an economic driver, but I think they've been proven wrong.*

## Sierra Nevada Brewing Company

Sierra Nevada remains "family-owned, operated, and argued over," as stated on its beer cans. Founder Ken Grossman is still involved in the day-to-day operations of both of the West and East Coast breweries, although he told me that he's trying to work less after thirty-seven-plus years in beer.

"Highly respected, Grossman is a rock star of brewing. If he made albums and played guitar, he would be on the same level as Mick Jagger or Bob Dylan," noted Tony Kiss in a 2015 *Asheville Citizen-Times* article.

Ken's son, Brian Grossman, manages the Mills River facility and lives with his family nearby. When asked for his title, Brian said he prefers to be called "second-generation brewer." He likely is one of the few American craft brewers today who can give himself that title. I predict we will see more second-generation brewers over the next few decades, however. Ken's daughter Sierra Grossman manages the Chico brewery, and if Ken ever completely retires, his two offspring will share company management duties.

The Mills River facility produces about 50 percent of Sierra Nevada's barrelage, which was more than one million barrels in 2017.

"We get called Malt Disney, Willy Wonka's Beer Factory, and the Biltmore of Brewing. All of these names are positive in my opinion," Brian said. "We work to treat everyone who walks in our doors the same."

The brewery has a restaurant and taproom, plus indoor and outdoor music venues.

# A Mountain Brew History

Two generations of family brewers: Brian (*left*) and Ken Grossman at Sierra Nevada Brewing's East Coast facility in Mills River. *Courtesy of Sierra Nevada Brewing Company.*

"Our reception has been very positive," Brian said. "During the week, around 70 percent of the people eating in our taproom are locals. Lots of locals come in here year-round, and that's what we want—a place for them all the time."

He added:

> *You can have the best equipment in the world, but that doesn't make us the best beer in the world. It's the people, the team that we put together, plus paying attention to the local community, its culture, its people, while staying true to yourself and your business's culture.*

## New Belgium Brewing Company

New Belgium is famously employee-owned and consistently ranked by *Outside* magazine and other media outlets as one of the top workplaces in the United States.

"The founders, Kim Jordan and Jeff Lebesch, started the company by establishing their core values and beliefs, and we all live those every

day here," said Jay Richardson, general manager at the Asheville New Belgium facility.

"Now everybody is an owner, and that means co-workers hold each other accountable," he added. "It's your money. It's my money. Let's take care of it together."

The process from site to opening would take the longest for New Belgium out of the three breweries, partially because of challenges with the building site. Brewing started at the end of 2015, and New Belgium's onsite taproom, the Liquid Center, opened in May 2016.

"We spent six months getting the site prepared for construction. We had to move a lot of dirt around, and there were lots of brown field regulations," Jay said. "But that was part of what we wanted. We wanted to find a place that needed to be rehabilitated."

The land that New Belgium built on once was home to, at various times, a cattle lot, a construction junkyard for the city and an auto repair shop. Thus, cleaning up the designated brown field was a huge chore. Additionally, the design process took longer than planned when the New Belgium team learned that a creek running through the middle of the property drained the storm water from most of the eastern part of West Asheville into the French Broad River. Needless to say, the creek had to stay.

"The city's willingness and motivation to partner with us in revitalizing the area, when they learned about the creek, was so helpful," Jay noted. "They had access to funding for storm water best practices, and they helped with the restoration of what is now called Penland Creek, so all that storm water is cleaned before it reaches the river. And we separated our taproom from the brewery, so now the creek is a central part of the property."

Also, New Belgium's location in the River Arts District, just west of downtown Asheville, was of concern to some residential neighbors and nearby business owners. A year to the day after New Belgium announced it had purchased the site, the Penland Auction House there burned to the ground and was ruled arson.

"Trucks became a major issue for our neighbors here," Jay added.

> *It would have been easy to take it personally, but we learned that any business that would be introducing more truck traffic to this area would be in the same position. The East/West Asheville corridor is the main street for this corner of Asheville. We all want fewer trucks on our Main Street. We were able to work with the neighborhood advisory committee and the city and figure out a solution that halved our truck traffic.*

New Belgium's taproom, with its large deck overlooking the river and part of the Greenway, is always hopping and seems to have integrated well into the neighborhood.

## Why Western North Carolina?

All three of these breweries cite similar reasons for choosing this region for expansion. Their owners enthuse about the natural beauty of the area, the easy access to wilderness and the quality and quantity of the water.

Each brewery was at or approaching capacity at its original location. The debate, of course, was whether to expand where they started or to build another brewery elsewhere.

All three of these breweries decided, separately, on the latter, for various reasons. Among other variables, shipping beer across this large country is expensive, especially given the need for refrigerated trucks to protect unpasteurized craft beer from temperature changes that can shorten shelf life. The closer one is to the brewery, the fresher the beer. It's both less expensive in the long run and better for the environment to produce beer in different parts of the country.

That doesn't mean there haven't been challenges to opening expansion breweries. I already mentioned some of those that New Belgium faced.

After learning that the nearby water treatment plant couldn't handle the temperature and organic content of the water leaving the brewery, Oskar Blues installed an onsite wastewater treatment plant. The brewery had three stages of treatment construction planned, but so far, stage one has handled the waste water sufficiently, Aaron said.

North Carolina's blue laws can be difficult to figure out and comply with as well.

"There are a million hurdles everywhere. Learning the differences between different laws and rules in every place is a challenge," Brian said. "We have been working since day one to help change some of the laws and rules in North Carolina. There is still a lot going on with craft freedom. I feel that everyone is willing to be open to conversation and to look at changing antiquated laws and rules."

Additionally, when local small craft brewers first heard that these big breweries were coming to town, some of them were concerned.

"People were scared to death when they heard the big breweries were coming in, but it's been nothing but positive for the beer community," said

Cartoon about the explosion of WNC's brewing industry into small towns, originally published in *Mountain Xpress*. Cartoon by Brent Brown.

Tony Kiss, longtime WNC beer reporter. "The big guys brought in more and more tourism, and that's helped everybody. And every one of those places has a different vibe to it. They're big, but they aren't in any way soulless."

That said, competition for tap handles and retail space has become fierce. Shelf space is limited, and when a grocery store's local beer section includes multiple beers from three of the largest U.S. brewers, the brewers who only have a few packaged options and small production runs get nervous.

"I don't think having Sierra local has hurt our business," said Joe Rowland, co-founder and president of Nantahala Brewing. "Sierra Nevada's beers are still in the same cold box in our tiny grocery store that they've been in for years. They haven't poached shelf space from local beer here."

Also, small brewers note they have benefited from the resources, knowledge and expertise of their larger brethren.

"One surprising thing at that time was that while I expected the local breweries to be cordial, I was surprised at how warm they were," Jay said. "Tim Schaller was super warm and helpful and welcoming, as was Oscar Wong. When we were deep in the construction process and [head brewer] Alex Dwoinen hadn't been able to brew for months, John Lyda called him and said, 'Hey man, you want to come make some beer?'"

Today, both WNC residents and brewery owners seem happy that these breweries are here. Local chambers of commerce and tourist boards are nothing less than ecstatic.

"I think the economic impact of the industry started becoming apparent in 2012 when the region got on the radar of the three expansion breweries," said Clark Duncan, executive director of the Economic

# A Mountain Brew History

Brewer Nate Wall doing what brewers really do most of the time: cleaning. *Photo by Bren Photography.*

Development Coalition of Asheville & Buncombe County. "We saw the growth potential there, and there were a few years of not only absorbing three great players, but seeing huge evolvement of other businesses. Then there was the acknowledgement that the beer industry here is a mature economic cluster."

He added, "Asheville has always stood out not as a southern town in mountains, but as a mountain town in the south."

Per a 2017 study by the Asheville Convention and Visitors Bureau, of the approximately 3.8 million overnight visitors to Buncombe County each year, more than a quarter visited at least one brewery, and 14 percent say that the beer scene was one of the primary reasons for visiting.

"In 2012, a segmentation study showed that our visitors were much more likely than the average U.S. traveler to engage in culinary and brewery experiences. However, at that time, beer did not register as a top tier motivator. That changed in just five years," said Dodie Stephens, Asheville Convention and Visitors Bureau director of communications.

## Deschutes Drama

In 2015, WNC residents learned that another brewery, Deschutes Brewery of Bend, Oregon, at that time the sixth-largest American craft brewery, was looking at Asheville as one of two cities in which to open an expansion outpost. In an *Asheville Citizen-Times* article, Joel Burgess reported, "At stake was a potential $135 million–$200 million brewing facility and up to 237 jobs."

After months of wooing by city and county government officials, the Economic Development Coalition team and the Asheville Brewers Alliance, Deschutes chose Roanoke, Virginia, over Asheville.

"Deschutes was an exciting opportunity. We loved interacting with them at that milestone in their growth, and I think they made the best choice for their business," Clark said.

There were, of course, probably many reasons that Deschutes chose Roanoke. However, former Buncombe County commissioner Miranda DeBruhl took heat for "inappropriate" tweets about the secret deal. This was back before it was common for American politicians to discuss delicate backroom negotiations on Twitter. One of DeBruhl's tweets about the offer to sell county property to Deschutes was hashtagged "Fairytale." Many of the players involved felt that this public snarkiness potentially derailed the deal, although the Deschutes team graciously never mentioned it.

"My guess is that Deschutes may have felt the market was oversaturated here," said Joe Rowland, who was president of the Asheville Brewers Alliance at the time. "But I was somewhat surprised given the infrastructure that was already in place, including railway spurs, shipping routes and raw materials."

Some think the expansion days for bigger breweries may be ending. Green Flash Brewing of San Diego overextended by opening a second facility in Virginia Beach, which closed after only a couple of years. However, support businesses for existing brewery clusters will continue to look for ways to be closer to their clients, as was the case when San Diego–based White Labs opened a yeast production facility in Asheville (see chapter 12).

Clark said to stay tuned—more beer-related businesses will come to WNC.

# 6
# BREWERIES OF THE CENTRAL MOUNTAINS

All of the breweries profiled in this chapter and the next five have opened for business between late 2012 and the summer of 2018. True story. While Asheville has experienced continued beer industry growth, what's striking is the number of small WNC towns and communities that have welcomed craft breweries. Numerous formerly dry municipalities, after revising their post-Prohibition regulations, have embraced breweries—creating community as well as attracting jobs and dollars.

Consider the impact alcohol sales have had in Waynesville compared to the still-dry town of Old Fort, about an hour's drive to the east.

"There are virtually no restaurants in Old Fort, other than Hardee's and McDonald's," said Daniel S. Pierce, historian, author and University of North Carolina at Asheville professor. "But drive through downtown Waynesville now, and there's a happening restaurant and brewery scene. A few years ago, if you'd told me I'd be seeking out downtown Waynesville on a Saturday night, I'd tell you you were crazy."

Many WNC towns grew up around a large plant or manufacturing industries—think DuPont and Ecusta in Brevard and Dayco in Waynesville. When those businesses shuttered their doors or, in the case of Canton's Champion Paper, changed ownership and downsized, these towns consequently lost money, resources and people. Community leaders wanting to revitalize their communities looked to the biggest city in the region—Asheville—and saw exponential growth, especially over the past ten years.

"Dayco was huge in Waynesville, and when it closed in 1996, it was a blow," Dan said. "The town needed to find something to bring in vibrancy and tourists."

That something, in many cases, was a craft brewery. Among the small WNC towns that have recently welcomed their first brewery are Burnsville, Marshall and Marion.

"People associate craft with quality. Even if they don't drink beer, they equate local breweries with livable communities that emphasize craft, sustainability and mindful living," said Derek Allen, food and beverage attorney at Ward and Smith, PA. "It's no surprise that breweries, farm-to-table restaurants and tourism are flourishing in this region."

Some locals are initially suspicious or disapproving of breweries in their towns. When Bryson City aldermen approved alcohol sales in that community, the measure passed by only one vote. As in the past, opposition often comes from church leaders, who believe alcohol sales will usher in other problems. When Haywood County residents finally voted in alcohol sales countywide in late 2016, the *Smoky Mountain News* reported that Pastor Mark Caldwell of North Canton Baptist Church voiced opposition, "citing drunk driving, alcoholism, and homelessness as just a few of the societal ills made possible by expanded alcohol sales."

"Bryson City was wet when we got here," said Joe Rowland, founder of Nantahala Brewing.

> *But we still faced the challenge of folks who were against alcohol. At the end of the day, it's a small town. It affects us in that people don't want to be seen coming into a brewery because they don't want their employer or preacher or neighbor to see them. I grew up in the small-town South. I get it. It's something we respect, but it's still a challenge.*

Unless they are one of the big breweries that set up shop in Western North Carolina to expand operations, breweries typically don't employ as many people as the larger manufacturers once did, but they do bring rippling economic benefits. The restaurant and brewery scenes support each other in bringing in visitors as well as becoming places for locals to hang out. Breweries often become community hubs and gathering places.

This chapter includes profiles of those breweries encircling Asheville, most within about a twenty-minute drive. As the number of breweries within the area's largest city has exploded, more and more beer entrepreneurs are exploring nearby bedroom communities. Some have

discovered amazing spots to house their businesses, from up-cycled railroad cars to riverside warehouses to picturesque farmsteads.

Let's start by rolling north from Asheville, from Woodfin to Weaverville to Marshall. Next we'll go east to Fairview, and then circle south to Fletcher and Mills River.

## Zillicoah Beer Company

The brainchild of five experienced local beer industry guys, Zillicoah Beer has a unique production setup. There's no brew house or hot side on site. Instead, the wort (the sugary substance made from boiling malted grains and water) is brewed elsewhere, and it's transported to Zillicoah in a tank on the back of a trailer and fermented on site.

"Our focus is on fermentation. We're more interested in what happens in the cellar than in the brew house," said John Parks, co-owner and lead brewer. "Instead we put our money into split cellars. We have a clean cellar for all our lagers and a wild and sour cellar with an open fermenter."

At some point, Parks said the partners will purchase a brew house, but the hope is that, by that time, they will have the cash to get exactly what they want.

"We can brew anywhere. It opens us up for lots of collaborations," said co-owner Jonathan Chassner. "We offer what lots of breweries don't have, which is a wild yeast and sour program."

The brewery is an equal partnership between John Parks, brothers Jonathan and Jeremy Chassner, Steve Wilmans and Mike Healey. The first three are the hands-on team, and the latter two, who founded and own Asheville's Lexington Avenue Brewery, primarily have an advisory role. Parks previously brewed for Asheville Brewing and Hi-Wire, where he spearheaded Hi-Wire's specialty beer program. Jeremy Chassner worked as Brian Grossman's assistant at Sierra Nevada in Mills River. Jon Chassner also is the head brewer at LAB. Luckily for him, the two breweries are only two miles apart.

Parks and the Chassner brothers are lifelong friends, and they have been planning this brewery for years.

"Parks is our adopted brother," said Jonathan. "We've been friends since sixth grade. We went to college together, and we brewed our first beer together as roommates at Florida State. Our first beer came out great, and

Jonathan Chassner (*left*) and John Parks, two of five owners of Zillicoah Beer Company, Woodfin's first brewery. *Courtesy of Zillicoah Beer.*

our second was awful. Then we moved to the Asheville area together after graduation. We've even almost starved to death together."

The threesome briefly experimented with playing in a grunge band. Luckily, said Parks, they discovered an affinity for brewing, which precluded a career in rock 'n' roll.

The brewery's location on the border of Asheville means it's Woodfin's first brewery. Woodfin was incorporated in 1971 to avoid annexation into the city. Jon said the team faced some challenges in opening, but nothing other than what most new breweries experience. Both the mayor of Woodfin and a local police officer have stopped by since the brewery opened in November 2017 to thank the guys for locating there.

The name *Zillicoah* comes from the word that the Cherokee Indians supposedly called the stretch of the French Broad River running past the brewery. The brewery's large covered patio and outdoor space feature a permanent taco truck run by Taqueria Muñoz, a traditional taqueria.

## WEAVERVILLE

The town of Weaverville, sometimes referred to as Asheville's hat, is located only a few miles north of the city. In 1872, the town's Masonic chapter of the Sons of Temperance opened Weaverville School, which later became Weaver College. These teetotaling brotherhoods were responsible for starting what basically were the region's first private schools, including Reems Creek High School in 1860. An Asheville Sons of Temperance chapter would be organized in the mid-1890s, proving

# A Mountain Brew History

again that those in nearby communities tended toward sobriety earlier than those in the city. Weaverville didn't approve beer and wine sales until 2007, and the first ABC store opened there in 2010, when liquor by the drink was approved.

The former farming village has seen tremendous growth in the past decade. As of 2018, three small breweries, all located within a few blocks of one another, make their home in Weaverville's charming and bustling downtown.

## Blue Mountain Pizza and Brew Pub

When the owner of a popular pizzeria asked home brewers Mike Vanhoose and Joey Cagle if they wanted to open a brewery in the restaurant's basement, their answer was "What's better than pizza and beer?"

Blue Mountain Pizza opened in the spring of 2004 on Weaverville's Main Street. The family-friendly restaurant quickly became a local hangout, offering an extensive menu in addition to its highly lauded pizza, music and open mic nights.

Blue Mountain Brewpub's brewing operations in the basement of Weaverville's Blue Mountain Pizzeria. *Courtesy of Blue Mountain Brewpub.*

Vanhoose and Cagle poured their first Blue Mountain beer on December 1, 2012, and thus became Weaverville's first licensed brewery. Vanhoose said the permitting, both local and federal, took a while, but the townspeople were happy to welcome a brewery of their own.

The brewers work on a two-barrel system and specialize in Belgian- and American-style ales. Some 98 percent of that beer is sold in-house, with only a few kegs finding their way to other restaurants and bars around town. Blue Mountain is at capacity in the restaurant basement, but Vanhoose said he's looking for a space nearby to start a sour and barrel-aging program.

"We've made more than one hundred different beers since we opened," he said. "It's great being a small-batch brewery because we're able to experiment with different yeasts and ingredients. And our beer is super fresh. We roll through it as fast as we make it. It's nice not to have to worry about expiration dates."

## Zebulon Artisan Ales

In late 2016, husband-and-wife team Mike Karnowski and Gabe Pickard opened Weaverville's second brewery, Zebulon Artisan Ales, in a former fire station just behind Main Street.

Karnowski was Green Man Brewery's assistant brewer for seven years and headed the specialty beer program there. Although he'd been brewing sours at home since the 1990s, Karnowski brewed the first three commercial sour beers in Asheville at Green Man, initially on a one-barrel system, in 2012. Green Man still produces these beers—Funk #49, L'homme Vert and Schadenfreude—on a seasonal basis.

"No one at Green Man understood these beers at all then," Karnowski said. "They thought it was amazing that people were lining up to buy them. But they were making money, so we increased production on them."

He also said he produced the first barrel-aged beers in Asheville for Green Man after securing rum barrels from a distillery in Louisiana where he worked before moving to WNC.

After looking at locations around WNC, the couple found Weaverville.

"I didn't want to be brewery number twenty-eight in Asheville," Mike said. "The size of this place wouldn't work in Asheville. It'd be a waste of space to be on the South Slope paying high rent on a tiny space. I'd say our customers are about one-third Weaverville locals, one-third Asheville

# A Mountain Brew History

Gabe Pickard and Mike Karnowski founded and own Zebulon Artisan Ales in Weaverville. *Courtesy of Zebulon Artisan Ales.*

locals and one-third tourists. A lot of people want to get out of Asheville nowadays, and Weaverville is a magic spot."

At Zebulon, Karnowski continues to make sours while also producing some traditional styles, as well as occasionally re-creating historic recipes.

"We're starting to specialize in sour beer fermented with spontaneously fermented yeast," Karnowski said. "One way to separate yourself out is by finding local terroir."

He equates the historic reproductions to being in a cover band.

"We recently made this 1850s Imperial Stout from old brewers' records. So we bought floor-malted grains from the UK. We try to get as close as we can without being ridiculous," Karnowski said. "People enjoy being able to

try beers from 150 years ago. Even though I think I could probably brew it better, the point is to re-create an old recipe and let people taste what beers tasted like back then."

In 2017, Zebulon produced about 150 barrels.

Zebulon offers draft, in recyclable plastic kegs, to a few regional restaurants and bars and bottle-conditioned 750-milliliter cage and cork bottles to area bottle shops. Mike will not fill growlers, which is becoming a trend for some local brewers who want to control the cleanliness and freshness of their product.

"My main rant is the adolescent palates of beer drinkers today. Why are we making beers that taste like juice or candy or cartoon character beers?" Karnowski asked. "I like making beer for adults who have advanced palates. Subtlety is lacking in the modern beer scene."

He added: "You can call me a curmudgeon in your book. I wouldn't be offended if you use that word. It's true."

Gabe makes low-sugar, nonalcoholic sodas with natural ingredients for the brewery. They are different each time, but when I was there, I sipped on a sparkling pomegranate ginger soda.

Karnowski said the brewery's name springs from a common old-fashioned name and notes that identifying available (not trademarked) names for both breweries and beers is a struggle. That said, North Carolina's controversial Civil War governor, Zebulon B. Vance, was born in nearby Reems Creek Valley.

While we're talking names, Karnowski said he couldn't be bothered to name the twenty-some different beers he's created thus far. Instead, he and Gabe dedicate each beer to a person or thing they find inspiring. For example, a recent dry-hopped saison was dedicated to the Cassini Spacecraft and the Toyko-style gose honors film director Akira Kurosawa.

Additionally, Karnowski is the author of *Homebrew Beyond the Basics: All-Grain Brewing and Other Next Steps*.

## Eluvium Brewing Company

Jon Varner, Shea Lewis and their Chihuahua, Randy Travis, opened Eluvium Brewing Company in Weaverville in late 2017. The small production brewery and taproom is just a few hundred yards from Zebulon Artisan Ales.

## A Mountain Brew History

The business and romantic partners are currently both owners and sole employees (which is fairly common in this area—many brewers are also their own beertenders—some only for a few months, some for years). Shea still works as a high-risk OB ultrasound technician at Mission Hospitals and as an ultrasound tech instructor at AB-Tech, while Jon is full-time at the brewery. Previously, he worked briefly for Land of Sky Mobile Canning and then at a small Virginia brewery.

The brewery name is a reference to the geological process of gold separating itself from the dirt around it. The first major discovery of gold in America was in 1799 in North Carolina, and that was the start of the nation's first gold rush. The Reed Mine in Carbarrus County was the site of the first documented gold discovery in America.

"Weaverville kind of reminds me of Sylva, where I grew up," Shea said. "We'd come to Zebulon all the time, and then we found the space, and it was perfect, and so we jumped on it."

Jon currently brews on a three-barrel system and is supplementing Eluvium's beers with guest taps.

Jon Varner and Shea Lewis opened Weaverville's Eluvium Brewing Company in late 2017. *Courtesy of Eluvium Brewing.*

"We're trying to source local as much as possible," he said. "My goal is being able to get more ingredients locally and work as much as possible with people I know."

A recent brew, "Golden" Ale, with turmeric, honey and peppercorns—based on the popular health drink Golden Milk—included ingredients from Barnardsville's Rayburn Farm.

"We want to build a community and have a place where people can hang out," Shea said. "During the 2018 snowstorm, we stayed open, and it was packed. We made a lot of great friends and a lot of great customers that day."

## Mad Co. Brew House

Downtown Marshall inhabits a strip of land between rugged mountain cliffs and the French Broad River at one of its widest points. The river is the world's third oldest and one of the few that runs south to north, thus further confusing lost tourists.

Per the stories of still busts, there was a good bit of illicit liquor production in Madison County from the late 1800s into the late twentieth century. There are stories of wealthy Asheville distillers shipping their product to Madison County via railroad at the turn of the twentieth century in an attempt to disrupt illegal production there. Today, Madison County remains dry, although the towns of Marshall, Hot Springs and Mars Hill allow alcohol sales.

Mad Co. was the first brewery to open in Marshall and Madison County. This small-batch craft brewery and taproom sits on the town's quaint Main Street and has a large deck overlooking the French Broad River.

In 2014, Brandon Edwards and a business partner purchased what was a dilapidated building, tore it down and built it back up as Mad Co.'s brewery and taproom. The business opened in 2016 with guest taps but started pouring in-house brews soon after. Brewer Ian Yancich works on a one-and-a-half-barrel system, and most of the beer is sold from the taproom.

"The model we want to stick with is selling beer onsite. We have no aspirations to can or even bottle," Brandon said. "Having max thirty local draft accounts is about all I want."

"In a world where's there's fifty million beers, I don't want to put our quality in the hands of someone else," he said. "It's not fair to my brewer. It's

A renovated historic building on the French Broad River is home to Marshall's first brewery, Mad Co. Brewing Company. *Courtesy of Mad Co Brewing.*

not fair to my business. I have no aspirations to be a beer baron. Plus, more money equals more problems."

Ian's brewing philosophy is not to play it safe too often, noted Brandon. "Our Grisette has got a name for itself, as has our Africa Pale Ale. We call it Africa Pale Ale because it's a halfway IPA. Africa is halfway between England and India," he said, laughing.

He added: "We want to make quality beer at reasonable prices. I just want to be a welcoming place to come try our beer and hang out or get some business done or take someone on a date."

With that philosophy in mind, the Mad Co. owners opened a second brewery in Sparta, North Carolina, in 2018.

Sparta, the county seat of Allegheny County, is in the upper northeast corner of WNC, just below the Virginia border. It's a solid three-hour drive from Marshall, but Brandon grew up in Sparta and was excited to open the county's first brewery there, as he did in Madison County.

The new brewery, Laconia Ale Works, is named for the region in Greece of which ancient Sparta was the capital. The two breweries share Ian as head brewer.

Brandon and his wife were at a wedding in Sparta when folks who were part of the downtown revitalization project approached them. This trend of towns actively recruiting breweries, especially in WNC, is a sea change from just a few years ago.

In 2017, an article in *Forbes Magazine* cited Sparta as one of the ten most affordable towns in the nation to move to if you want to quit your job and become an entrepreneur. The article references Sparta's gigabit fiber-optic Internet and low cost of living.

"Yeah, I didn't believe it. I had to look that up on my phone right away," Brandon said.

Laconia has a seven-barrel brew house, so it now serves as the main production facility for the two breweries.

"There's no reason why these outlying communities shouldn't have craft beer," Brandon said. "Folks shouldn't have to drive one hour or two hours to drink craft beer. I love being the first brewery in two counties. We have that blue ocean model. We fish where no one else is fishing."

## Whistle Hop Brewing Company

The bright-red caboose on top of a hill overlooking Highway 74 attracts curiosity. When folks learn it's a brewery taproom and they can sit in the upper berths of a restored train car while quaffing in-house brews, they're usually psyched.

Fairview's first brewery, Whistle Hop Brewing Company, is owned and run by the Miceli family, who also are railroad buffs.

"Tom's family restores old train cars for fun," said Gina Miceli, co-owner, marketing director and spouse to head brewer Tom Miceli. "In the '90s, after trains became computerized, the family bought three old cabooses. One they sold to a museum, one they turned into a guest house on their property and they decided to use the third for a brewery."

The family had also owned a lot on Highway 74 since the 1980s. They purchased the property above it, which had been part of one of the oldest farmsteads in Fairview before the highway was widened. Now the lower lot provides a place for brewing operations and storage, while the upper offers the taproom and an outdoor patio, which includes an old boxcar for protection from the weather. Fairview is an unincorporated community east of Asheville.

"The train car part is from our love of adaptive reuse and design. Repurposing a caboose to be a taproom was a challenge—both for us and for the building department," Gina said. "Our goal was to keep the historical charm while making it useful and bringing it up to code. Every single square inch of that tiny space is used."

The family owners, in addition to Gina and Tom, are Tom's parents, Frank and Lulu Miceli, and his brother Frank Miceli Jr. The brewery opened in December 2016. Longtime home brewer Tom started on a one-barrel system but expanded to a ten-barrel in early 2018. The first year of production, all beer was sold inside the caboose, but with the bigger system, the brewery can offer draft to local accounts.

"We take a culinary approach to beer. Tom creates beers from flavors he likes in foods, such as a Coconut Curry IPA with curry from [Asheville restaurant] Blue Dream Curry House," Gina said. "His main goal is to make approachable beers that reach across style lines."

Local food trucks regularly visit the brewery, and locally made snacks are sold in the taproom.

"Our main goal in opening was to create a place in Fairview for people to hang out. We both grew up in Fairview when there wasn't much here," Gina said. "Our taproom is not traditional, and our beers aren't traditional either."

## Turgua Brewing Company

Fairview's second brewery, Turgua Brewing, opened on a farm on St. Patrick's Day 2017. While breweries on farms have become popular in recent years, Turgua was one of the first WNC breweries to make it work. The five-acre farm has fruit trees, vegetables, herbs and roots, all of which provide beer ingredients. What doesn't come from the land is locally sourced.

"We use Riverbend malts almost exclusively," said Philip Desenne, Turgua owner and head brewer. "A neighboring farmer has started a hop yard with hop varietals that grow well in North Carolina. We used the first crop this year in our fresh hop IPA. As for fermentation, some of our beers are brewed and soured with wild yeast and bacteria."

While Phil currently is a one-man show, he gives credit to his partner, Debbie Weaver, for supporting him.

Fairview's Turgua Brewing Company is on a farm with five acres of produce grown for onsite beer production. *Courtesy of Turgua Brewing.*

"Opening a brewery was a dream I've had for over ten years," Philip said. "I started home brewing in college in Colorado back in the early '80s with my microbiology professor Ken Andrews—who later became a big brewery microbiologist."

Phil grew up in Venezuela and moved back there after college; he lived on a farm in a mountainous region of the country called Turgua. The word loosely translates to "Valley of the Birds," he said.

"The farm was off the grid," he said. "I grew organic vegetables and fruits and made beer, orange wine and other tropical fruit and root fermentation beverages."

Political and economic instability in Venezuela prompted Phil to return to the United States, where he attended graduate school and then worked

in information technology in the Northeast. He said he was desperate to return to his farming roots, however.

"I started searching for a place to open a farmhouse brewery about seven years ago," Phi said. "Of all the places I looked into on the East and West Coasts, and even Hawaii and the U.S. Virgin Islands, Fairview had the land and terrain and climate that made me feel at home again."

He admits to starting on a shoestring budget and said because the brewery has limited inside space, he's planning to build more covered outdoor areas.

In the first nine months of production, Phil produced just over eighty barrels, almost all of which was sold onsite, with some very limited local draft self-distribution.

Turgua also has a barrel-aging program and soon will start producing barrel-fermented ciders using local cider and wild apples.

## Blue Ghost Brewing Company

Fletcher, fifteen miles south of Asheville, is home to Asheville Regional Airport and the WNC Agricultural Center, which hosts the North Carolina Mountain State Fair every September. Until recently, the only reason people typically went to Fletcher was to fly, either on an airplane or a roller coaster.

Now, however, there's a brewery, Blue Ghost Brewing, in the tiny municipality, which wasn't incorporated until 1989. Nearby are Mills River Brewery, Bold Rock Hard Cider and, of course, the Malt Disney of beer, Sierra Nevada Brewing. Needless to say, that part of Henderson County has grown and changed in recent years. Ten miles south is Hendersonville, the county seat, also home to a handful of breweries.

Blue Ghost opened its doors in the spring of 2016. Co-owners and brewers, Zach Horn and Erik Weber, are longtime friends, home brewers and former teachers. Both even got their first commercial brewing jobs within months of each other at Brevard's Oskar Blues before breaking away to start their own business.

This brewery is a family-run affair, with Erik's brother, J. Weber, working as the taproom manager and marketing guy, and the permanent food truck, The Hungry Ghost, managed by Erik's wife, Maggie Weber. Per J., everyone from the two families pitches in wherever needed. The cash that the partners initially scraped together to purchase the building and land was raised from family.

While Zach and Erik started brewing on a two-barrel, they will upgrade to a larger system in 2018. Both are parents to young children, so the brewery is super family-friendly, with a designated play area under a huge oak tree. There's also a twenty-one-and-older area in the small hop yard on one side of the building.

"It's where people who want to drink beer without kids around can hang," J. said.

The brewery has both inside and outside music venues, with a "beer barn" with taps next to the outdoor stage. Blue Ghost offers six year-round brews plus rotating seasonals.

Then there's the name, which is special to the region. Throughout the Smoky Mountains, Blue Ghost fireflies hatch and mate, usually in early June. These unique fireflies emit a blue-white glow, and they don't flash, but merely glow. It's an annual family tradition for the Webers and the Horns to go see the fireflies in nearby DuPont State Forest.

## Mills River Brewery

Mills River Brewery opened in Arden, an unincorporated suburban community next to the town of Mills River. However, the brewery soon will relocate to the town for which it's named.

The brewery opened in the spring of 2015 with a three-barrel system in a strip shopping mall about a mile from Asheville Regional Airport.

Brothers-in-law PJ McCarthy and Joey Soukut founded the brewery. Joey was born and raised in Mills River, and he felt like it would be a great place to put a brewery.

"Me and Joey were surf fishing on the beach in Hilton Head about 3:00 a.m., and we started talking about opening a brewery. Before this, we were garage home brewers," PJ said.

Then Joey saw the empty building and thought it would be a good location for a small brewery and taproom. The partners jumped on the space so they could get up and going expeditiously.

While Mills River Brewery was the first to open in the area, the owners knew that Sierra Nevada would soon be brewing just down the road. That said, PJ noted the brewery doesn't get as many visitors coming in from the bigger brewery as people might think. He said it does get a lot of tourists because of its location right off an I-26 highway exit.

# A Mountain Brew History

Mills River Brewery is building a new production brewery and taproom in the town for which it's named. *Courtesy of Mills River Brewery.*

The new brewery will include an eight-thousand-square-foot production facility and taproom with room onsite for a fire pit, beer garden and even hiking trails. The property formerly belonged to the Town of Mills River, and it's just around the corner from Bold Rock Hard Cider.

PJ said they aren't sure whether or not they will keep the current location or not once the new brewery is up and running.

For the first few years, Mills River self-distributed draft to local watering holes. But in early 2018, the brewery signed with wholesaler Budweiser of Asheville, which more than doubled its number of accounts. The new facility will include a ten-barrel system and a canning line.

"We don't go crazy with the beer. We want to be close to true to style. We just focus on making good liquid and having solid core beers," PJ said.

Mills River Brewery initially included a deli, but that shut down, except for once a week. "We give away free food every Friday night, no catch. We hand it out until we run out," PJ said.

# 7
# BREWERIES OF THE EASTERN FOOTHILLS

If you jump on Interstate 40 East in Asheville, you pass by the towns of Black Mountain, Morganton and Marion before dropping down into Hickory. Some of the first settlements in WNC were in the latter two towns, mostly because of their location east and south of the highest mountains on America's East Coast. Even today, driving over Old Fort Mountain on the four-lane divided highway from Marion to Asheville is treacherous. It would have required a large amount of arduous persistence for early pioneers from the east to get to all points west.

Let's follow I-40 the opposite direction, from Asheville to the east, to learn about the breweries along the way. I've included the breweries of Rutherford County, just southeast of McDowell, and that area's beer history in this chapter as well.

## Black Mountain

The town of Black Mountain got its start as a railroad station. The tiny town grew up around the station, which was called Gray Eagle or Grey Eagle. Incorporated in 1893, Black Mountain is renowned as a haven for artists, mavericks and free spirits. The famed Black Mountain College, founded there in 1933, attracted some of the most creative and artistic thinkers of the twentieth century. Although the college closed in 1957, its influence

was far-reaching and imbued a level of worldly sophistication on this small mountain town.

I tell the tale of the town's first brewery, Pisgah Brewing, in chapter 4, as it was an early twenty-first-century pioneer. Several years after Pisgah opened its doors, the town welcomed a second brewery.

## Lookout Brewing Company

Lookout Brewing opened in the spring of 2013 in one of four units of a tiny strip shopping center in downtown Black Mountain. As of the spring of 2018, the brewery had expanded to fill all four units.

John Garcia, owner and self-described janitor, opened the tasting room with brews made on a half-barrel SabCo brewing system. He soon upgraded to a three-barrel and, as of 2018, upgraded again to a ten-barrel brew house.

John's parents, Rich and Patricia Jones, temporarily moved nearby to help with Lookout's original build-out. In a fun twist, they enjoyed the process so much that, after they left, they opened their own brewery: Good Hops Brewing, in Carolina Beach, North Carolina. John said he and his wife regularly collaborate with his parents on recipes, ideas and system improvements.

While John doesn't brew as much as he once did, he's still deeply involved in recipe production and the day-to-day brewing operations. Lookout currently employs two full-time brewers: Mike Fuller and Brian Corbin.

After a short stint with Skyland Distributing, John said the brewery is back to self-distribution, although in 2017, practically every ounce brewed was sold in-house.

"It's been nuts," he said. "Last year we were up just a tad under 30 percent. And it's not slowing down at all."

When asked why, he replied, "I think we're getting way better at brewing. Mike and Brian and I—we fight over stuff every day, but believe me, it's all about getting better. They are after it."

Once production increases, John plans to pick up around thirty retail accounts in the WNC area.

"We want to choose accounts that have the level of customer service and knowledge that we feel will represent us well. They know us, and we know them. We know their dog's name and their kid's name, and they have a relationship with us and an attachment to our product."

Lookout Brewing Company's logo resembles both a caution sign and a mountain wayfaring sign. *Courtesy of Lookout Brewing.*

While Lookout produces a variety of styles, the brewers focus on hoppy beers. Two of the brewery's recent New England–style IPAs, Mountain Hop Shine and Hoprès (a play on the French word *après*), sell out practically the moment they're tapped, per John.

He also plans to increase the brewery's sustainability over time. To that end, he works to source local ingredients, including some local hops, and only non-GMO products go into the brew kettle. John said the brewery eventually will expand to a thirty-barrel system before stopping growth to focus on environmental systems. However, his all-consuming passion remains quality.

"My number one goal is to go after making the absolute best possible beer you can drink. And I tell everyone that," he said. "That's why we experiment so much and do all the crazy adjustments we do. We're making our beer as badass as possible."

## Hickory Nut Gorge Brewery

Husband-and-wife team Marc and Merri Fretwell are the founders and owners of Hickory Nut Gorge Brewery in the village of Chimney Rock.

## A Mountain Brew History

Like McDowell and Madison, Rutherford County is dry except for the incorporated towns, such as Rutherfordton, Spindale, Lake Lure and Chimney Rock.

In 2011, the Fretwells moved to Lake Lure into the vacation home that has been in Merri's family since before she was born. They had been living in Texas, although Marc is English by birth and learned to brew from his father.

The couple purchased the building in the Hickory Nut Gorge on the Rocky Broad River in the summer of 2016 and opened a year later after extensive renovations. The taproom decks offer a breathtaking view of the Chimney Rock at Chimney Rock State Park. The rock has been a tourist destination since a stairway was built to its summit in 1885.

"We wanted to celebrate the feeling of the Gorge," Merri said. "It's a special, special place."

Hickory Nut Gap Brewery was the only brewery in Rutherford County when it opened in mid-2017. Today there are two, with Yellow Sun Brewing

Hickory Nut Gorge Brewery has decks on the Rocky Broad River with views of nearby Chimney Rock. *Courtesy of Hickory Nut Gorge Brewery.*

in Rutherfordton being the second. The first brewery in that town, Ruff'ton Brewhouse, didn't last long.

"We've had lots of support from the community in general, but it was hard with the town in terms of zoning issues," Merri said. "Rutherford is a dry county, so we have to be in a township to sell beer. And we're facing difficulties with wastewater. We want to expand, but it takes time to make changes."

The brewery has a one-barrel system that the brewer double-batch brews on practically every day. AB-Tech fermentation sciences graduate Matt Karg is the day-to-day brewer, as both Merri and Marc have kept their day jobs.

The brewery produced around 160 barrels in its first several months, all of which was sold onsite. This was despite storms that caused severe flooding in October 2017. Those damaged some of the brewery's decks and closed down the state park for weeks. However, the area has bounced back from that natural disaster, and Marc said expansion is in the plans.

"If my darling wife persuades the city to let us upgrade to the five-barrel system I'm looking at, we will be looking for accounts at local restaurants," Marc said.

Marc's background causes him to gravitate to English-style beers, but the brewery produces a range of styles. Hickory Nut Gorge offers two cask beers at all times, and per the Fretwells, beer lovers come from all over for those throwback brews.

"Our mission is to have a gathering place to celebrate what's unique here—the hiking, the quaintness of town and our uniquely malty beer," Merri said.

## Yellow Sun Brewing Company

One of WNC's newest brewery and pizzeria combinations, Yellow Sun Brewing Company, opened at the end of January 2018 in downtown Rutherfordton. Husband-and-wife team James and Kim Nichols had been home brewing since 2011, and according to Kim, it changed the course of their lives.

Kim's a native of the area, and James has lived there since high school.

"We love our little town, and there's a need here. There aren't a whole lot of restaurants and no other breweries," Kim said. "The town has been accommodating and supportive. There were no challenges to opening other than time and money."

Both attended Blue Ridge Community College's Institute of Brewing and Distilling (IBD) certification course for fun. James took the IBD exam and passed it. He's currently brewing on a three-barrel system that he and Kim assembled piecemeal over three years.

"I couldn't be any happier," James said. "The brewing is somewhat labor intensive, but that's where a lot of people start out."

The pizzeria has six taps, and Yellow Sun opened with three of its own beers and three local guest taps.

"The restaurant part may have been a temporary lapse in reasoning on our part, but we've noticed that when craft breweries don't offer food, people don't stay as long," Kim said.

James and Kim Nichols, owners and founders of Yellow Sun Brewing Company in Rutherfordton. *Courtesy of Yellow Sun Brewing.*

She added, "The county is big but very rural. The towns of Spindale and Forest City and Rutherfordton are all close together. They all welcomed us with open arms."

"Our first night open, we had hundreds of people show up. We were lucky to have friends and family step in to help us out. So many people have thanked us for being here," Kim said.

## Marion

McDowell's county seat, founded in 1844, was named for a man whose nickname was "Swamp Fox." Francis Marion was a Revolutionary War hero celebrated for his guerrilla fighting tactics. Like many small WNC towns, most newspaper mentions of beer, even going back 150 years, are of the liquid being consumed in other places. However, there are many articles about still busts of illicit liquor in McDowell throughout much of the twentieth century.

The county remains dry, and Marion only eased restrictions on on-premise beer sales in 2017, thus allowing the beverage to be sold outside of "private clubs." So, it seemed like a good time to open a brewery there.

## Mica Town Brewing Company

Husband-and-wife team Jason Snyder and Emily Causey opened Marion's first legal brewery, Mica Town Brewing, on New Year's Eve 2017.

They were looking for a place to live between where he worked in Spruce Pine and where she worked in Black Mountain when they found Marion. When they first moved there, Jason said opening a brewery was not part of their plan.

"We've been big brewery buffs for years and would target breweries to visit in the region," Jason said. "When we realized it was twenty-five miles to the nearest brewery from downtown Marion, we saw it as a business opportunity."

The longtime home brewer wants to bring tourists to the town, as the breweries in nearby Morganton have done.

"There's a lot of traffic that comes through here in the summer of folks coming for outdoor recreation as well as folks who own properties around Lake James and Linville Gorge," Jason said.

When the couple first contacted town employees about opening a brewery, they were met with support. After looking at numerous vacant buildings, the

The ribbon-cutting for Mica Town Brewing Company, Marion's first brewery, which opened on New Year's Eve 2017. *Photo by Kendra Penland.*

couple purchased a building just off Main Street that had stood empty for a couple of years. They spent most of 2017 renovating the two-story historic brick structure, adding a game room upstairs and an outdoor deck.

After installing a four-barrel brew house and four eight-barrel fermenters, they had already maxed out the available space when they opened, per Jason. Although local restaurant owners immediately approached them for kegs, the couple initially decided to sell their beer only from the brewery. They plan to explore distribution after they get a handle on the flow of the taproom.

The brewery's name is a play on Jason's former career with a mining company: "I'm a rock hound and mining buff. There's an old mica mine in McDowell County at Tom's Creek Falls as well as one in Spruce Pine."

North Carolina remains the nation's leading producer of mica, which is used in shingles, paint, plastics and other building materials. Spruce Pine's first and only brewery, Dry County Brewing Company, closed after eight years in business the same day that Mica Town opened.

Mica Town's taproom offers a variety of in-house styles, including a Grisette, a type of beer that was popular with Belgian laborers.

"Grisette can be a little bit of a tough sell here in Marion, but I wanted to bring in a beer that was made for miners," Jason said. "It's one of our lightest beers, and when people try it, they like it."

## Fonta Flora Brewery

Catawba Brewing Company gets lots of ink in chapter 3 as one of the region's pioneer breweries and the first to open outside of Asheville that's still rocking and rolling. Morganton's second brewery has an interesting story as well.

Fonta Flora may be a young brewery, but it has old roots. It was named for the lost farming village of Fonta Flora. That town now lies under the waters of Lake James, which Duke Power created in the early 1900s, damming the Catawba River to provide electricity to Burke County. Fonta Flora Brewery opened its doors in the fall of 2013.

Todd Boera, co-founder and head brewer, worked for Catawba for four years before leaving to start his own business. Fonta Flora quickly became popular as one of the first plow-to-pint breweries in WNC.

"Brewing sprang from agriculture," said Todd. "My mission is to take it back to its agricultural roots and, in the process, create unique and distinct North Carolina and Appalachian styles of beer."

Every Fonta Flora beer contains malts from Asheville's Riverbend Malt House. The brewers also create beer recipes using less traditional local ingredients, from beets and carrots to wild cherries and fennel. Todd and his team even forage, much like early WNC settlers did, to find ingredients to make the fermented beverages.

Todd tapped into the hyper-local zeitgeist in a way that other brewers continue to emulate. Fonta Flora hosts an annual festival, called State of Origin, and includes other breweries that offer regional fauna and flora in their brews.

"We're lucky to have a plethora of amazing local ingredients in this region that can be used in brewing," Todd said. "Ingredient sourcing is our number one priority. When we don't brew a beer with local ingredients, we try to be really transparent about that. But this style of brewing isn't for the faint of heart. It's a lot of painstaking work."

Fonta Flora's brews attract beer lovers in droves. "As we've gained popularity and attention from around the country and even from around the world, we've seen a blast of tourism. When we first started bottle releases, people would come and spend the night on our sidewalk to buy our beer. We had to learn from that and change how we did it," Todd said.

Fonta Flora Brewery and taproom in downtown Morganton. *Courtesy of Fonta Flora Brewery.*

Burke County named Fonta Flora one of the county's top tourist attractions of 2017. The brewery was second only to Linville Gorge in numbers of visitors that year.

"The state of craft beer is so wildly different from what anyone could have imagined it becoming. The idea that people will travel far and wide for craft beer is mind-blowing," Todd said. "When we started Fonta Flora, our initial plan was to be a quaint community watering hole."

He continued:

> *Then it's slowly morphed. It certainly is a local watering hole, but the beer tourism is almost a double-edged sword. We have a reputation around Morganton of being less inviting because we get so many visitors now. It took off in a direction we didn't foresee at all. But to be the second most visited thing next to Gorge is pretty cool.*

Until recently, the only way to get a sip of a Fonta Flora beer was to visit the Morganton brewery and taproom. That has changed, however.

In 2017, Fonta Flora purchased a former dairy farm in the town of Nebo, about twenty miles east of Morganton. The addition of a fifteen-barrel brew house at Whippoorwill Farm has quadrupled production capacity. Todd brewed his first batch at Whipporwill on Christmas Eve 2017.

More beer means the brewery now self-distributes in North Carolina, from Asheville to Raleigh. The additional space also allows Fonta Flora to package more bottles, including saisons and mixed-culture beers, plus canned brews via mobile canning.

"I want to be selective about where our product is going," Todd said. "But now we're looking to distribute in Georgia. My mindset has changed. We're making all these hyper-local beers with North Carolina ingredients, and I initially thought we should stay in North Carolina, but I've realized that I want to share these beers."

It took the brewery's ownership more than two years to acquire the farm property, which will include a public tasting room by the end of 2018. Additionally, the Foothills Nature Conservancy of Morganton purchased a portion of the available acreage and is working with Fonta Flora to put most of the land under conservation.

"It's becoming more common to hear of breweries opening up on farms. Until recently there were only a handful, but it's always been a dream of mine," Todd said. "We are all insanely in love with the property we acquired. We were all losing sleep over the process. There

were so many ups and downs. I'm lucky to have out-of-the-box business partners."

The other Fonta Flora owners are Morganton natives and brothers Mark and David Bennett and a college friend of theirs, Michael Kren.

"For them, investing in us is a unique way to enhance the community where they are from and where they are raising their families," Todd said.

## Gone but Not Forgotten

Brewing is hard, physical labor that requires planning, attention to detail and focus. You can't just walk away if you're in the middle of a boil or a transfer to fermentation tanks, even if it's the end of the day and all you want to do is sit down and enjoy a pint of what you've been making.

Sometimes folks get into the business without understanding the scale of what they are undertaking. Ramping up from a home brew system to even a three-barrel can be challenging in terms of maintaining quality and consistency.

It can be difficult to start a successful brewery these days, even in a beer-rich region like this one. Brewing equipment is expensive, and given the increased competition, breweries must make good, clean beer from day one. Customers are better educated now. Many can identify and won't stand for off-flavors. Also, there's often another brewery or breweries nearby, and brand loyalty has become a rare bird.

As someone who has been writing about small businesses, or as they are often called these days, startups, on and off for thirty years, I can say that success often comes down to planning, sufficient capital, a quality product and a little luck. Sometimes, you can have all of these and still not make it.

In 2017, 165 U.S. craft breweries closed, per the Brewers Association. While that's only a bit more than 2 percent of the breweries in operation, it's an increase of 70 percent from 2016.

"Look at the first wave of legacy breweries," said Tony Kiss, longtime industry reporter. "They got in on the game when there weren't a lot of guarantees, but there also wasn't much competition."

Additionally, some folks start off successfully, but they are stymied by the same challenges that many small businesses face, from rising rents to equipment failures to plain old exhaustion.

## A Mountain Brew History

Here's a list of the WNC breweries that have closed or sold, in order of closing. The year 2017 saw lots of change in the industry here. I discuss the breweries that sold all or a piece of the action to big beer or private equity in the "What Is a Craft Brewer?" section in chapter 3.

- WNC's first breweries, Boone's Cottonwood Brewery and Haywood County's Smoky Mountain Brewery, closed within a couple years of starting brewing operations. Cottonwood moved locations and brought in new partners, per its former brewer, and those decisions ultimately weren't right for the funky brewpub. Per Rich Prochaska, co-founder of Smoky Mountain, running a brewery was fun but, ultimately, too much hard work.
- Asheville's Craggie Brewing Company closed in 2012 and sold its assets and space to Hi-Wire Brewing. A press release from co-owner Bill Drew cited a lack of profitability in the face of limited funds.
- Altamont Brewing in West Asheville closed in 2016 and sold its assets and building to John Cochran, who started UpCountry Brewing there. Altamont owner Gordon Kear did not disclose his reasons for selling.
- Ruff'ton Brewhouse was Rutherfordton's first brewery. It closed in 2016 after several months in business, possibly because of landlord issues.
- Winding Creek Brewing Company was the first brewery to open in both the town of Columbus and Polk County in 2016. The brewery lasted about a year and a half. Brothers Ken and Les Potter were co-owners. Reasons for closing were not disclosed.
- Sylva's Heinzelmännchen Brewery was the first brewery to open in Sylva and, in fact, the first twentieth-century brewery to open in the westernmost region of North Carolina. Founded by married couple Dieter Kuhn and Sheryl Rudd, the brewery had a great run from 2004 to 2017. In 2018, Dieter became head brewer at Cashier's first brewery, Whiteside Brewing and, per owner Bob Dews, is having a blast focusing on brewing and not having to run a business as well.
- Waynesville's Tipping Point Tavern & Brewery closed in 2017, as owner Jon Bowman said he wanted out of the restaurant

side of the business. Jon moved to Brevard and started Peaks & Creeks Brewing there.
- Howard Brewing was Lenoir's first brewery. It closed in 2017 for unknown reasons.
- Hendersonville's second brewery, Basic Brewery, shut down after a year and a half in 2017. Per a letter left on the front door, the owners cited the challenge of owner Rich Wegner's daily commute from Greenville, South Carolina, and a family health issue.
- Hendersonville's Black Star Line Brewing Company opened as the first black, queer-owned brewery in WNC. Its mission was inclusion and diversity in the brewing industry. The brewery, which opened in Basic Brewery's former space, lasted for only a few months. Highly publicized racist threats and property vandalism sent the owners into a tailspin, said founder LA McCrae. She told me it might have been the wrong location and the wrong time for a number of reasons, including a lack of sufficient funding. "I wish we would have stayed focused on making great beer, because, sadly, a lot of people couldn't handle our social mission," she said.
- The founder of Flat Top Brewing in Banner Elk sold the business in 2017. New owners Mark and Yumiko Ralston changed the name to Flat Top Mountain Brewing
- Sneak E Squirrel Brewing of Sylva offered small-batch beers and pub food for two years. The owner cited health concerns as a reason for closing in 2017.
- Dry County Brewing Company, a nano-brewery inside a pizzeria in Spruce Pine, closed at the end of 2017 after more than eight years of brewing, for undisclosed reasons. Renowned Spruce Pine restaurant Knife & Fork closed soon after. In a Facebook post, owner and chef Nate Allen said closing the restaurant was a financial decision—it likely was the same for Dry County.
- Ben's Tune-Up in Asheville is one of the country's first craft sake brewers and, in 2018, was North Carolina's only sake producer. For about a year, head brewer Michelle Acheson-MacLeod and her team also brewed and sold small batches of craft beer on site. She said that craft sake is more unique than beer (especially on the South Slope, where there are nine

breweries, at present). Sake also offers a higher profit margin, so Ben's decided to forsake brewing beer in order to focus on expanding sake production.

Other WNC breweries that have changed ownership but retained the existing brand include Asheville's Green Man Brewery (2010) and French Broad Brewery (2017).

# 8
# HIGH COUNTRY BREWERIES

**N**orth Carolina's High Country runs northeast from Asheville into the highest mountains east of the Rockies and includes the towns of Boone, Blowing Rock, Banner Elk, West Jefferson and Sparta.

I've also added Burnsville to this chapter. That town, which is about halfway between Asheville and Boone, typically might not be included as part of the High Country, although it's nestled in the shadow of Mount Mitchell, the highest peak in the Appalachians. So, Burnsville is pretty damn high.

The counties of Yancey, Mitchell and Avery are among the least populated in North Carolina, with fewer than twenty thousand people in each. The breweries that have opened in these towns—and, in a few cases, closed there—are bold to do so.

Let's start with Burnsville, established in 1834, the seat of Yancey County.

## HOMEPLACE BEER COMPANY

It made lots of sense for John Silver to open the first brewery in Burnsville and Yancey County. After all, he grew up there and is descended from generations of WNC folk on both sides. He's even related to one of the most infamous local Silvers: Charles Silver, who was axe-murdered by his wife, Frankie Silver. Frankie was hanged in Morganton in 1833, and the gruesome

story has threaded itself into the history and literature of WNC. The story goes that she was abused and fought back but paid with her life. John brews a beer named for her: Frankie Amber.

Yancey County remains dry, and Burnsville didn't vote in alcohol sales until 2010. The widening of U.S. Highway 19 into a four-lane, which finally reached the town in 2017, made having a brewery there feasible.

John is brewer, marketing and programming coordinator, janitor and occasional bartender at Homeplace Beer Company, which opened in June 2017. He co-owns the business with his wife, Emily Silver, who also spends a good bit of time there, along with the couple's two young children.

Homeplace is just off Burnsville's town square, behind the town's grand dame, the Nu Wray Inn, built in 1833, a year before Burnsville itself was incorporated. The National Historic site is still a working bed-and-breakfast.

"We've been welcomed, for the most part," John said. "It doesn't hurt that I'm from here. Some people who might otherwise be nervous about going to a brewery have come by to congratulate us because they know my family."

One of WNC's most experienced brewers, John started out washing kegs at Pisgah Brewing in Black Mountain before taking a brewing position at Catawba Brewing in Morganton. He went back to Pisgah for a stint, then on to Asheville's French Broad Brewery, Brevard's Oskar Blues Brewery and, finally, to Asheville's Hi-Wire Brewery. I jokingly call him the Kevin Bacon of WNC beer, as, at one time or another, he's worked with or is only one degree removed from pretty much everyone in the beer business here.

Understandably, after ten years of working for other breweries and gaining a huge amount of knowledge in the process, John was ready to start his own brewery. He said he has remained on good terms with everyone he's worked with and, in particular, gives another native of the area, Scott Pyatt of Catawba, huge props for teaching him when he first started out.

John brews on a five-barrel system and focuses on traditional beer styles, while working to include a local ingredient, from Yancey County, in each beer whenever possible. He prefers sessionable, plow-to-pint beers, and many of those he brews come in at 5 percent or lower ABV. John self-distributes draft to a few accounts throughout the region, including Asheville. He plans to add a canning line, although he said that's mostly so his customers can purchase to-go beer from the taproom.

"We named the brewery Homeplace because that's an important word here, an old-fashioned but meaningful word, and we want our brewery to have the feeling of a home place," John said.

Decorations in the taproom include photos from John's family past and home items that are decades old. He said people bring him stuff they've had stashed in their attics or barns, including an ancient kitchen range. The brewery's logo, a woodstove with a blazing hearth, also feels, well, homey, as does the slogan: "Don't be a stranger."

## Flat Top Mountain Brewery

Banner Elk's first brewery, Flat Top Brewery, opened in 2013. Founder Nathan Paris sold the business to Mark and Yumiko Ralston in 2017. The Ralstons' company name is Banner Elk Brewing Company, and while they added "Mountain" into the brewery name, they haven't yet decided whether or not to completely change it from Flat Top Mountain to Banner Elk Brewing.

Mark retired from the corporate side of the automotive industry in Detroit, and the longtime home brewer decided to follow his dream.

"We decided to purchase a brewery because there would be less time involved in setting it up. I wanted to take an existing brewery and make it great again," he said.

He found Flat Top Mountain Brewing for sale online. He and his wife had visited Banner Elk before for family vacations.

"Then I tested the water here, and it's the greatest water ever. It's so soft and the mineral content is almost nil, and it just comes out of the ground that way. That makes it so nice for brewing," Mark said.

That and the beauty of the area prompted the couple to purchase the brewery. First off, they rebranded and redesigned all the beers. The current recipes are ones that Mark has been developing for years. He said he enjoys creating traditional beer styles, and his approachable Tropical IPA is popular.

"Banner Elk includes lots of second home owners. We've received lots of positive feedback and compliments on beer. Our focus is on quality beer and a family-friendly taproom," Mark said.

In his first year of ownership, Mark significantly upgraded the brewery, purchasing a canning line and a keg washer and adding automated controls to the twenty-barrel brew house.

He noted that the seasonal aspect of this area can be challenging. Banner Elk is known as the South's ski capital for its proximity to Sugar Mountain, Beech Mountain and Hawk's Nest ski resorts. It's also the

The annual Beer City Festival in downtown Asheville showcases WNC breweries. *Photo by Anne Fitten Glenn.*

Nonprofit Asheville on Bikes works with regional breweries to advocate for biking and walking culture. *Photo by Marc Hunt.*

The 2017 solar eclipse caught over Whistle Hop Brewing's caboose taproom in Fairview. *Photo by Kevin Dobo.*

Siblings Kelsie and Ben Baker are co-owners of Waynesville's Boojum Brewing. *Photo by their mom.*

Hi-Wire Brewing and the Asheville Brewers Alliance sponsor Asheville City Soccer Club's amateur soccer teams. *Photo by Derek Allen.*

Blue Ghost Brewing co-founders Zach Horn (*left*) and Erik Weber at their small batch brewery in Fletcher. *Photo by Erin Adams Photography.*

Beer Can Man is a regular passenger on LaZoom's BYOB comedy tours of Asheville. *Photo by Anne Fitten Glenn.*

*Above*: Burial Beer's mural of Sloth and Tom Selleck is one of the most photographed sites in WNC. *Photo by Andrew May.*

*Right*: Ginger's Revenge Craft Brewery founders David Ackley and Cristina Hall got married in their new tasting room soon after it opened. *Photo by Alex Moody.*

A brewers' panel at the 2017 Asheville Beer Expo. *Left to right*: Burial Beer head brewer Tim Gormley, Green Man head brewer John Stuart and Asheville Brewing lead brewer Brandon Mountain. *Photo by Dan Peschio.*

John Silver, founder and owner of Homeplace Beer Company, Burnsville's first brewery. *Courtesy of Homeplace Beer.*

Michael Rayburn and his son, Elijah, on their family farm in Barnardsville, where they grow crops specifically for WNC breweries. *Courtesy of Rayburn Farm.*

*Above*: New Belgium Brewing Company's expansion brewery on the French Broad River in Asheville. *Courtesy of New Belgium Brewing.*

*Right*: John Davis owns and operates Sticky Indian Hops Farm in Candler with his son and grandson. *Photo by Erin Adams Photography.*

*Left*: Mobile canning operations enable breweries to try canning before committing capital to new equipment. *Photo by Erin Adams Photography.*

*Below*: Family owners Leah Wong Ashburn and Oscar Wong with Highland Brewing's rebrand, which rolled out in early 2018. *Courtesy of Highland Brewing.*

Cute pup in a taproom, because everyone wants to drink a fresh craft beer with their best friend. *Photo by Erin Adams Photography.*

Huge grain silo outside of Oskar Blues Brewery in Brevard. *Courtesy of Oskar Blues Brewery.*

Wedge Brewing's second location in Asheville's River Arts District. *Photo by Anne Fitten Glenn.*

The crew at Boone's Lost Province Brewing celebrates the release of Hula Girl Coconut Porter. *Left to right*: Joey Edmison, Andy Mason and Anderson Marx. *Courtesy of Lost Province Brewing.*

Asheville Beer Expo attendees tasting WNC crafted beers. *Photo by Dan Peschio.*

*Right*: Eda Rhyne Distillery owners shelling black walnuts for Rustic Nocino, a liqueur. *Left to right*: Pierce Harmon, Chris Bower, Andy Berthone and Rett Murphy. *Photo by Erin Adams Photography.*

*Below*: Malted grains ready for milling and mashing. *Photo by Bren Photography.*

Bryson City's Mountain Layers Brewing Company offers lots of outside options for beer drinking. *Courtesy of Mountain Layers Brewing.*

Billy Pyatt, co-owner and co-founder of Catawba Brewing Company of Morganton, Asheville and Charlotte. *Photo by Erin Adams Photography.*

Willie Watson, formerly of Old Crow Medicine Show, performing on the inside stage at Pisgah Brewing in Black Mountain. *Photo by David Simchock.*

Asheville Brewing Company brewers Pete Langheinrich and Doug Riley. *Photo by Bren Photography.*

Ecusta Brewing Company's taproom at the foot of Pisgah Forest. *Photo by Kenneth Voltz.*

Tim Weber, owner and head brewer of Asheville's Twin Leaf Brewery. *Courtesy of Twin Leaf Brewery.*

Sierra Nevada Brewing Company's expansion brewery in Mills River. *Courtesy of Sierra Nevada Brewing.*

Beers brewed with locally sourced ingredients, such as this heirloom corn, are popping up at breweries throughout WNC. *Photo by Erin Adams Photography.*

Flat Top Mountain Brewery's welcoming taproom in Banner Elk includes canned beer to go. *Courtesy of Flat Top Mountain Brewery.*

Christmas tree capital of the world, as much of the land surrounding the town is dotted with Fraser fir farms. However, the year-round population of the town is less than 1,200 people.

Flat Top Mountain self-distributes beer to accounts throughout WNC as far as West Jefferson, but Mark said he's researching wholesalers.

## Blind Squirrel Brewery

Blind Squirrel Brewery opened in 2012 in tiny Plumtree on the Toe River, about a thirty-minute drive from Banner Elk. Founded by Cleve and Robin Young, it was Avery County's first brewery. Unincorporated parts of the county remain dry. The establishment offers onsite accommodations, including a campground and cabins and a disc golf course alongside the river. Blind Squirrel opened a taproom outpost in Burnsville but closed it in 2017 after a couple of years.

When I tried to learn more, I found Blind Squirrel had closed down its website, and when I reached out, a representative replied: "Due to the

unsurety as to the direction of our business, we are not talking to media until further notice." However, per the brewery's Facebook page, Blind Squirrel is now open seasonally on weekends from Memorial Day to Labor Day. The brewery features small batch-brews and rotating food trucks. Former owner/head brewer Will Young has moved to the head brewer position at Beech Mountain Brewing.

## Blowing Rock

The end of the Civil War ushered in the birth of the resort industry throughout WNC. Per numerous accounts, local citizens, especially in picturesque towns such as Blowing Rock, began renting out rooms in their homes in the 1870s. Almost a century and a half later, the advent of Airbnb has reinvigorated this practice. Boardinghouses began to emerge soon after, followed by hotels and inns. Several major resort hotels sprang up in the High Country in the 1880s and '90s, including the Watauga and Blowing Rock Hotels in Blowing Rock, Grandfather Hotel at the base of Grandfather Mountain and Blackburn Hotel in Boone.

Blowing Rock was incorporated in 1889, and once the town received its charter, alcohol was sold within town limits. Thornton Ingle opened the town's first saloon a year later. However, the Skyland Institute, a private school, prohibited the sale of alcohol within a two-mile radius of the school grounds, which basically included the entire town at the time, and this sparked debate among the citizenry. Many locals felt that alcohol sales were an important tourist draw. However, the sale of alcohol was an issue until Prohibition, with the town being wet or dry depending on who was mayor. One mayor went so far as to disincorporate the town for a few years in the 1890s and, as the county was dry at that time, disallowed alcohol sales.

However, after Prohibition, the Town of Blowing Rock approved beer and wine sales earlier than most other WNC towns outside of Asheville, in 1965. It would be twenty-one years before nearby Boone would do the same.

P.B. Scott's, a music venue, opened in Blowing Rock in 1976 and benefited from the fact that Boone was dry. Blowing Rock was a regular party destination for Boone-based Appalachian State University students for many years. Scott's brought in famous live music acts, including REM, Bonnie Raitt and B.B. King. However, in the early '80s, P.B. Scott's and four other Blowing Rock establishments had their sales licenses revoked because

of the state's "51 Percent Rule." This rule required that half of sales at businesses selling alcohol be from food. Scott's stayed open for a while as a food-only establishment but closed in 1983.

After a couple of decades of being a party destination, Blowing Rock reverted to being a quaint, quiet town, populated in great part by second home owners.

## Blowing Rock Brewing Company

Jeff Walker and Todd Rice co-founded Blowing Rock Brewing in 2008. Initially, the business partners formed Boone Brewing Company, which they still own in name.

When they formed the business, Boone was not interested in having a brewery, per the owners. "When we talked to the Town of Blowing Rock, they welcomed us with open arms," said Ryan Parks, Blowing Rock Brewing sales and marketing manager.

The business partners started by contract brewing their beers out of state in 2008, but that lasted only a few years. Then they opened the Blowing Rock Ale House & Inn, a brewery with accommodations.

"The concept has proven to be a success. People love to stay here, and it really lets people experience everything that Blowing Rock has to offer," Ryan said.

Jeff and Todd also own American Honor Ale House in Hickory, which has a thirty-barrel brew house. They started brewing Blowing Rock beers there in 2014 and opened the taproom and restaurant a year later.

The Blowing Rock location remains a boutique, small-batch brewery.

"Our ownership feels that it's best for us to provide beer for our little community here," Ryan said. "The biggest bonus is that we are at the headwaters of the Elk River. Our water quality is insanely good. We start with great water and add great grain and great hop profiles. We use the purest ingredients possible. Our backyard is the best of the best when it comes to living the high country lifestyle."

Ryan added: "There has been serious beer turmoil in the high country. AMB [Appalachian Mountain Brewing] wanted to be in downtown Boone, but politics kept them on the outskirts. They were interested in the Lost Province space, and it created political turmoil when that opened because the owner is on the town council."

Blowing Rock Brewing Company offers a combination small-batch brewery, taproom and inn. *Courtesy of Blowing Rock Brewing.*

Blowing Rock's beers are canned at the brewery's canning line in Hickory and distributed statewide in North and South Carolina.

"We source our cans from a North Carolina aluminum distributor. We label our own beers. And our labels are produced locally," Ryan said.

The brewery also sources local ingredients, from regionally grown cucumbers to heirloom pumpkins and juniper berries. Cattle munch on the spent grain in Lenoir, about halfway between the two breweries. And those cows, in turn, feed hungry diners at the two restaurants.

"The fact that we're a growing brand is important to me. We have close to seventy staff now. The impact of a North Carolina brewery in a community can be real," Ryan said. "That's a big takeaway that a small brand can grow and have real impact on the community."

A Mountain Brew History

# Boone

Boone, the county seat of Watauga County, was carved out of several other WNC counties in 1848. The town is named, of course, for iconic pioneer and explorer Daniel Boone, who lived in the Yadkin River Valley on and off in the 1750s and '60s. The town of Boone is home to Appalachian State University (ASU), which is part of the public University of North Carolina system and enrolled around nineteen thousand students in 2018. ASU almost doubles the year-round population of the town, which was just under twenty thousand in 2017.

The railroad didn't make it to Boone until 1919, and it would last only twenty-one years there. At the welcoming ceremony for the East Tennessee and Western North Carolina Railroad, Banner Elk mayor J.H. Shull famously said, "I remember when the only way a person could get to Boone was to be born there." In 1940, storms blowing up from a Gulf coast hurricane ravaged many rails and bridges in the area, and they were never repaired. The first paved access road into Boone was completed in 1925, and a good portion of Watauga County didn't get electricity until the 1960s. Thus, growth has been slow to find Boone, despite the presence of the university.

Boone's Tumbleweed Grille, which would later become Cottonwood Brewery, opened in Boone in 1992 and closed a few years later (chapter 3).

Currently, there are three breweries in Boone proper: Appalachian Mountain Brewery, Lost Province Brewing Company and Booneshine Brewing Company. Nearby is Beech Mountain Brewing Company, one of the few U.S. breweries owned by a ski resort.

# Appalachian Mountain Brewery

Cousins Chris Zieber and Nathan Kelischek both grew up in Asheville, where they attended T.C. Roberson High and Asheville High, respectively. Chris then attended the University of North Carolina in Chapel Hill, and Nathan headed to ASU. Both independently became avid home brewers.

After college, Chris was traveling overseas and Nathan was bartending at Mellow Mushroom pizzeria in Boone. There, Nathan met Sean and Stephanie Spiegelman, who were interested in investing in a brewery. Chris was in Mallorca when Nathan called and told him to get his butt back to WNC to help him start a brewery.

That brewery became Appalachian Mountain Brewery (AMB) and incorporated a decade after Cottonwood, Boone's first brewery, closed. In 2011, there was no local ordinance for a brewery to exist in the town. Some folks were not happy about a new brewery opening there, Chris said. Even so, after a year and a half of construction and permit applications, the brewery opened in early 2013.

"We had a fantastic reception immediately," Chris said. "Our customers are around one-third students, one-third tourists, and the rest are locals."

AMB's core tenets are sustainability, community and philanthropy, and keeping those at the forefront has helped the brewery gain acceptance. Additionally, the co-owners started a nonprofit whose mission includes the revitalization of communities, mountains and rivers. Among other events, the brewery holds the annual Daniel Boone Rail Jam every winter. It's a family-friendly skiing and snowboarding competition and fundraiser for which the brewery trucks in a huge block of ice and snowmaking equipment.

"We promised we would give back to the town, and we are," Chris said. "We gave them a check that they used to add solar LED lights throughout

Appalachian Mountain Brewery is a popular hangout for Appalachian State University faculty and students (of age, of course). *Courtesy of Appalachian Mountain Brewery.*

the amphitheater where we hold Rail Jam. We also paid to put in Wi-Fi for the entire park permanently, which also is where the Watauga County Farmer's Market is."

The brewery partners with the Craft Brew Alliance (CBA), which gives them access to AB-InBev's distributor network as well as the ability to brew batches at the AB brewery in Portsmouth, New Hampshire. AB has an undisclosed, minority stake in the brewery.

The partnership came about when Appalachian Mountain Brewery was invited, at the last minute, to participate in a new brewery startup challenge organized by Brewbound, a craft beer industry news and events business. Sean drove all night to Boston, but when he arrived, he learned it was Harvard commencement weekend and there wasn't a hotel room to be had for miles. After sleeping in his car, he presented at the Brewbound event and, despite his sleep deprivation, won the challenge. The prize was to brew with Widmer Brothers Brewery in Portland, Oregon, which is majority-owned by CBA. After talking to the Widmer team about their experiences with the Alliance, the AMB co-owners realized that a partnership would be helpful, especially from a distribution standpoint.

In 2017, the brewery produced three thousand barrels in Boone and another seven thousand barrels in Portsmouth. Both Chris and Nathan, who share head brewing duties, regularly fly to AB's New Hampshire facility to oversee what's basically contract brewing. Chris compared it to Green Man Brewery's deal with Florida-based Brew Hub. Brew Hub only contract brews, offering small, established breweries the ability to brew, package and distribute in new markets without having to lock in wholesale agreements or state licenses.

All of the draft beer at the Boone taproom is brewed onsite on a ten-barrel system, while the bulk of the canned beer is brewed up north. Currently, AMB only distributes in North Carolina, but Chris said they hope to add a few states at some point.

AMB also is a publicly traded company, a rarity for a craft brewery. The Spiegelmans own the controlling stock, but anyone can purchase a piece of the company, and apparently, a number of beer drinkers have done so.

In 2015, the brewery added a cidery and, a couple years later, started distributing canned ciders. It's been a game changer, Chris said.

In 2017, the brewery won a gold medal at Great American Beer Festival for Boone Creek Blonde Ale.

While he was a student, Nathan brewed for Ivory Tower Education Brewery, a nonprofit organization that grew out of ASU's fermentation

program. Now, Ivory Tower partners with both AMB and Booneshine Brewing to brew and package beers. Proceeds from sales then go to brewing education and research at the university.

## Lost Province Brewing Company

Boone's Lost Province Brewing Company takes its name from when the three counties of Watauga, Ashe and Allegheny were referred to as the "Lost Provinces." The natural barrier of the Eastern Continental Divide isolated this area of the High Country in the nineteenth and early twentieth centuries, making it feel "lost."

The gastro-pub and brewery, co-owned by husband and wife Andy and Lynne Mason, opened in August 2014. The couple's two sons also work for the business.

"I was looking for a name that celebrated the history of the area, and when I read about the Lost Province, I knew that was it," Andy said.

Andy, who has a background in chemistry, started home brewing in 1989. In 1995, the Masons moved to Boone, and Lynne has served on the town council since 2001. The couple's passions for good beer, good food and community growth made opening a brewery and restaurant a no-brainer.

"Downtowns are the heart of a community. It's great to see the revitalization of downtowns," Lynne said. She added that it's been a challenge for Boone to make its downtown a hub for tourism.

"Appalachian Mountain Brewery came into a situation where the town hadn't foreseen breweries as an opportunity. They led the way by helping update ordinances and showing the town that craft breweries could be an important part of economic development," Andy said.

The building that the Masons renovated, just behind King Street's Mast General Store, was built in the late 1930s and housed, at various times, a Chevy dealership, a tire store and the offices of the *High Country Press* newspaper.

Having both a restaurant and a brewery helps when looking to source ingredients from local providers. The "from scratch" restaurant, based on seasonal fare, bakes all its breads and purchases whole animals. It turns out not only do cows like spent brewing grain, but ducks do as well. Lost Province gives a local duck farmer spent grain and then purchases those grain-fattened ducks to become menu specials.

## A Mountain Brew History

Lost Province produced around nine hundred barrels in 2017. New equipment in 2018 will increase production to two thousand barrels. The brewery self-distributes to around one hundred accounts within a two-hour drive of Boone. However, the owners are looking into distributing farther afield at some point. The brewery has packaged a few special brews in 750-milliliter bottles.

For Lost Province's 200th brew, the brewers invited Kinney Baughman, former Cottonwood Brewery brewer, to brew Black Bear Stout, a beloved Cottonwood beer back in the day. Andy said his first commercial brewing experience came from helping Don Richardson brew at Cottonwood.

Andy and Lynne said they offer a broad range of beer styles at Lost Province. One of those, Kiss My Grits Southern-Style Lager, is made with North Carolina's Lindley Mills organic grits.

"It requires hours of simmering, and it's truly a gateway beer for non-craft beer drinkers," Andy said. "I joke that we wave a hop cone over the beer kettle and then throw it away."

He added, "We want to increasingly make this area a beer destination. More breweries mean more business for everyone."

## Booneshine Brewing Company

Founded by Carson Coatney and Tim Herdklotz in early 2015, Booneshine Brewing started by partnering with a restaurant interested in having fresh craft beer onsite. So Tim started brewing next to Basil's Pasta and Deli in a shopping center just outside of downtown Boone, and the restaurant basically served as the brewery taproom. However, Booneshine is expanding into a new, larger building with its own taproom and restaurant.

Carson is a local entrepreneur who owns Boone businesses Melanie's Food Fantasy and Stick Boy Bread Company. Tim is a former ASU student and worked in the electronic payments business for twenty years, but he always wanted to start a brewery.

"When I was an App State student, I remember going to Tumbleweed, and I thought it was so cool that they were making beer here," Tim said.

"We started talking about opening a brewery back before Appalachian Mountain opened. We're both longtime home brewers and passionate about craft beer," he added.

Carson Coatney and Tim Herdklotz are the owners of Booneshine Brewing Company in Boone. *Courtesy of Booneshine Brewing.*

He brews on a ten-barrel brew house, which will move to the new location, where they will add fermentation tanks.

"We're focused on doing fewer things better rather than doing too much," Tim said. "We've been calculated about our growth plans. We're not trying to take over the world."

Booneshine self-distributes to around ninety bars and restaurants around the High Country. Part of the reason for expansion, said Tim, is that Booneshine hit capacity in 2017 and has a waiting list of regional watering holes asking for its beer.

## Beech Mountain Brewing Company

Beech Mountain Brewing Company, owned and operated by Beech Mountain Ski Resort, opened in 2014. The resort's general manager, Ryan Costin, was the visionary behind the brewery, which is in the village at the base of the ski mountain.

"We are always looking for new and unique experiences for our guests," said Talia Freeman, the resort's director of marketing. "These days,

# A Mountain Brew History

Beech Mountain Brewing Company is one of only a handful of breweries owned and operated by a ski resort. *Courtesy of Beech Mountain Brewing.*

everyone's hometown seems to have a brewery, so guests are excited to try our local flare. It really adds to the skiing experience and has helped us shape a fun culture around the resort. I would say resort-owned breweries are far and few between."

At just over 5,500 feet of elevation, Beech Mountain claims to be the highest incorporated town east of the Rocky Mountains. The town has fewer than 400 year-round residents, although the resort attracts around 130,000 visitors annually. The inaugural ski season was 1967–68, although there are reports of people skiing Beech Mountain, especially students from nearby Lees-McRae College, as far back as the 1930s. The town wasn't actually a town until it was incorporated in 1981.

While most folks visit in the winter, the resort offers mountain biking trails, a disc golf course and other activities when there's no snow.

The brewery started as a nano-brewery but expanded to a seven-barrel system in 2018, which more than doubled capacity. While all beer has been sold from the resort's four bars and restaurants, Talia said offsite sales might be in the brewery's future.

"We have guests from all parts of the United States and the world come through our door, and they all know beer and appreciate our beer. That makes us feel good, knowing we've been able to reach the masses without actually leaving the mountain," Talia said.

That said, the location and elevation of the brewery can prove challenging at times.

"There might be a time or two that a grain delivery will be delayed due to weather, but we always take that into consideration prior to ordering," Talia said. "Also, sometimes it can be a bit challenging to effectively advertise to our consumer. People think they have to ski to visit the brewery, but they don't."

## East Western North Carolina

Ashe, Alleghany and Wilkes Counties round out the far northeast corner of WNC. Ashe's county seat of West Jefferson is home to Boondocks Brewing, while Alleghany's county seat of Sparta now has its first brewery, Laconia Ale Works, sister to Madison County's Mad Co. Brewing. Wilkes, formerly known as one of the top moonshine regions of the country, remains brewery-free. Lansing's New River Brewing will move to West Jefferson in 2018.

However, the town of Elkin, which straddles the Wilkes and Surry County line, has two small breweries, Skull Camp Brewing and Angry Troll Brewing. Both breweries fall on the Surry County side, and because I had to stop somewhere, they are not included in this volume.

Mitchell County's first brewery, Dry County Brewing in Spruce Pine, ceased brewing operations in late 2017.

Below Watauga County is Caldwell County, home to Loe's Brewing Company of Lenoir. Howard Brewing Company was Lenoir's first brewery, but it closed after a few years in business. Again, I had to stop somewhere on the road to Hickory, so even though Lenoir is on my WNC map, I didn't profile Loe's.

## Boondocks Brewing

Boondocks Brewing, which opened in 2012, was and still is the first brewery in West Jefferson and Ashe County. It started with a downtown taproom and restaurant and then added a second location, the nearby Brew Haus, home to the brewing operations and a venue space.

"This brewery was really about helping downtown West Jefferson revitalize itself," said Gary Brown, founder and head brewer. "I wanted to give people a reason to come into town and bring the town into the modern age a little bit. This area was ready for what we had to offer."

Around 2010, Gary, a longtime home brewer, started hanging out at Fraser's Restaurant and Pub, one of the only beer bars in West Jefferson, near where he and his wife had a vacation home. Within a couple of years, he was in negotiations to purchase Fraser's, which he then "gently transformed," over a period of several months, into the brewery and restaurant he'd dreamed of owning.

# A Mountain Brew History

Gary Brown, owner and founder of Boondocks Brewing, West Jefferson's first brewery. *Photo by Pixels on Paper Photography.*

Boondocks employs between forty and sixty staff year-round, which Gary said makes it the seventeenth-largest employer in Ashe County.

Boondocks doesn't distribute. "We're purely a destination brewery. Our goal is to bring people into the brewery and the town," he said.

Gary opened the second location in 2015 because he was getting lots of requests for private events. He also needed more space, other than the tiny area just inside the restaurant door where he brewed on a nano-system. So he upgraded to a three-barrel and moved all brewing operations to the Brew Haus. By the summer of 2016, he was able to upgrade to a five-barrel.

"I don't subscribe to closing down or closing part of the brewery when we have regulars who might come in," Gary said. "Ashe County didn't have a nice events facility. Now they do. We have weddings and events booked well into 2019."

Gary said between his strong wintertime local client base and the fact that the town population increases by 50 percent in the summer, he's never bored.

"The one thing that we stress to our staff and everyone who comes in is our craft is our passion," he said. "We're passionate about everything we do, whether it's food or beer or customer service, and we've got a team that's kicking butt."

# 9
# SOUTH BY SOUTHWEST MOUNTAIN BREWERIES

**S**outh of Asheville is Hendersonville, currently home to three breweries, although there may be five by the end of 2018. From there, you can meander west through Etowah to Brevard, then southwest to Cashiers and Highlands. Farther west is Franklin, seat of Macon County. All of these towns are now brewery towns.

Hendersonville has, for numerous reasons, seen a fluctuating number of breweries in recent years. Southern Appalachian Brewery was the only game in town for a good while (chapter 4). Then Basic Brewery, founded by Linda and Richard Wenger, opened and closed within about eighteen months. Black Star Line Brewing took over Basic's space, but that operation lasted only a few months. Sanctuary Brewing has done well downtown, and Triskelion Brewing started pouring nearby in late 2017. More breweries are on the way for Hendersonville, including Dry Falls Brewing and Guidon Brewing. Sideways Farm and Brewery opened in Etowah in 2018.

## SANCTUARY BREWING COMPANY

A pig, a chicken and a dog walk into a brewery…This isn't a joke, but a regular occurrence at Hendersonville's Sanctuary Brewing. However, the beer is only for human consumption.

"Partners in everything" Lisa McDonald and Joe Dinan opened their unique brewery in 2015. The couple started the brewery in order to help

support their animal sanctuary, Sweet Bear Rescue Farm, in nearby Flat Rock. In late 2017, the animal advocacy organization became a separate nonprofit, but Lisa and Joe still pour the majority of their profits into caring for animals.

The couple moved to the area from Chicago. Lisa was a corporate attorney, and Joe worked for Wicked Weed's Funkatorium. However, their dream was to start a brewery and to use the profits to support both an animal sanctuary as well as other regional animal rescue organizations. To that end, the brewery hosts regular animal adoption events, weekly yoga with pets and other charitable events.

"We've adopted out more than two hundred dogs and cats at the brewery since we opened," Lisa said. "We realized that we can have an awesome product, and we can also try to do some good in the world. If we were in it to get rich, first of all, we wouldn't have seventeen animals." That's the couple's 2018 rescue count, and it includes a pig, turkeys, goats and chickens, as well as dogs and cats.

Sanctuary was the first brewery in Hendersonville's historic central business district. In order to open, the business had to apply to change the zoning code. (Southern Appalachian had to do the same, although its location is outside the CBD in a more industrial part of town.)

Hendersonville's Sanctuary Brewing takes cat yoga to a whole new level, combining craft beer and animal advocacy. *Courtesy of Sanctuary Brewing.*

"But we started looking at locations, and we found this building in Hendersonville, and we knew it was perfect," Lisa said. "It was so perfect it was like being pushed off a cliff. We had no intention of leasing so quickly, but those things happen."

The building is 140 years old, and it was originally built as a stable, which seems appropriate. Head brewer Joe brews on a three-and-a-half-barrel system, but he plans to upgrade to a fifteen- or twenty-barrel brew house and start packaging and distributing.

"We started out small, with a $50,000 loan, and we had to get super creative about getting our name out in the industry," Lisa said. "So we try to do things out-of-the-box. We've done pop-ups in random towns in bookstores and tattoo parlors."

Chef Laura Theodore, known for her vegan-centric public television show, opened the Jazzy Vegetarian/Vegan Cafe inside the taproom in the spring of 2018. The celebrated chef's menu meshes well with Laura and Joe's meat-free brewery.

Every Sunday, starting at 1:00 p.m. until the food runs out, the brewery hosts a free vegan meal, open to all. Lisa noted that soon after opening, she realized that her vision of sanctuary included human beings as well as animals. So, she started the Sunday community meal, and the "Kindness Wall," a metal bar outside the brewery where people can hang donated coats and other clothing, free for the taking.

"Hendersonville still is definitely a seasonal town. Our population doubles in the summer. But we've become a community center for locals," Lisa said. "We're just trying to stick to our fundamental plan of making beer and saving animals."

## Triskelion Brewing Company

Like numerous small breweries striving to open their doors, Triskelion Brewing started off with a different name.

"We were going to be called Stag's Head Brewing, but a larger brewery with significantly deeper pockets politely told us we couldn't use that name," said Jonathan Ayers, Triskelion co-owner with his wife, Becky Ayers.

The new name comes from an ancient symbol of a triple spiral that represents symmetry in motion. The first piece of jewelry Jonathan gave to Becky was a triskelion. The brewery's logo contains the symbol, and

Jonathan and Becky Ayers in front of the empty lot on which they built Triskelion Brewing Company in Hendersonville. *Courtesy of Triskelion Brewing.*

per Jonathan, it fits with the couple's business philosophy of movement and change.

Both have lived in Hendersonville for a long time, so it made sense to open their brewery there. Becky attended high school in the town, and Jonathan moved to the area in the 1990s. Both are brewers, and Jonathan attended Blue Ridge Community College's Brewing, Distillation, and Fermentation Program.

They built the brewery from the ground up. Triskelion's brew house and taproom are in two separate buildings, although there's a small tasting room inside the brewing operations area. The two-story taproom includes a large beer garden with a stage. While the brew house tasting room opened on New Year's Eve 2017, the taproom wasn't completed until late spring 2018.

"We get to make a brand-new mark. It's unusual to find vacant lots in a historic town. We were lucky to be able to put this new thing in this old part of town," Jonathan said. "We've changed here in Hendersonville. There are lots of younger people moving here who can't afford to live in Asheville."

The Ayerses plan to add a canning line, and eventually, they want to distribute their product throughout North Carolina. They are brewing on a three-and-a-half-barrel system.

Triskelion's beers cover a diverse mix of styles. The first beers out included a tart raspberry ale, an imperial coffee stout, a strong Scottish ale and an Argentinian IPA. Per Jonathan, that IPA style is clean and delicate, more like early American IPAs before the haze craze.

"Our focus on quality and diversity really works with the whole craft lifestyle. It's hard to be an artisan in a small town, but beer is one of the things that people have gravitated to," Jonathan said.

The couple also wants to set up an educational fund to offer brewery students the opportunity to gain hands-on experience at Triskelion by developing, brewing and sending a beer out into the market. Then proceeds from those beers' sales will benefit brewing schools.

"Western North Carolina now has a worldwide reputation for making great beer. I want to keep that momentum going," Jonathan concluded. "I know a guy in Belgium who only imports beers from WNC. How cool is that?"

## Ecusta Brewing Company

Pisgah Forest is an unincorporated community just outside of Brevard at the foot of the actual Pisgah Forest.

Ecusta Brewing Company initially opened in downtown Brevard, below Jamie's Creole Brasserie on Main Street, in 2016. Brevard Brewing was the first brewery to open in Brevard, followed several months later by Oskar Blues, which is on the outskirts of the town.

About a year after starting to brew, Ecusta's owners opened a second taproom and production facility in a shopping area in Pisgah Forest. Soon after, the brewery turned the downtown taproom back over to the restaurant.

"With the growth we were seeing at the Pisgah Forest location, it didn't make sense to run two taprooms," said Bill Zimmer, Ecusta Brewing co-owner. Bill and Josh Chambers, the head brewer, own the brewery.

Longtime home brewer Josh moved to the area in 2010. Bill, who also owns Craft Financial, a financial planning business for the craft beverage industry, was based in Raleigh. However, he was itching to move to Brevard, which he did with his family in 2017.

"I wanted to be in a place I love for fishing and mountain biking. Brevard has always been a great place for mountain biking, but until the past few years, you didn't see the plethora of mountain bikers that you do now," Bill said.

Ecusta produced 689 barrels in 2017 and set a goal to hit 1,000 in 2018. So far, all beer has been sold in-house, but Bill said self-distribution isn't far off. The brewery offers a wide variety of beer styles, and Bill said Josh is developing a sour yeast, so expect more wild and sour beers to debut there. Additionally, the brewery will add a canning line, so folks going into the forest can take a six-pack with them. Ecusta offers food options as well, including to-go boxes.

"Learning all of the manufacturing and retail processes has been drinking through a fire hose in a good way," Bill said.

Ecusta likely was the Cherokee name for the Davidson River, which runs behind the brewery. While historical documents say Ecusta translates to "rippling waters," Bill called someone at the Qualla Boundary, home of the Eastern Band of the Cherokee, who told him the word actually translates to "distant," because it's where "the people" would travel to fish and hunt. Thus, the brewery's slogan is "Get distant."

Ecusta also was the name of a paper mill, Ecusta Corporation, that was a primary economic driver for Brevard and surrounding areas for much of the twentieth century. The plant employed 3,000 people at its peak. The nearby DuPont Corporation, which in the 1980s employed 1,500, also closed at the turn of the century. When these manufacturing businesses closed, the nearby communities lost people, money and confidence. Only recently has an influx of tourism and new business helped Brevard recover. That the town is now home to four breweries seems a clear sign of an upswing in fortune. Welcome to the land of the tourists.

## Peaks & Creeks Brewing Company

Jon Bowman added in-house brewing to his popular Waynesville pub, Tipping Point Tavern, in 2012. Five years later, he was done with the restaurant business and wanted to focus solely on brewing. So he bought out his partners and shut down Tipping Point.

"I was spending more time in the kitchen than in the brewery," Jon said.

Before he closed, he secured a lease in Brevard at the renovated Lumberyard Arts District with his romantic and business partner, Tracy Walker. The couple's plan to build out a brewery and taproom in Brevard hinged on the sales of Tipping Point's assets, including the three-story building that had housed the pub. It went under contract within two weeks of going on the market to Barry Bialik of Thirsty Monk Brewpub, but the deal fell through several months later. Soon after that, Jon sold the restaurant part of the business but said the sales kerfuffle slowed the opening of the new brewery, Peaks & Creeks.

"That put us in quite a bind, but you do what you have to do. I was in a poker tournament at Harrah's, and that helped," Jon said.

Peaks & Creeks Brewing Company's tap truck in the Brevard Lumberyard. *Courtesy of Peaks & Creeks Brewing.*

Jon and Tracy opened with a beer truck with six taps on the side in the Lumberyard's courtyard and starting selling beer in October 2017. They are brewing on the three-barrel system that was at Tipping Point.

The Lumberyard was home to building supply businesses for well over one hundred years. Then, in 2012, Leder Properties purchased the site, a few blocks from Brevard's downtown, to preserve the historic buildings and turn the property into a mixed-use development, including a rentable venue, farmers' market and a brewery or restaurant.

Peaks & Creeks beer is mostly the same as it was at Tipping Point. Jon's focus is on farmhouse, saisons and Belgian styles. The name Tipping Point is trademarked by a California-based winery, and while that business agreed to let Jon use the name provided he didn't distribute outside of North Carolina, he decided to change it when he moved over the mountains from Waynesville to Brevard.

Jon said he likes selling most of his beer from a small taproom, and he doesn't have plans for expansion other than self-distribution to local accounts.

# A Mountain Brew History

"I think where you're going to see success is at the taproom. A taproom can be 80 percent of beer sales. I'm crossing my fingers, of course, but I think the taproom model will keep the beer bubble from bursting," Jon said.

When he was looking for a new location, he said his primary goal was to move closer to mountain biking trails. When he saw the outdoor courtyard at the Lumberyard, he was sold. There are old railroad trails that have been paved for biking and walking trails, and one of them meanders from Peaks & Creeks' location straight into nearby mountain biking mecca Pisgah Forest.

Even as Brevard's fourth brewery, Jon said he thinks there's plenty of room for growth there, especially as the town continues to develop into an outdoor adventure destination.

## Lazy Hiker Brewing Company

The town of Franklin's first brewery, Lazy Hiker, truly is a community-driven business. It's owned by an investment group of thirty-five people, most of whom are town residents. Per managing investor Ken Murphy, all are folks who wanted to see a brewery bring good things to their town. Ken and the two other managing investors have lived in the town for at least twenty years. The additional thirty-two investors are silent partners.

Lazy Hiker's brewery and taproom opened in 2015 in the building that once housed Franklin's town hall, jail and fire department. Thus, the town board meetings held to discuss changing local alcohol laws took place in the same building. Although alcohol sales had been a subject of much debate in Franklin for years, the board members put the matter to a public referendum in 2006. It passed, but only by 57 percent of the votes cast.

"I never thought I would have seen a brewery in my hometown," Ken said.

> *We've faced some of the similar challenges that people face when alcohol sales are first allowed. There were a couple of bars here before us, but we still had some pushback. However, the majority of folks were excited to see that we're not just pumping out a bunch of drunkards from our taproom. Once people saw how we were partnering with the community, they came around.*

Like many craft breweries, Lazy Hiker supports numerous community nonprofits. Each month, the owners invite a different organization to brew

Lazy Hiker Brewing Company, Franklin's first brewery, opened in a historic downtown building. *Photo by Garret K. Woodward.*

a pilot batch with the brewers. Proceeds from that beer's sales then benefit the organization. For example, a crew from the Appalachian Animal Rescue Center recently brewed a beer called Man's Best Friend.

Lazy Hiker head brewer Graham Norris grew up in Franklin and started working for the brewery as assistant brewer before it even opened.

Lazy Hiker beers are available via wholesaler distribution in WNC and North Georgia. Initially, beers were draft only, but the brewery started working with Iron Heart Mobile Canning in early 2017. The brewery has a fifteen-barrel brew house in addition to a pilot system and is developing a barrel-aging program.

"Our go-to is approachable beers that go well with food for our flagships. Then we branch out and add more variety with our seasonals," Ken said. "We like having barrel-aged beers and traditional sours on draft too."

Tourism in the town is fairly seasonal, although Ken notes that Franklin's location nine miles off the Appalachian Trail makes hiking season huge. The brewery's outdoor stage for summer music shows also draws a crowd.

"We'll have hikers who are taking their first zero day come in from mid February until early May," he said. "We really cater to the hiking crowd for our taproom business."

And from that springs the brewery's name.

# A Mountain Brew History

## Currahee Brewing Company

Franklin's second brewery opened in the summer of 2016. Currahee Brewing's lead team moved to WNC from Georgia, where most of them had worked in craft beer.

CEO and co-founder Brandon Hintz brewed for Atlanta-based Sweetwater Brewing, was an original founder of Burnt Hickory Brewery in Kennesaw, Georgia, and owns Hop Alley Brewpub in Alpharetta, Georgia. Brew master Taylor Yates was lead brewer at Savannah's Moon River Brewery, and his wife, Currahee taproom manager, Andrea Yates, worked there as well. CFO and co-founder JT Schroeder was also based in Georgia, but in Atlanta's financial world.

When they were looking to open a new brewery, Georgia's laws were such that brewers couldn't sell beer from an onsite taproom. Taylor said he and Brandon realized that "we could go twenty miles across the imaginary line where the laws are different and do what we want to do." That Georgia law has since changed.

Additionally, the founders recognized Franklin's location as a perfect combination of small town and central distribution hub.

"The Lazy Hiker guys paved the way for us. Macon County has been looking for economic stimulus, and we wanted to be up here for the hiking, backpacking and quality of living," Taylor said.

Currahee's business plan is based on distribution. Beers are sold throughout the western part of the state and in North Georgia. While using wholesalers elsewhere, Currahee self-distributes in Macon County. Currahee beers will be available in South Carolina as well as in more of North Carolina.

"If you're going to or from Atlanta, this is a great place to stop," Taylor said. "We're looking to be a regional player." He guesstimated that 60 to 75 percent of Currahee's taproom traffic is tourists.

Currahee has on-site canning and an extensive barrel-aging program with over one hundred different whiskey, wine and spirit barrels. While offering seven year-round canned flagships, Taylor said he likes to play with creative beer styles from Hazy IPAs to a Berliner hybrid kettle sour. Currahee won a bronze medal at the Great American Beer Festival for coffee milk stout in 2017, which increased that beer's production.

"We brew the beer that we like to drink a lot," Taylor said. "Our craft lager in a can is made with love and local ingredients."

The brewery's name loosely translates as "stand alone" in Cherokee, per Taylor. The name also has roots in military history, and the brewery focuses on fundraisers benefiting military nonprofits as well as the outdoors.

The Appalachian Trail Committee recognized Currahee Brewing Company's work on its behalf. *Left to right*: Lenny Jordan, Andrea Yates, Brandon Hintz, Kristina Moe, Matt Bateman and Bill Van Horn. *Courtesy of Currahee Brewing.*

The two-thousand-square-foot taproom includes a patio on the Little Tennessee River and a permanent food trailer from Mountain Fresh Grocery, out of Highlands. In 2018, Currahee will begin building out an additional ten-thousand-square-foot space in preparation for expansion and growth.

"We want to grow organically and be quality focused and consistent. All the normal stuff that everyone else is always talking about—being innovative while growing and making great beer," Taylor said. "The liquid is the reason we do this, right?"

## WHITESIDE BREWING COMPANY

Bob and Lisé Dews moved to Cashiers from Atlanta in 1995 and purchased Laurelwood Inn. When the adjacent property, which included a former restaurant, went up for sale, the couple purchased that, seeing it as a natural extension of their hospitality business. They renovated the

## A Mountain Brew History

building, ordered brewing equipment, and opened Cashiers' first brewpub, Whiteside Brewing, in 2018.

"We're excited to be the first brewery in Cashiers. We're hoping to bring vitality and unity to this side of town—to be a catalyst for growth," Bob said. "People came by while we renovated to tell us what they think, and they've mostly been excited. It's like the Waltons up here. Everybody knows John Boy's business, but I love it. We're excited to be a community hub for Cashiers."

In a coup for the new brewery, Bob snagged experienced brewer Dieter Kuhn, founder of Heinzelmännchen Brewery.

"I expected Dieter to bring old-world brewing into this place, and he has quite the following," Bob said. "He's a right jolly old elf. We want the brewery to feel homegrown."

The seven-barrel system and fermentation tanks sit in the middle of the restaurant. The beers are a mix of traditional and experimental styles.

Co-owner Bob Dews (*left*) and head brewer Dieter Kuhn at Whiteside Brewing Company, Cashiers' first brewery. *Courtesy of Whiteside Brewing.*

"There are so many cool fruits, flowers, roots and nuts that are indigenous to our area," Bob said. "Like the Chinquapin nut that grows up here. We're going to make a beer with that. We're going to experiment a whole bunch."

Most beer is sold on-site, although Bob plans to self-distribute to nearby country clubs.

The restaurant menu includes light fare that pairs well with a variety of beers. There's lots of outside space and a small lake, which includes an area that Bob thinks will make a great music venue. There also are views of Whiteside Mountain, for which the brewpub is named.

"I've been part of this community for twenty-two years, and I've had a lot of relationships, and I want to live up to expectations that we do things well," Bob said. "Whiteside will be more of a destination than a taproom. I think the combination of a great chef and a great brewer pulls people here."

He then described his perfect Cashiers weekend: "Come up and have a couple beers, eat a good meal, listen to music, visit nearby shops on the walking paths, crash at Laurelwood Inn and hike Whiteside Mountain the next day."

Nearby is Sapphire Mountain Brewing Company in Sapphire, between Cashiers and Highlands. That brewery contract brews three brands with Thomas Creek Brewing Company in Greenville, South Carolina. However, the owners say they have plans to set up in-house brewing.

## Satulah Mountain Brewing Company

The first brewery in both Macon County and Highlands, Satulah Mountain Brewing, opened in the summer of 2014. Owner and brew master Dale Heinlein is native to the area. His grandfather was a pickle farmer and well-known stonemason who built numerous older Highlands buildings. The brewery's name comes from a mountain in nearby Blue Valley where Dale's family settled a few generations ago.

"Reception has been super, mostly because of the nature of tourism here," said Kelsey Reible, operations and taproom manager. "Atlantans look forward to coming here and trying our beer. And it's been awesome to have the ability to let them take cans home with them."

As one of the WNC towns closest to the Georgia line, Highlands boasts a huge number of Atlanta-based second home owners.

## A Mountain Brew History

Dale started small, brewing fifteen gallons at a time and selling all his beer in the small taproom. He moved to a one-barrel pilot system in 2015 and added a few nearby retail accounts. Then, in late 2017 and early 2018, Dale stopped brewing for a few months in order to install a seven-barrel brew house, set up canning with mobile canning and push self-distribution out toward Asheville and Charlotte. During the expansion, Kelsey kept the taproom open by bringing in guest taps from nearby WNC breweries.

In 2017, Satulah Mountain Brewing of Highlands upgraded from a small-batch to a seven-barrel system to meet demand. *Courtesy of Satulah Mountain Brewing.*

Satulah offers a wide variety of beer styles, from stouts to kettle sours. Per Kelsey, the most popular brew is Sunset Saison, a farmhouse ale made with parsley, sage, rosemary and thyme, like the famous Simon and Garfunkel song. Dale also forages locally when possible, as he did to create a beer benefiting Highlands Land Trust that included wild mountain mint and juniper.

There's no food service at the brewery, as the Town of Highlands won't allow a commercial kitchen based on parking availability, said Kelsey. She is working with the town to get food trucks approved.

Kelsey moved to the area to work for the Highlands newspaper and started moonlighting in the brewery taproom on weekends. Now she's full-time at the brewery, but the team consists of only her and Dale.

"We're family-oriented and small," she said. "We don't have a stage, but we have a corner with a PA system. We're the only place in Highlands that has open mic nights."

## 10
# BREWERIES OF THE WESTERN MOUNTAINS

Highway 74 West, also known as the Great Smoky Mountains Expressway, is the trans-mountain highway that runs from Clyde, west of Asheville, past Waynesville and then past Sylva, Cherokee, Bryson City, Andrews and Murphy, before crossing the Tennessee border.

This far western region of North Carolina, like the High Country, was fairly isolated for a long time. The farther one travels from Asheville, the less populated the communities become, although, like many of the towns in the southwest mountains, many of these areas benefit from tourists driving up from Atlanta and folks visiting Great Smoky Mountains National Park.

## WAYNESVILLE

The town of Waynesville, a thirty-minute drive west of Asheville, gets props for being home to one of the first post-Prohibition breweries in Western North Carolina, Smoky Mountain Brewery. After Smoky Mountain closed, it would be almost twenty years before another Waynesville brewery opened.

In 2011 and 2012, three breweries would open in quick succession. Frog Level Brewing was the first, soon followed by Headwaters Brewing. That brewery, now called BearWaters, moved from Waynesville to Canton in 2017. Tipping Point Tavern next added brewing equipment in the basement of its downtown Waynesville location. After that brewery and restaurant

closed, former co-owner Jon Bowman opened Peaks & Creeks Brewing in Brevard. In early 2017, Boojum Brewing opened a production space on the outskirts of town and a downtown brewpub. Thus, at the beginning of 2017, Waynesville was home to four breweries, but a year later, the town was down to two: Frog Level (chapter 4) and Boojum.

## Boojum Brewing Company

A tall, shaggy man-beast holding a staff topped with a giant gemstone peers out of a cave on top of a mountain in the Smokies. He's a Boojum, the legendary Bigfoot of Haywood County. The intricate, colorful drawing of this creature isn't on a book or on the wall of a gift shop; instead, its portrait is wrapped around a beer can.

Waynesville's Boojum Brewing takes its name from myth, and its cans tell bits of the Boojum's tale.

Boojum consists of a production brewery on the outskirts of Waynesville and a taproom and full restaurant on Main Street. It opened in early 2015. The business is family-owned and operated by the Baker family, consisting of parents Corrine and Woody and their adult children Kelsie and Ben. Kelsie and Ben work as operations manager and head brewer, respectively. Neither had experience in the beer business, but they had family connections in the area.

"We had long been huge fans of craft breweries and craft beer, and we thought it would be amazing to run a business where we could be both creative and technical, and where we could create products and places that brought people together," said Kelsie.

The local Boojum legend dates back to the early 1900s when the man-beast was said to roam the mountains around Waynesville's Eagles Nest Hotel. The hotel, built in 1900, sat on a nearby mountaintop in the Balsam Mountain Range at more than five thousand feet. It burned down in 1918.

When the Boojum team was looking for designs for its beer cans, Asheville-based Big Bridge Design solicited sketches from three different artists. The Bakers chose the artwork of illustrator and tattoo artist Becka Schoedel of Asheville's Thistle & Pearl Tattoo.

"Becka's first sketch for King of the Mountain Double IPA really spoke to us," Kelsie said. "It looked like something out of a dark children's book. The

Boojum looks powerful and in control up there sitting on a wild, wooden throne. Her drawing made me want to know more about this character."

Although there were three breweries in Waynesville when Boojum opened, Kelsie said:

> We thought we could really take the beer experience further by offering more styles, releasing new and exciting beers often, and developing a larger distribution footprint. We also found out that people here were really interested in having the full brewpub experience, and that if we could serve great food and great beer, we would have something special.

In its first two years of business, Boojum expanded its downtown brewpub three times and expanded the brewery by basically building a larger warehouse around the existing production space. That enabled Boojum to add a canning line, after initially using mobile canning. The brewery produced close to three thousand barrels in 2017. That same year, 99 percent of the brewery's beer sales were in the twelve most western WNC counties from Black Mountain to Tennessee through Budweiser of Asheville.

"At this size, we would max out our barrelage at around nine to ten thousand barrels, and we think that's where we'd like to stay," Kelsie said. She noted that managing two locations, one a manufacturing business and the other a customer service one, can be a challenge.

She concluded:

> Trying to find the right balance between the taproom and the brewery and deciding how to distribute finite amounts of time, energy and money between the two has been difficult. We planned to run a production brewery and have a small, simple taproom to complement it, but we saw the potential of a large taproom and decided to make it happen.

## Innovation Brewing Company

One of the biggest beer stories of the past few years was Innovation Brewing's David versus Goliath trademark dispute. When Bell's Brewery of Kalamazoo, Michigan, sued Sylva's Innovation in 2015, it raised the hackles of brewers all over the nation, and especially in WNC.

Bell's, a huge national brand, claimed the name "Innovation" infringed on its slogans "Bottling Innovation since 1985," and "Inspired Brewing." The lawsuit was dismissed in late 2017, and Bell's claim ruled erroneous. Thus, Innovation retains its brewery name and branding. No word at publication time if Bell's might appeal the decision.

Married couple Nicole and Chip Dexter founded Innovation Brewing, Sylva's second brewery, in 2013.

"They are what craft beer ought to be. I would have given up—all that money and all that time. I would've thrown in the towel and walked away. But they persevered, and they won," said Billy Pyatt, co-founder of Catawba Brewing and former Asheville Brewers Alliance president.

Numerous regional establishments initially removed Bell's beer from their menus, and there was a hefty local consumer boycott, although over time that lessened.

Nicole notes that Chip grew up in Michigan drinking Bell's beer, so the situation made him particularly sad. She also said after the lawsuit settled that they're ready to move on and don't want the brewery to be defined by the suit.

That said, people love when an underdog wins. Round that out with a variety of great beer, and the brewery's large and loyal customer following makes sense.

The couple met in Asheville when Nicole worked as a server at Asheville Brewing and Chip was a mechanical engineer. They spent a couple of years looking at potential brewery sites all over WNC. Nicole said they were looking for a small town that would be a great place to raise a kid.

"We probably looked at twenty buildings in twenty different towns within an hour's radius of Asheville, and we hadn't found the right place," Nicole said.

At that point, they pretty much gave up on the idea of starting their own brewery. Then Nicole decided to take a class in field biology at Highlands Biological Research Station, and her professor there persuaded her to look at Sylva.

"We hadn't even looked at Sylva, but we came to visit and fell in love," she said. "I can't imagine wanting to live anywhere else now. This community is so unified and supportive and amazing."

The Dexters purchased a building and opened Innovation in late 2013. At that point, the only brewery in town was Heinzelmännchen, which has since closed. In the spring of 2018, Chip and Nicole opened a wood-fired pizza shop next door to the brewery, which sits on the sinuous Tuckasegee River on the outskirts of town.

In addition to offering lots of sour and barrel-aged beers, Innovation Brewing Company of Sylva has a permanent food truck and a wood-fired pizzeria next door. *Courtesy of Innovation Brewing.*

Innovation produced just over one thousand barrels in 2017 and started self-distributing draft and specialty bottles to over one hundred accounts, although Nicole said most of the beer was sold from the taproom. In 2018, Innovation opened a second taproom and production space in nearby Dillsboro. The Dexters purchased a building at the train station and installed a three-barrel pilot brewing system there. The Great Smoky Railroad starts at the station, and the quaint town is a regular stopping point for tourists on their way to the national park. Additionally, the five-thousand-square-foot building will have lots of room for Innovation's aging and sour program.

"We usually have about six sours on tap that are aged from six months to two years," said Nicole. "When we first started making sours, it would take forever to kick a three-barrel. Now we can hardly make them fast enough. We have totally trained this community to love them. It's been awesome to watch the transition in a couple short years."

# A Mountain Brew History

## Balsam Falls Brewing Company

Balsam Falls Brewing is yet another small brewery founded and run by a married couple (speaking of a labor of love). In the fall of 2017, proprietors Laurie and Corey Bryson opened their doors for business in downtown Sylva.

Corey has family from Sylva, and he graduated from high school there. Although he left soon after, he said he had been scheming about how to get back ever since.

"We were living in Tampa, and we were very involved in craft beer there. We're both home brewers and I'm a beer judge," Corey said. "After seeing a couple of friends do it, we thought this might be possible. We were desperate to get to the mountains."

Laurie added, "We looked at Haywood and Jackson Counties and Canton and Waynesville. What we found through our research was that Sylva, although a small town, had a very vibrant beer culture."

They were disappointed to learn that Heinzelmännchen was closing, as Laurie said they were looking forward to being neighbors with Dieter and Sheryl, founders of that German-style brewery.

Corey describes Balsam Falls as a very small nano-brewery of a one-barrel brew system and a few two-barrel fermenters.

Balsam Falls Brewing Company in downtown Sylva has a small-batch brewing system and taproom. *Photo by Garret K. Woodward.*

"Our focus is on variety," he said. "While we have some core beers, every week we put out a new beer. It gives us a chance to try new stuff and keep our customers coming back."

The couple are sourcing as much local produce for their beers as possible, including crops from Corey's grandparents' farm, which has been in his family since the 1950s. The land has grapes, blueberries, cherries, apples, peaches and pecans, and the couple plans to plant a small garden there to help supply additional beer ingredients.

There's no food service at Balsam Falls, but there is complimentary popcorn and delivery available from a few local restaurants. Wine, cider and guest beers are available in addition to the house beer.

So far, 100 percent of Balsam Falls' beer has been sold in-house, although Laurie said she and Corey regularly receive requests from local restaurants for kegs.

"Sales are already outstripping what we had planned," she said. "But we just want to keep making good beer and taking care of our customers."

The brewery's name references both the Great Balsam Mountains, a subrange of the Blue Ridge, within which Sylva nestles, as well as Dills Falls, the waterfall that was demolished when the Highway 74 bypass was built in the 1970s. Before then, Sylva laid claim to being the only incorporated town in the United States with a natural waterfall inside its city limits.

## 7 Clans Brewing Company

The sovereign nation of the Eastern Band of the Cherokee, known as the Qualla Boundary, encompasses fifty-six thousand acres within Western North Carolina. The reservation is dry, allowing no sales of alcoholic beverages, except within its casino, Harrah's Cherokee Casino Resort. The casino opened in 1997, although the tribe did not approve alcohol sales there until 2009. The tribe also owns Harrah's Cherokee Valley River Casino, which opened near Murphy in 2015. North Carolina law prohibits complimentary alcoholic beverages, so gambling in WNC is a little different than gambling in Vegas. However, around 3.6 million people visit Harrah's Cherokee annually, making it the largest private tourist attraction in North Carolina.

Having Harrah's open up to alcohol sales ushered in changes throughout this westernmost portion of North Carolina, including revisions to liquor-by-the-drink restrictions in Bryson City and Sylva. Alcohol on the reservation

has long been controversial for cultural and moral reasons. The Baptist faith, which promotes abstinence, is widespread on the Qualla Boundary.

However, two female Cherokee entrepreneurs, Collette Coggins and Morgan Owle-Crisp, started 7 Clans Brewing Company in early 2018. Initially, they are contract brewing at BearWaters Brewing. However, the business partners say they want to open a brewery on the reservation.

The so-called Blue Ridge Law is often debated in Cherokee. This law allows alcohol sales within one and a half miles of a Blue Ridge Parkway exit or entrance ramp. Several Cherokee businesses have been issued permits under that provision. While the nation has its own Tribal Alcoholic Beverage Control Commission (TABCC), which is independent from the North Carolina ABC, when it comes to alcohol, the tribe's laws must mesh with those of the state. Thus, 7 Clans could locate within a mile and a half of the parkway, with the goal of pulling in some of the nine to fifteen million people who drive that road each year.

"We are longtime business owners and women who have been involved in this community for many years," Morgan said. "And we know that the craft beer industry has created a spark of economic growth in other small towns. So, we thought why not start making beer in Cherokee?"

Collette added:

> *I go through Bryson City every day, and I've seen the huge growth and the changes that the breweries there have made in town. These breweries are changing the persona of beer drinking. They don't have that old social stigma. Now, they're about community and craft and social interactions. Look at the growth that small breweries have made in Sylva too. They've made a huge difference in that town.*

The casino sells local craft beer on draft, and 7 Clans Brewing's first beer, Mother Land Blonde Ale, was released there.

## Westernmost North Carolina: Bryson City, Murphy, Andrews, Haysville

There's Western North Carolina and then there's far Western North Carolina. This region, bordering East Tennessee and North Georgia, consists of Swain, Cherokee, Clay and Graham Counties (and Macon

to the south, although its breweries are in chapter 9). These small, quiet communities are nestled smack in the heart of the Great Smoky Mountains and national forestland. Their locations meant that, until recently, they mostly were a quick stop on the way to somewhere else. The area is rich with rivers and streams, including some of America's most rafted white water on the Nantahala and Tuckasegee Rivers.

Because Great Smoky Mountains National Park is the most visited park in the nation, it means a good number of people pass through. In 2017, 11.2 million people visited the park, which celebrated its centennial that year.

The National Park Service added an information center in Bryson City's former courthouse in 2017, and that's also increased tourists to the area.

Prohibition lasted longer in this region than in most of the rest of North Carolina. Only in the past few years did Cherokee County (2016) and the Towns of Murphy and Haysville vote in alcohol sales. Graham County remains the only WNC county that has yet to have a brewery open or plan to open within its borders.

Currently, there are seven breweries in the far western reaches of WNC, and most of them opened in the past couple of years.

## Mountain Layers Brewing

Bryson City's second brewery, after Nantahala Brewing (see chapter 4), opened its doors in spring 2017. Former Minnesota-based law enforcement officer Mark Pettit and his wife, Kim, fell in love with Bryson almost two decades ago when they stopped there for lunch during a drive to Florida. A few years later, the high school sweethearts purchased a cabin outside of town, and when Mark took early retirement a few years ago, they moved there.

Talking to Mark does feel like walking onto the set of the movie *Fargo* and running into the "good" cop. His speech is peppered with "oh my" and "oh my goodness," and he said people come to trivia night, which is emceed by Kim, partially just to listen to her upper midwestern accent.

Several years before moving to Bryson, the Pettits purchased a 1940s downtown building on the Tuckasegee River. Mark said he's heard it originally housed a men's haberdashery, and locals have told him it was a somewhat shady pool hall in the 1970s, back when the town was dry. He said that he and Kim initially considered starting a coffee shop in the building, but then they became enamored with the craft beer industry.

## A Mountain Brew History

"We felt having another brewery in Bryson City would make the town more of a beer destination. We want to bring people in to visit and enjoy both of the breweries," Mark said. "I'm not sure if I've ever told Joe, but I was one of Nantahala Brewing's first customers seven years ago."

So both Pettits enrolled in a craft brewing class at Sylva's Southwestern Community College while renovating the building into a production space and taproom. Then Mark spent several months interning at Frog Level Brewing in Waynesville.

"My wife and I were trying to find a name that reflected our passion for the area. We went through about a thousand names," he said.

> *Then one day she was reading* Our Southern Highlanders, *and I could tell she was getting emotional. She was touched by Horace Kephart's stories. And she said, "There are so many layers in this area." I said, "What do you mean, dear?" She went on to talk about the layers of people and the layers of culture and history and the layers of the mountains.*
>
> *It really struck a chord with us. There are layers in beers and the mountains are layered, so Mountain Layers Brewing felt right.*

Mark is particularly proud of the brewery's "Honor and Remember Wall," which honors U.S. military and Swain County first responders.

"We are dedicated to all the first responders who keep our people safe here in Swain County," he said. "It has been a blessing and an opportunity to do something like this in this community."

## Andrews Brewing Company

Andrews Brewing Company is one of only a handful of North Carolina breweries that also is a winery.

Co-owners Eric and Judy Carlson moved to Andrews from New Hampshire to retire, although retirement didn't stick for long. The couple opened a tiny winery, Calaboose Cellars, in 2006, after buying an established three-acre vineyard and the building on the property, which was originally the town's first jail. Calaboose is an archaic word meaning "small jail."

In 2013, the Carlsons added brewing to the mix, becoming Cherokee County's first brewery.

Andrews Brewing Company has both a nano-brewery and a vineyard on site. *Courtesy of Andrews Brewing.*

"The town welcomed us with open arms. We've been a winery since 2006, so it was not a big deal to add another form of alcohol," Eric said. "Making beer is so much more enjoyable than making wine. Wine you make once a year, and it's very intensive for a few weeks, then it just sits there for months."

The Carlsons recently purchased the old A&P Grocery building, a nine-thousand-square-foot building on Main Street, and moved brewing operations there, which will allow them to increase capacity. There's no public access at the production space. At present, most beer is sold on-site, although draft tap handles pop up from Murphy to Waynesville.

"Our vision is to bring folks to this spot and to be profitable here," Eric said. "While we are only a block off Main Street, we're still off the beaten path."

## Hoppy Trout Brewing Company

Cherokee County is the trout capital of North Carolina, and Tom Rodeck grew up fishing there. When Rodeck and his business partner and former spouse, Kristin Spradling, opened a brewpub in Andrews, they named it Hoppy Trout Brewing Company, combining two of Tom's passions.

The brewpub opened on New Year's Day 2016, making it the first North Carolina brewery to open that year and the second in the tiny town of Andrews. Tom brews on a one-barrel system, while Spradling manages the food side of the business. Rodeck left Andrews for several years after high school, but he came back, as he said, for the slower pace of life and the beautiful mountains and streams.

# A Mountain Brew History

Bartender Drew Tilford (*left*) and co-owner Tom Rodeck at Hoppy Trout Brewing Company in Andrews. *Photo by Kendra Penland.*

"We've had lots of support from this community," Tom said. "This area is pretty conservative, but most people have come to see that a craft beer restaurant is different from a beer bar. Most people come here to taste the beers, not to get drunk."

Tom brews a diverse pool of beers, rarely making the same beer twice, and customers have come to expect something different on tap every time they visit.

"We're known for doing crazy beer styles. I'm not afraid to experiment with flavors. For example, I did an eggnog beer for Christmas. I don't know of anyone else who has done that," Tom said.

## Haysville Brewing Company

Haysville Brewing Company became Haysville's first brewery in the spring of 2017 when Lisa and Jody Jensen, spouses and business partners, opened the small-batch brew house. A few months later, the town's second brewery, Valley River Brewing, would open a few blocks away.

"After living here for eight years, we thought Haysville needed a brewery, and both of us have worked in restaurant management all of our lives," said Lisa. "We didn't know Valley River was opening and they didn't know we were. We were introduced to each other by the health inspector."

Lisa and her husband had to teach themselves how to brew, but now Jody is obsessed and brews constantly, she said. The brewery offers six regular beers, including a Belgian Blonde and a chocolate coffee porter. The brewery includes a small kitchen.

"So many Floridians and folks from Atlanta come up here in summer," said Lisa. "We really thought it would slow down a lot in winter, but our locals are great supporters. They've been so welcoming."

The Jensens hope to expand their draft distribution at some point, although currently, Lisa said they are barely keeping up with demand in the brewpub.

Haysville Brewing Company's small-batch brewery and restaurant. *Courtesy of Haysville Brewing.*

# A Mountain Brew History

## Valley River Brewery and Eatery

Mike and Dawn Marsden opened Murphy's first brewpub in 2016 and then added a second location in nearby Haysville in 2017. Mike has been in the brewery business for a while, as he was one of the original partners at Nantahala Brewing. He parted ways with that brewery a few years after it opened and moved to Murphy.

"Murphy had just been opened up for alcohol sales when we moved here, and we decided they weren't quite ready for a brewery," he said. "At that point, the only beer was at the country club [Cherokee Hills Golf and Country Club], where they had a resort license. Budweiser of Asheville would load up and bring a truck load of beer up here."

When Harrah's Cherokee Valley River Casino opened just outside of Murphy, Mike felt that the time had come to open a brewery. "We get a little business from the casino, but we get more casino employees than casino patrons," he said. "If someone loses a couple thousand dollars in the casino, they aren't likely to come out for dinner afterward."

Valley River Brewery and Eatery has locations in both Murphy and Haysville. *Courtesy of Valley River Brewery.*

At present, all brewing takes place in Murphy, but Mike plans to add a second brewing system at the Haysville location. The eatery side of both locations offers wood-fired pizza as well as a selection of sandwiches, soups and salads.

"The local government people were so happy to have a brewery here in Murphy. And the mayor over in Haysville was just ecstatic," Mike said.

He said he spends lots of time educating his staff so they can educate the public, although he credits the Parson's Pub in Murphy with helping educate many locals about craft beer.

Mike brews on a two-barrel system. He learned about great beer in England, he said, so while he offers different styles, many of his beers are English in origin.

"Most of all of our house beers, such as our English Mild and ESB, you may not find at other breweries," Mike said. "It's a challenge, but it's rewarding too when I hand someone an English Mild and say, 'Don't look at the color, just take a sip.' It's amazing when they learn that a beer drinks so light, but it still has color."

Mike doesn't intend to distribute, other than a few kegs here and there to local restaurants. "I don't think anything you put in a bottle gets better than draft," he said.

# 11
# SIX YEARS IN BEER CITY, USA

Most of my first beer history book tells the stories of Asheville-based breweries, because, in 2012, when I was writing it, there were only nineteen breweries in six Western North Carolina counties, and ten of those were in Asheville. This book profiles seventy-four operating breweries in eighteen WNC counties, several breweries in planning and several that have closed.

The volume you're now reading is a companion to—not a revision of—*Asheville Beer*. If you want the entire history of beer in WNC, you need both books, for which both my publisher and I thank you.

Clearly, a tremendous amount has happened in the beer biz in the Paris of the South since late 2012. This chapter includes the breweries that opened inside Asheville's city limits between late 2012 and early 2018 in chronological order, or as close as I can get to it.

## WICKED WEED BREWING COMPANY

When Wicked Weed Brewing opened a brewpub in downtown Asheville in December 2012, the owners had no idea how rapidly their business would explode.

"Our initial goal was 1,500 barrels a year," said Ryan Guthy, president and one of five founders. "The brewpub just took off. We brewed 2,700 barrels in our first year of production."

In 2017, Wicked Weed produced just shy of thirty-five thousand barrels. The business is WNC's brewery Cinderella story, although in this version, Prince Charming has a reputation for being less than charming—and Cinderella didn't exactly start out as a mistreated scullery maid.

Siblings Walt and Luke Dickinson partnered with Ryan and his parents, Denise and Rick Guthy, to start the brewery. The Guthys moved to the area when Ryan was three years old in 1998, while the Dickinsons came to Asheville in 1996 and attended T.C. Robeson High School. Rick Guthy was a partner at Guthy Renker, an infomercial business that sells motivational and beauty products and has a major distribution center in Arden.

When the home-brewing Dickinson siblings approached the Guthys with the idea of starting a brewpub, Rick saw a way to retire without retiring. The Guthys invested, but with the caveat that they be involved in the day-to-day operations of the business. A year and $2 million later, Wicked Weed opened a brewpub capable of holding five hundred people. In 2014, the partners opened the Funkatorium, a tasting room and barrelhouse on the South Slope, just a few blocks from the original location. Soon after that, they added what Ryan calls their "clean beer" production facility in Enka-

Canning at Wicked Weed Brewing's production and packaging facility in Enka-Candler. *Photo by Erin Adams Photography.*

Candler. Then, in 2017, a sour production brewery called the Funk House got going in Arden, where the business's corporate offices are located.

In what was one of the biggest national beer news stories of 2017, the owners sold the business to Belgian-owned AB InBev. Numerous breweries across the country reacted, including Texas-based farmhouse brewery Jester King, which announced it would no longer carry Wicked Weed products. On Jester King's website, founder Jeffrey Stuffings wrote: "We've chosen this stance, not because of the quality of the beer, but because a portion of the money made off selling it is used to oppose the interests of craft brewers."

Large corporate breweries have, again and again, opposed law changes that would help small craft brewers. This, really, is why people who work in the craft side of the industry often react negatively to buyouts from big beer.

Additionally, the acquisition came soon before the brewery's highly regarded Funkatorium Invitational, and while Wicked Weed initially said the festival would go on, the owners soon changed their minds, as brewery after brewery decided not to participate.

Per Ryan, post sale, all five of the original owners are still involved, although their roles may have changed. Ryan went from being director of sales to president.

"We had a lot of pursuers, but we wanted to partner with another brewery that would help us continue our model and help us keep our employees happy," Ryan said.

"There's been some heartache," he added. "The hardest part has been adapting to all the new systems—a new accounting system, a new sales system, etc. It's been a learning curve."

Part of what initially made Wicked Weed unique is its barrel-aged sour program. Before the brewery opened, Walt told me that they wanted mostly to focus on hoppy, West Coast–style beers and big Belgians. However, he soon decided to brew a couple of sours, which he had home brewed in the past, to see how customers reacted.

"We had no idea they'd be so popular. We would tap a keg, and it would be gone in about an hour," Ryan said.

"I think the younger generations are looking for something really complex and flavorful. My generation grew up on sour candy, and we love sour, sour, sour," Ryan said. "And I think these beers compete better with wines and spirits."

Wicked Weed's beers are distributed around the country. Outside of the Southeast, the beer is mostly available in large cities such as Boston, Philadelphia, Houston, Chicago and New York. Because of the sour program,

Wicked Weed hasn't had high enough production of its clean beers to open up entire states. Of course, with AB InBev's help, that might change.

"I think we have one of the largest nationally distributed portfolios in the country," Ryan noted. "We sent about seventy-four different beers to market with only five year-round brands. All the rest are seasonals and one-offs." He said the brew team has created more than six hundred different recipes in five years.

"We're a brewery that always wants to focus on quality and innovation," Ryan said. "We want to grow and be as big as we can without sacrificing quality or community."

## Burial Beer Company

Like Wicked Weed, Burial Beer quickly gained a rabid following for its creative line of beers, including farmhouse styles, Belgians and double IPAs. The brewery offers a wide variety of beers flavored with unusual ingredients and often graced with even more unusual names. "In the Sirens and Silences" and "Post Apocalyptic Awakening" being just two examples.

The brewery opened on Asheville's South Slope in the summer of 2013 with a tiny one-barrel system but expanded to a ten-barrel within a year. Husband-and-wife team Doug and Jess Reiser and their friend Tim Gormley founded and own Burial. All three moved to WNC from Seattle. Tim formerly brewed for Sound Brewery.

Immediately after opening, the brewery had rave reviews and folks lining up out the doors for bottle releases. About half the beers at any given time contain herbs, flowers, vegetables or other ingredients either sourced from local farms or grown in the gardens behind the downtown brewery. The term "beer garden" takes on a whole new meaning when you can admire a rose bush in bloom while sipping a beer scented with its petals.

The taproom's industrial décor with a decidedly ghoulish theme comes from the New Orleans tradition of celebrating rather than mourning death. I've always said that Burial would be a great place to be when the zombie apocalypse breaks out, as there are numerous farm tools, including scythes and pitchforks, hanging on the walls.

The ownership's original plan was to open an additional farmhouse brewery, similar to what Fonta Flora has done. After years of looking at land, however, that plan changed when the crew found and purchased a two-

# A Mountain Brew History

Burial Beer Company's production facility in a renovated warehouse that was once part of a Civilian Conservation Corps camp near Asheville's Biltmore Village. *Photo by Anne Fitten Glenn.*

acre former Civilian Conservation Corps camp property. The site includes historic buildings built in the early 1900s, and it's not far from Asheville's Biltmore Village. It took almost two years to build out a twenty-barrel production brewery in the largest building on the property, now called The Forestry Camp. The name stems from when the property transitioned into a national forestry research center during World War I. Brewing and in-house canning started there in 2017.

"We were one of the only people looking at the property who could figure out a use for these buildings," Doug said. "We worked with the Department of Forestry, and they shared all their old documents and photos of the site. They've been so excited that we are preserving the buildings."

While Burial's first five years in business have been fast and furious, Doug noted that the goal is to hit ten thousand barrels annually and stop there. The brewery produced eight thousand in 2017.

"It was always our goal to go hard for five years, then once we reach capacity, our only growth will be in terms of quality," he said. "Our goals are

to forever be able to connect directly with our customers as well as to find a balanced quality of life for us and our staff."

In 2018, an American craft beer bar featuring not only Burial beers but also specialty and vintage beers from around the country will open on the Forestry Camp property.

"We only sell beer from people we know and whose stories we can tell," Doug said. "Our goal is to connect beer drinkers to the breweries. We love doing collaboration beers. We love bringing brewers here to tell their stories. It's what craft is all about for us."

Additionally, the site has a barrelhouse to expand on the brewery's successful sour and barrel-aging program.

Burial's distribution is what Doug called "event-based." The brewery self-distributes regularly throughout North Carolina and to Georgia and New York City. Other times, Burial will show up with a couple of pallets of beer and have a big event, said Doug. They've done that in Denver, Cleveland and New Orleans, where they throw an annual fundraiser for the Mardi Gras Indians.

The original taproom features a permanent restaurant with a seasonal-based menu. The Forestry Camp beer bar offers charcuterie boards, sandwiches and other locally purveyed snacks.

"Don't worry, though. Collier Road will always be our taproom. We'll be on the South Slope forever," Doug said.

## Hi-Wire Brewing

Barely a month after Burial opened, Hi-Wire Brewing started pouring beer on Asheville's South Slope. Managing co-owners Adam Charnack and Chris Frosaker purchased Craggie Brewing, which had closed after almost five years in business. The commercial realtor and retail pharmacist, respectively, heard that Craggie was for sale at a dinner party. Within six months of taking over Craggie's location and assets, Hi-Wire was distributing draft beer to accounts and bottles to local grocery stores.

"We wanted to focus on a strong cohesive message from the start. We went with the circus theme because circuses are traditionally fun, and beer is supposed to be fun and light-hearted," Chris said. "Also, Asheville is kind of a circus. Look at the Friday night drum circle downtown. And metaphorically, starting a new business is like balancing on a tight rope."

## A Mountain Brew History

Hi-Wire Brewing's roots are circus-themed, because beer should be fun. *Left to right*: Chris Frosaker, Matt Kiger and Adam Charnack. *Courtesy of Hi-Wire Brewing.*

When the partners wrote their business plan, only Highland and Asheville Brewing were putting beer in twelve-ounce containers, Chris said. But he believes one of the reasons Hi-Wire has grown so quickly is because the brewery distributed bottled beer from day one. He admitted that route can be risky because it's so capital intensive.

"I can't believe how much has changed so fast. Everyone in this industry has had to grow up very quickly to evolve with the market," said Chris. "When we opened, Wicked Weed was six months old; now they're part of an international conglomerate."

The brewery soon outgrew its downtown location and opened the "Big Top," a thirty-barrel production brewery, packaging plant and taproom just

north of Biltmore Village. The brewery continues to expand regularly and added eight ninety-barrel fermentation tanks in early 2018.

After opening the new production space, Hi-Wire turned the original brewery over to a sour and wild barrel-aging program, hiring John Parks, formerly with Asheville Brewing and now lead brewer at Zillicoah Beer, to develop those beers. At the time, that was a risky move. Since then, the brewery has bottled many of its funky beers in high-end wine bottles with colorful, geometric labels.

Hi-Wire distributes in North Carolina, South Carolina, Tennessee, Georgia, Ohio and Kentucky, with more states in its future. The brewery expanded outside of WNC by opening a taproom in Durham in late 2018.

"We're focusing more and more on sales. You can make the best beer in the world, but if you can't sell it, it doesn't matter," Chris said.

Hi-Wire's flagship beers are fairly traditional, with the lager and the brown ale being big sellers. The brewery's slogan is "approachable ales."

## One World Brewing

Asheville's first underground brewery opened in 2014 in a historic building on Patton Avenue, right behind Pack Square, which always has been the epicenter of the town.

Spouses Jay and Lisa Schutz were home brewing hobbyists. After a family member opened Farm Burger at 10 Patton Avenue and showed them the building's basement, they realized it would be a great spot for a nano-brewery and taproom.

After a few years, the couple decided to expand and started looking for another building. They found one, on Haywood Road in West Asheville, and opened a production brewery and taproom in 2018 after a year of renovations. Like Asheville Brewing, Hi-Wire, Catawba and Burial before them, One World is sustaining two taprooms only a few miles apart.

"People have been concerned that we're moving, but the original One World will stay right here," Lisa said.

Lisa and Jay added managing partners to help with the expansion. Lindsay Andrasik and Thomas Perry are now co-owners of One World as a whole, and Lindsay is bar manager at the new location. The new brewery has a ten-barrel system managed by brewer Andy Shepard, while Brandon Audette remains the downtown brewer.

# A Mountain Brew History

One World Brewing's basement brewery in downtown Asheville. *Photo by Andrew Cooke.*

"We love how the new brewery contrasts with this location. There are tons of windows and a yard and garage doors. The taproom is at street level, and we have parking in the back," Lisa said. "We only ever use sixtels downtown because we have to negotiate stairs."

Brandon has the enviable position of being able to brew two or three different beers daily on the downtown system with assistant brewer Elise Spruance.

"Our situation is unique. We have twenty fermenters in constant rotation. Having two people work at this rate is unheard of," he said. "It opens a lot of room for experimentation. We brew the beers that customers love, and then we do saisons and farmhouse beers and kettle sours."

Lisa and Jay moved to Asheville twelve years ago, and according to Lisa, their mission is to connect the brewery to the city, including its eclectic musicians, artists and nonprofits. To that end, both locations offer regular live music, art shows and benefits for local organizations.

## Twin Leaf Brewery

Tim Weber, sole owner and head brewer at Twin Leaf Brewery, started brewing, because, in his words: "It's freaking cool. I'm an engineer and a scientist. Brewing is a little bit art and a little bit science. I get to build stuff and tinker and be creative."

Tim opened Twin Leaf in the spring of 2014 with his former spouse, Steph Weber, who is no longer involved with the business. Tim said he started planning a brewery in 2006, which is about when he started home brewing a batch a week—and he did so for five straight years.

He then had a two-year wait to attend the American Brewers Guild education program. He and Steph graduated from that in 2011 and soon after moved to Asheville with their three-month-old baby boy.

Tim discovered the perfect location for his brewery and taproom on the South Slope by driving around.

"I always wanted big windows. I drove by and thought, 'Look at those windows,'" Tim said. "There was no sign on the building, but when I looked it up on Google Earth, there was a For Sale sign on it with a phone number. I called the number that was on Google Earth."

Twin Leaf opened about a year after he leased the building.

"The hardest part was we had a one-year-old and I still had a full-time job, and I was hiding the fact that I was doing this from my company for a while," Tim said. "It was a lot of fricking work getting it done, even after I quit my job."

He submitted his application for the brewery's Alcohol and Tobacco Tax and Trade Bureau permit (TTB), and the next day was the 2013 government shutdown.

"I freaked out," he said. "I emailed every congress person and politician in North Carolina, and someone contacted the TTB, and we got it in twenty-eight days. It was crazy."

Tim has a full wood- and metal-working shop in the back of the brewery and a machine shop at his home. "We build everything ourselves," he said. "Everything inside and out was built by me or by me supervising one of my employees."

Over 90 percent of Twin Leaf's beer has been sold in-house, but Tim started self-distributing in kegs and five-hundred-milliliter bottles in early 2018 after adding fermentation tanks.

"I used to make clean, traditional styles, but I've started shifting toward saisons, Belgians and now more toward wild ales," Tim said. "We're starting

a barrel program, which I'm really excited about. I'm a dinghy instead of a cruiser. I can change on a dime and make new beers, and our customers stay excited too."

Twin Leaf was one of Rayburn Farm's first clients. That family-owned farm now grows numerous crops just for regional breweries.

The parking lot adjacent to Twin Leaf is now outdoor space and includes gardens to grow ingredients for small batch brews.

"My intention always was to turn asphalt into gardens," Tim said.

He adds that he loves being on the South Slope and seeing the growth of Asheville's unofficial "brewery district."

"We've been close to Burial since we opened six months after they did. We even stored all their grain for them for a year," Tim said.

He's also passionate about giving back, especially to organizations that support his interests of environmental conservation and STEM (science, technology, engineering and math) education.

"I love my job, but at same time, I kind of view Twin Leaf as my soapbox," Tim said.

For example, Mass Extinction Bourbon Barrel-Aged Imperial Stout, released annually, benefits the Asheville Museum of Science.

Regular food trucks visit the brewery, and the sandwich shop around the corner delivers to the taproom.

## Sweeten Creek Brewing

No new breweries opened in Asheville between the spring of 2014 (Twin Leaf) and December 2015. Believe it or not, that eighteen months was one of the longest stretches without a new brewery opening in the city this century. Sweeten Creek Brewing broke the drought, opening on Sweeten Creek Road south of Biltmore Village at the end of 2015.

Erica and Joey Justice and Chef Chad Gibson jointly own the brewery, taproom and sandwich shop. A husband-and-wife team and master brewers, Joey and Erica both worked at Highland Brewing, where they met, and where Joey was head brewer. Erica also worked in quality control at Oskar Blues in Brevard. Chad, formerly of 12 Bones Smokehouse, is the guy behind the brewery's simple, but delicious, menu.

"Having really good, really consistent food has helped a lot," Erica said. "We are off the beaten path, but the food options bring people in."

Both Erica and Joey had dreamed of one day owning their own brewery, even before they met. "When I first went to (brewing school) at UC Davis, I thought I was going to move back to Arkansas and start a brewery, and while education is fantastic, hands-on experience is invaluable," Erica said. "So I moved to Asheville because there were a lot of breweries here. Joey moved to Asheville for the same reason."

Originally, they were looking farther south of Asheville for their brewery location, but then they found the former automotive warehouse along a creek with more than two acres of land.

"This building had so much to offer in terms of infrastructure—a floor drain, three-phase power, high ceilings, room for growth," Erica said. "Plus the land.

Bernie, brewery dog at Sweeten Creek Brewing, guarding the tanks. *Courtesy of Sweeten Creek Brewing.*

We put in some serious sweat equity on the meadow. We hauled off so much trash and automotive stuff. And it was all overgrown."

Now the meadow is dotted with picnic tables, and throughout the summer, Sweeten Creek throws monthly Saturday parties with live music while Chad grills up food specials. The brewery even adopted a picnic table as its logo.

The poplar, cherry and oak wood on the taproom walls all came from downed trees on the property. And the sycamore bar top came from a friend's yard.

The brewery started as a one-barrel with a bank of repurposed refrigerators for fermentation. In 2017, the team added a fifteen-barrel brew house and stainless-steel fermentation tanks.

The expansion allowed the brewery to start self-distributing draft to twenty to twenty-five retail accounts. Until then, almost all of Sweeten Creek's beer was sold on-site, with three hundred barrels produced in 2017.

Around 85 percent of Sweeten Creek's customers are regulars. "In our business plan, our bread and butter are locals," Erica said. "While we hope to attract beer tourists, we don't want to depend on them. Our goal is to keep this homey—to be a neighborhood and community-focused place."

# A Mountain Brew History

As far as beers go, the brew team mostly stays with clean, traditional styles, including a house pilsner, pale and IPA. With the brewery expansion, more small-batch seasonals will be made.

"We as a brewery are sticking to more traditional styles but doing it well and consistently," Erica said. "There are a lot of blue-collar people who live and work within a three-to-five-mile radius of us, and we want to be affordable and accessible for them."

## Bhramari Brewing Company

It would take the founders of Bhramari Brewing more than two years between occupying a downtown Asheville building and opening for business, which they did in January 2016. After the extensive build out, there was a delay with their TTB (brewing) permit. So, Bhramari opened as a restaurant and taproom with guest taps. Once the permitting came through a few months later, in-house craft beers were added to the draft list.

The managing co-owners are head brewer Gary Sernack and Chef John Dillard, formerly of Zambra Tapas Bar. Founding partner Josh Berman left the business.

"We were originally looking to have just a small brewpub with snacks," said Allison Simpkins, director of operations and Gary's spouse.

Bhramari's location, behind the Orange Peel music venue, on the far edge of the South Slope and within walking distance of numerous established breweries, attracts beer tourists as well as folks looking for a beer and a bite before shows.

"The restaurant keeps people in seats, plus Josh is immensely talented. He's great at figuring out dishes that work with our beers," Allison said.

"Beer-wise, Gary has a really innate ability to put flavors together and keep them balanced. He loves making kooky, creative,

Gary Sernack, co-owner and head brewer at Asheville's Bhramari Brewing. *Photo by Erin Adams Photography.*

culinary-inspired beers, but it's rare for me to drink one of his beers and not find it approachable," she said.

Gary and assistant brewer Ryan Freeman brewed 2,700 barrels in 2017 on a fifteen-barrel system. Only around 20 percent of that was sold in-house as, once the brewery started canning via mobile canning and distributing with Budweiser of Asheville, sales took off.

"Honestly, we did not expect the stupendous response to our canned brands. Our sales have blown our projections out of the water," Allison said. She added that the brewery plans to add a new canned beer every month moving forward.

The original name of the business was Hive Mind, but a Chicago brewery already had trademarked that name. So the owners started looking for a name that would mesh with both their philosophy and the bee logo they already had designed. When they learned that the Hindu goddess of bees is called Bhramari, they adopted her name.

## Archetype Brewing Company

West Asheville, once referred to as Worst Asheville, has exploded with restaurants, bars, funky shops and yes, breweries. There's still some grit to the area, but it's being scrubbed. Housing costs are now comparable to those in downtown and North Asheville.

The first brewery to grace West Asheville was Altamont Brewing on Haywood Road, which opened in 2012. That brewery is now UpCountry Brewing. Oyster House Brewing opened a year later in a building in the middle of the West Asheville stretch of Haywood Road. After almost four years of just the two breweries, Archetype Brewing opened in the area that locals call East West Asheville, up the road from New Belgium Brewing. Since then, One World's expansion brewery and All Sevens Brewing in Westville Pub have joined the West Asheville brewing family. UpCountry owner John Cochran owns a funky old bus that he wants to use to provide transportation between all these breweries. I'm sure more organized West Asheville beer tours aren't far behind.

Brad Casanova and Steven Anan met when both worked at Hi-Wire Brewing in the quality-control lab and the cellar, respectively. The business partners co-founded Archetype Brewing and opened the brewery and taproom in January 2017.

## A Mountain Brew History

The building, constructed in the 1970s, housed Putnam's Auto Body for decades. Concrete floors with drains, rolling garage doors, significant square footage and high ceilings work equally well for both types of businesses, which is why numerous breweries have found homes in former auto shops.

Brad and Steven did tweak a few things to get the space to work. They put a grain silo outside the building and then suspended the grist case above the roof. This preserved taproom space, which is important to them. However, the partners said they had few challenges to opening the new business.

"It's kind of surprising that we had minimal setbacks from what we hear," Steven said. "I think we did it differently in terms of not trying to bootstrap stuff that wasn't in our wheelhouse."

Brad added, "It cost more, but it was worth it in that it helped us open more quickly."

Steven, as head brewer, manages the production side of the brewery, while Brad handles all other management, including financials.

Most beer is sold on-site, although Archetype started self-distributing kegs to a few retail accounts about a year after opening. The brewery produced 240 barrels in the latter half of 2017 and is running at about a quarter of its capacity, per Brad.

Co-owners and founders of Archetype Brewing, Brad Casanova (*left*) and Steven Anan, working hard. *Photo by Sally Tanner.*

"Our model is taproom-focused. It's very important to us to have a close connection to both our beer and to the end user," Brad said. "We want to make this a place for family and community-centered space."

Steven added, "Our focus is on quality. We don't want six-packs sitting on shelves where we can't control the variables."

Steven brews on a ten-barrel system and keeps two ten-barrel fermenters dedicated to Brett or mixed-culture beers.

"Our beers are Belgian-inspired and saisons and some American ales. We're not doing sours, but straight up funky saisons," Steven said. "We're also diving into the Brett side as well. Brett is a totally different monster, and the consumer is starting to go that direction."

Local developer Jim Diaz owns the large piece of property on which Archetype sits, and he's been thoughtful about the local businesses going into the space, said Brad. On the same corner are Pizza Mind Restaurant, Gan Shan West and Owl Bakery. Archetype encourages customers to bring in food from the restaurants and bakery to enjoy with their beer.

## Ginger's Revenge Craft Brewery and Tasting Room

Asheville's first and only ginger beer brewery, Ginger's Revenge, opened in the spring of 2017 in a warehouse at the corner of Riverside Drive and Broadway Street.

Co-founders David Ackley and Cristina Hall took time off to get married in the brewery's tasting room just after opening it. David is fairly sure that Ginger's Revenge is the first craft ginger brick-and-mortar brewery in North Carolina.

The couple met in Nashville, and their first vacation together was in Asheville, so the city has always been important to them. When they met, David was a home brewer, and it soon became Cristina's hobby as well. Then the couple moved to Panama.

"We wanted to continue home brewing, so we would pack hops and grains and fly them from the United States to Panama," David said. "Then we were home at a family reunion and tried alcoholic ginger beer. We realized we could make it in Panama without importing ingredients. Soon after that, Cristina went gluten-free, so it seemed ideal."

Then they moved to Asheville, and they took their ginger beer to a couple of home brew festivals, where the response was overwhelmingly positive.

"A decent number of people are unsure about what we're doing," David said. "We are classified by the TTB as a brewery because cane sugar is an alternative to malted grains, so we are a brewery. One of the nice things about our product is it's a gluten-free option that's classified as a beer."

He added that while there's lots of literature on how to make malt and hop-based beers, there's not much on how to produce ginger beer on a commercial scale. David said they are learning every day and, he hopes, getting better every day as well.

Ginger's Revenge does make a few traditional beers, including an IPA and a rye saison. "We encourage people to get creative with mixing our ginger beers with other beers or rums," he said. The ginger mostly comes from Hawaii and Peru and is 95 percent organic. David also sources local ginger for an Appalachian Ginger Beer.

The brewery started bottling a few of its ginger brews in late 2017 and selling those at local bottle shops.

"There are a handful of ginger beer brewers around the country, but it's a trend that I think will increase," David said. "At one time, before Prohibition, there were hundreds of us. During Prohibition, ginger beer morphed into nonalcoholic soda."

Ginger beer was once popular in North Carolina. Going back to the 1860s, newspapers often ran recipes for fermenting the brew at home. Those recipes stopped appearing in print in the early 1900s with the rise of the temperance movement.

For example, an 1873 article titled "Summer Drinks" in the *Goldsboro Messenger* leads with:

> *At this season of the year the farmer and his laborers require some cooling but palatable beverage that will quench their thirst, and not heat or intoxicate their blood, yet will afford a grateful stimulant to their digestive powers. And among all the stimulating substances which are employed in making these drinks, there are none superior to ginger, and none more easily procured or equally refreshing.*

The article goes on to note that fermented ginger beer is "highly relished by ladies of weak digestive powers, as well as strong laborers in the fields."

The same article also offers a recipe for homemade "hop beer" using powdered ginger for flavoring.

Later North Carolina newspaper opinion pieces note that temperance proponents often discounted the intoxicating effects of ginger beer, to their detriment. Ginger beer was so accepted and widespread that apparently even the drys often forgot it contained alcohol.

Interestingly, the "Summer Drinks" article said of the hoppy ginger beer, "It is well on large farms to make a fifteen gallon keg of it, and let men drink of it freely, and they will rarely care or ask for rum or whiskey, and when this evil can be done away, surely the housewife will not grudge the extra labor she incurs in preparing a beverage which will cheer but not intoxicate."

## Habitat Brewing Company Tavern & Commons

Just north of downtown Asheville, next to the world-famous Moog Music factory, is a small-batch brewery that, true to its name, has become a neighborhood and community gathering spot. Owners Jen and Matt Addis like to use the entire name, Habitat Brewing Company Tavern & Commons, as each piece of the name is part of their larger intentional puzzle.

"Our logo is a table, and we chose that because being gathered around a table is as important as what you're drinking," Matt said. "In European villages, the town hall, the church and the tavern are the three pillars of the community."

The couple founded the business with Jonathan Myers in late 2016. Myers has since moved out west and sold his shares to Luke Liengel and Christine Madonna. Matt and Jen remain majority owners.

"We hope people come here for the dialogue and the relationships and the intentionality, along with the good beer. We use the word 'commons' because we wanted to be intentional about making that part of our identity," Matt said.

It took about a year to renovate the building, which they gutted, taking it back to the original brick walls and tin ceilings. Matt, a carpenter in his former life, built all the tables and the bar himself. Matt and Jen's second child was born nine days before the taproom opened.

The brewery is divided into two long rooms, one containing the brewing equipment and bar and the other a community space, with a performance area and plenty of picnic-style tables for meetings and the like.

The brewery offers some unique programming, including Pint with a Professor, a monthly presentation and discussion with a University of North Carolina at Asheville professor, a monthly Beer and Hymns night and regular improv comedy performances.

A Mountain Brew History

Reflecting its name, Habitat Brewing Company Tavern & Commons in Asheville is a community hub. *Photo by Anne Fitten Glenn.*

"About a quarter of the stuff we facilitate, but now folks come to us," Matt said. "We've even had weddings and receptions. The space also is available for meetings even when the bar isn't open."

Matt focuses on brewing, and Jen does all the event and programming organization. He brews on a one-and-a-half-barrel system. The taproom opened with guest taps for the first four months because its TTB hadn't arrived.

Former home brewer Matt describes his brewing style as "creative within tradition." For example, he brews a Baltic porter instead of a regular porter. Other house taps are traditional English-style beers, including an oatmeal pale and a stout. On Broadway just north of I-240, Habitat attracts numerous neighbors, but it isn't yet on tourist radars.

"Right now we're on the wrong side of town, but it soon may be on the right side of town the way things are going," Matt said. "There's no foot traffic here yet, but there's also no more room downtown. I think this corridor will be next to develop."

He added, "We do get a great response from the tourists who find us. They know they are coming into a locals' spot. That's the identity we want to develop."

## UpCountry Brewing Company

John Cochran was the co-founder of Terrapin Brewing in Athens, Georgia, which he opened with Spike Buckowski in 2002. When Terrapin sold to MillerCoors, the twenty-year brewing veteran knew it was time for him to leave.

"When MillerCoors closed on Terrapin in August 2016, they already had a minority stake in the brewery," John said. "It was a good decision for the company, but it just wasn't where I wanted to be."

At that point, Asheville's Altamont Brewing Company was on the market, and John felt like it was where he wanted to be.

"It's Asheville," he said. "If you're in the beer industry in the Southeast, you're going to come through Asheville at some point. And I knew I wanted to be involved with something in the North Carolina mountains."

His goal was to try to improve on what Altamont had built without changing the neighborhood vibe.

"Craft beer is all about community, and Gordon had built up a great community here," John said, referring to one of Altamont's founders, Gordon Kear.

"There's a romance to craft beer, and everyone wants to get into it for that reason, but people don't realize the amount of hard work and capital needed," he added. "And there's so much competition now. We are constantly questioning ourselves and asking ourselves how we're doing and if we're doing the best we can."

# A Mountain Brew History

UpCountry Brewing Company owner and founder John Cochran. *Courtesy of UpCountry Brewing.*

He purchased two fifteen-barrel fermenters to double capacity right away and added an in-house canning line. He also renovated the restaurant next door, which was part of the sale. The taproom moved into that area so the brewery has room to expand. The restaurant, formerly a wood-fired pizza and Italian eatery, has been revamped into a brewpub with a back deck, front patio and grassy outdoor space.

John plans to limit beer sales to the Carolinas only. He initially self-distributed UpCountry draft and cans, which wasn't possible in Georgia. The brewery signed with Budweiser of Asheville for WNC distribution in early 2018. John said his end game is to hit a maximum of three thousand barrels annually.

"In my opinion, you have to be relevant in your local market," John said. "If you can't do that, you aren't going to be relevant anywhere else, especially today, now that there are so many other breweries."

He added, "When we opened Terrapin, we were considered local across the Southeast, but now Terrapin isn't even considered local in Atlanta. Terrapin became a big brewery really fast."

John may look into replicating the small brewpub model elsewhere at some point, but he noted it has to be the right place and time.

"When breweries get up to twenty-five thousand barrels or higher, that's no man's land," he said. "Then most of your money has to go into sales and marketing."

John helped the brewing team develop new beers and tweaked a few of Altamont's brews. Upcountry's Hop Dread, a red IPA, was an original Altamont beer. John also added a kettle sour series.

Any beer available in UpCountry's pub is available to West Asheville watering holes up and down Haywood Road, the area's main corridor.

"We talk about ourselves as a West Asheville, not an Asheville, brewery," he said.

The name UpCountry is a reference to the mountains that John loves, although he still lives with his family in South Carolina, a two-hour drive from the brewery. He cited the high price of housing in West Asheville as problematic and mentioned that he typically sleeps on a cot on the brewery stage when he's in town.

## Hillman Beer

Hillman Beer is another example of a small family-owned and operated brewery. Brothers Greig and Brad Hillman and Greig's spouse, Brandi Hillman, opened the brewery in 2017. It's located on Sweeten Creek

The family founders of Asheville's Hillman Beer. *Left to right*: Brad, Brandi and Greig Hillman. *Courtesy of Hillman Beer.*

Road about halfway between French Broad River Brewery and Sweeten Creek Brewing.

Brandi grew up in Sylva, and she and Brad also own three Subway restaurant franchises. Additionally, she and her sister own a feed and seed store in Cullowhee.

"I've been drinking craft beer since I was eighteen in Jackson County and getting made fun of," Brandi said. "Then I worked in Yellowstone one summer and tried all these amazing beers. It was eye-opening."

Brandi also claims "deep roots in moonshine": "I grew up with it, but the boys made me stop selling moonshine when we got our TTB."

Brad started home brewing in a tiny apartment in Brooklyn while Greig and Brandi were home brewing in their garage in Oakley. When they saw the Sweeten Creek Road building was for lease, they jumped on it. Brandi's mom was the contractor on the build out.

Brad has taken on the role of head brewer, developing recipes he's been working on for years on the brewery's five-barrel system.

Hillman opened with a separate business, Rise Above Deli, providing an in-house sandwich shop. There's also parking and an outdoor patio area.

In its first year of production, Hillman won a bronze medal at Great American Beer Festival for the Belgian Quad.

"We were shocked," Brandi said. "We were pouring at Asheville Oktoberfest, and our phones started blowing up."

## Eurisko Beer Company

High school buddies Zac Harris, Zack Mason and Matt Levin opened one of Asheville's newest breweries, Eurisko Beer, in the spring of 2018. The taproom-focused brewery is on the southern edge of the South Slope behind Adam Dalton Distillery.

The historically industrial area is still home to a few auto repair shops, but that is changing with a high-priced condominium complex going up next to Eurisko and the recent transformation of a nearby gas station into a Takosushi restaurant. The brewery sits at the foot of Lee Walker Heights, Asheville's oldest public housing project, which Buncombe County has committed to rebuild as mixed-use affordable housing starting in 2019.

The friends hail from Charlotte, but they all fell in love with Asheville said Matt, Eurisko's general manager. The brewery spans two conjoined

The team behind Asheville's newest (as of 2018) South Slope brewery, Eurisko Beer Company. *Back to front*: Zac Harris, Matt Levin and Zack Mason. *Courtesy of Eurisko Beer.*

buildings—one contains the brewing operations while the other houses the two-story taproom. The parking lot will become a beer garden with a serving window. The downstairs taproom formerly was the location of Flavorz Beauty & Barber Shop.

Zac is the brewery owner and brewer, while Zack (with a K) is head brewer. Zac attended the prestigious Siebel Institute for brewing school, which included a stint at Doemens Academy in Munich, Germany. He then worked at Charlotte's NoDa Brewing, one of North Carolina's largest breweries. However, his goal has always been to own his own small brewery and produce approachable, traditional-style brews.

"We're brewing a lot of hoppy stuff and some saisons," Matt said. "We're sticking to clean fermentation because of the size of the brew house (fifteen-barrel system). We like our beers dry. We'll be playing with some lagers too."

Initially, the team will sell beer only on-site, but they are exploring limited self-distribution. Bottles of specialty beer are for sale in-house as available.

"We're just about good beer. That's the point behind it all. We're not trying to be a global brand," Matt said.

Eurisko is a Greek word that's related to eureka and means "I find" or "I discover." It's also the name of a fictitious artificial intelligence company in the television series *The X-Files*.

# A Mountain Brew History

## All Sevens Brewing

Westville Pub owner Drew Smith added an on-site brewery to his successful watering hole in 2018. The five-barrel brew house, named All Sevens for the street address, 777 Haywood Road, opened with brewer Dirk Hillegass at the helm.

Drew's mother and her partner founded Westville Pub in 2002, and Drew took over a few years later.

"When we opened, it was a different world here in West Asheville. It was just us and West End Bakery," Drew said. "That isn't the case anymore. We get tourists now."

He laughed about making a T-shirt for the pub in 2004 that read, "It's where the tourists will never find you."

Drew purchased the building next door to Westville to add the brewery. He took down most of the adjoining brick wall to add brewing equipment, a second bar and additional seating.

"How often do you get the opportunity to buy the space next to you? You gotta do whatever it takes to make it happen," Drew said. "We were bursting at the seams already, and we'd been thinking about a brewery. We make our own bread here, why not make our own beer too?"

Dirk Hillegass, head brewer at All Sevens Brewhouse inside Asheville's iconic Westville Pub. *Courtesy of All Sevens Brewhouse.*

The expansion also made more room for the kitchen and an updated menu. Except for a few days, the pub remained open throughout the remodel.

"The community of beer people have been so helpful. It benefits everyone to have all these breweries on the street," Drew said.

Dirk was Highland Brewing's cellar manager. His beers vary from classic styles, including lagers, to oak barrel-aged and cask-conditioned experimental brews. "We're chasing Zebulon in packaging in champagne bottles," Dirk said. Bottles are sold on-site.

"Because of our setup, we'll have some of the freshest beer in town," he said. "We have the potential to go directly from our conditioning tanks to our taps."

The plan is to sell All Sevens brews in-house and via limited self-distribution in West Asheville.

"We realized that with a wheel dolly from here, we can self distribute to nineteen establishments within an hour—on foot," Dirk said.

## Brewery Cursus Keme

Also opened in Asheville in the spring of 2018 is Brewery Cursus Keme, the brainchild of Jeffrey Horner.

If you're counting, that's three new breweries within just a few months in Asheville, with at least two more scheduled to open soon after. So, with thirty Asheville breweries (not counting those that have brewing operations in more than one location), that's one brewery for every three thousand residents, based on a city population of just under ninety thousand. Often, the Convention & Visitors Bureau and other groups tout the numbers of breweries in the greater Asheville area, including places like Fairview and Fletcher. However, I'm referring only to breweries inside the city limits for this per capita equation.

Jeffrey owns Brewery Cursus Keme with his wife, Jessica. He has been brewing professionally for twenty-one years. Among other positions, he was brew master at Cisco Brewery on Nantucket Island, where he developed that brewery's first barrel program.

Jeffrey's approach to brewing is unusual, to say the least. He disdains modern equipment. His mash/lauter tun is a wooden foeder that he cut in half. The wort is pumped into a specially fabricated copper kettle outside of the building, which is above a brick firebox. He brews over direct fire, either cordwood or charcoal. The majority of the beers are then fermented in oak foeders, puncheons or barriques—all of which are types of old-fashioned wooden casks.

"Our mill is as modern as mills get, but the rest of the brew house is very old world," Jeffrey said. He's had some equipment custom fabricated to his specifications, including a grist mixer.

"We worked through a six-month battle for permits with the city because they were confused by what we were doing," he said, laughing. He's been working on this concept since 2011.

The brewery and beer garden are on the end of Thompson Street. It was the home of the Wright family from 1931 until one of the original owners'

grandsons started a trucking business there in 1968. Jeffrey purchased the property a couple years before opening the brewery.

"They didn't want to clean it up, so we have a bunch of relics. Others might call it a junkyard," he said. "But my goal and intent is to purchase nothing new."

He also noted he doesn't want to put too much focus on the brewery but on the beer garden destination on the two-plus acres along the Swannanoa River.

Cursus is a Latin word that means "courses."

"I've taken artistic license with the word. I want to reflect the historical courses of the relationships between humans and beer that we've been developing for millennia," Jeffrey said. "Also, I like doing things differently. I'm not trying to squeeze seven shift brews into twenty-four hours."

Jeffrey said he and his wife chose Asheville as the spot to open their brewery primarily because of the educated beer drinkers in the area.

"My beers are esoteric and off-the-beaten path. Lambic-style and mixed fermentation and esoteric beers aren't training wheel beers," he said. "We had to come to a community that understands the types of beers we're trying to produce. Part of that was having educated beer lovers."

He added:

> *It's amazing here. One of my favorite things to do is to visit breweries, and I love that here I can visit two or three a week. The majority of people in our industry aren't in this for the bottom line. It's completely passion-driven.*

# 12
# BEER'S PIT CREW

As the number of breweries have increased, so too have the number of ancillary businesses that support the industry. The economic development world refers to these as the supply chain, meaning all of the interconnected businesses, organizations, people and resources that serve the same customer, which, in this case, are the breweries.

These suppliers naturally divide themselves into three groups: those that provide breweries with stuff, from raw ingredients to tap systems; those that showcase the beer, from festivals to tours to wholesalers to bottle shops; and those that advise breweries, from law firms to insurance providers and marketing firms.

It's next to impossible to write about every Western North Carolina business that has a toe, or even a foot, in the beer industry, so I primarily touch on those that have a true symbiotic relationship, like that between clownfish and sea anemones.

This chapter explores beer's support team, from farmers to home brewers and educators, and ends with some recent economic indicators and a look into the crystal ball.

## Raw Ingredients

When most folks raise a pint, they aren't necessarily thinking about where or how the ingredients used to brew that beer came from. However, what's in

what we imbibe can be important, both from a sustainability point of view as well as a health perspective.

"There's a movement happening where people want to be connected to where their food and beverage comes from," said Nicole Dexter, co-founder of Innovation Brewing. "I think that will only continue to grow."

The primary ingredients in beer are water, hops, malted grains and yeast. According to the ancient German brewing purity law, Reinheitsgebot, only those four ingredients can be used to create beer. There certainly are many, many American beers that utilize only these ingredients. There also are many, many American beers that contain additional ingredients, often referred to as adjuncts, from spices to fruit and coffee.

More and more, I'm hearing the word *terroir* used in relation to craft beer. Terroir is the French word that describes wine flavors arising from specific soil, topography and climate. Farmstead breweries, such as Turgua and Flora Fonta, grow many of their own ingredients. Numerous other breweries have urban gardens or small hop yards on-site. The relationship between agriculture and brewing in Western North Carolina has never been stronger, and my guess is that it will continue to strengthen as the locavore movement does.

"I am loving the farming renaissance we are seeing across North Carolina. We are presented with incredibly unique and different crops each day, offering us the ability to make more North Carolina–terroir beers," said Doug Reiser, co-founder of Burial Beer.

## Water

Let's start with water, which typically makes up 90 percent or more of a beer's volume. Throughout this book, brewers laud the water quality of Western North Carolina again and again. It is one of the reasons to open a brewery here.

Water can have terroir, based on geology, pH and mineral content. Just as New Yorkers claim the city's bagels and pizza dough are so good because they're made with New York water, a region's water and water sources can affect beer flavors and influence favored styles.

WNC's mountain water filters through rock and comes out cold and clear with a neutral pH. This soft water is perfect to brew with—it's similar to cooking in that it's always easier to add salt than to remove it.

"The quality of the water is really exceptional. It's so, so clean. It's almost like brewing with distilled water," said Sean Coughlin, quality manager at BearWaters Brewing.

## Hops

Primary ingredient number two, hops, is the scarcest of the four in WNC. In 2017, hopped-up IPAs accounted for more than 25 percent of total craft beer sales in the United States according to the Brewers Association. The enormous popularity of hop-forward beers has created a correspondingly high demand for the hop flower. Local farmers, though, are not meeting that demand.

There currently aren't enough hops produced in Western North Carolina to brew more than a few batches of beer. Hop farming is risky, labor intensive and requires a large capital outlay. Newly planted rhizomes can take three years to start producing the cone-shaped flowers sold to brewers.

Most hops varieties grow best at higher latitudes in arid climates. Long summer days offer more daylight for faster growth, and dry weather keeps mildew from decimating the crop.

"There's so much demand for local, local, local, but 99 percent of U.S. hops are still grown in the Pacific Northwest," said Beau Evers, Southeast account manager for Crosby Hop Farm, a fifth-generation grower based in Oregon. "More than 40 percent of the U.S. hop crop is now purchased by craft breweries. Acreage has doubled in the U.S. to respond to this demand."

Western North Carolina's latitude is right on the edge of the minimum number of daylight hours this perennial plant needs.

"Hops really love long days," Beau added. "I think there absolutely is a market for small niche hops growing, but if small growers can't produce quality product and get yield, they're going to need to change that product up."

At the Mountain Horticultural Crops Research Station in Mills River, Dr. Jeanine Davis and her team have been testing hop varieties to see what grows best in the Appalachians for several years.

Cascade, a versatile and popular hop, has been the winner in terms of production in the research station's hop yard. Chinook, Nugget and Galena hops are also showing promising yields there. But the risks remain considerable.

Julie Jensen, owner of EchoView Farm in Weaverville, spent eight years experimenting with hops farming and production before losing most of her plants to downy mildew in 2015.

"It wasn't a viable project for us to continue," Jensen said. "My advice to farmers starting out is to make sure to get disease-free rhizomes and make sure that you have enough land."

EchoView now operates as a fiber mill, processing wool from alpaca and sheep, and the former hop fields are planted with sunflowers, heirloom corn and sorghum.

Most small regional hop farms sell their crop to area brewers as fresh hops, harvested in late August, for use in wet-hopped beers. Ideally, fresh hops need to be tossed into a brew kettle within hours of harvest. Compared to dry hops, however, it requires four times the amount of fresh hops to produce the same levels of bittering and aroma. As a result, buying local hops can demand a significant cash investment on the part of breweries. But that investment tends to pay off.

Western North Carolina farms growing hops include Hop'n Blueberry farm in Black Mountain, Sticky Indian Hops Farm in Candler, Blue Ridge Hops in Marshall, Winding River Hops in Clyde, Mountain Hop Farm in Waynesville, Holmes Brothers Farm in Leicester and New River Hops in Laurel Springs (Alleghany County).

Sticky Indian Hops Farm is owned and run by three generations of the Davis family on farmland that's been in their family since the 1930s (no relation to Jeanine Davis). The farm supplies freshly harvested hops to several regional breweries, including Catawba Brewing. The Davises call one of the varieties the "grandmother" hop, as it is a descendant of a hop plant brought from an ancestor's homestead in Cashiers and planted on the Candler farm.

Numerous breweries, including Blue Ghost Brewing, have a hop yard, where they showcase a few hop bines. They may even produce enough for a small-batch wet hop brew at harvest time.

As the university extension program and local farms continue to experiment with native hop plants, the hope is that they will discover hardy varieties that grow well and profusely in WNC.

## Malt

The third ingredient in beer, malted grain, is a hometown success story.

Riverbend Malt House takes local sourcing seriously by purchasing only barley, wheat and rye grown within a five-hundred-mile radius of Asheville. That acreage is increasing, benefiting both farmers and brewers. Riverbend now sources from five states.

Even Biltmore has joined the game. The estate cultivates barley on thirty acres. After harvesting, it's malted at Riverbend and then trucked to Highland Brewing, where it's brewed into one of Biltmore Brewing Company's beers. Then those beers are sold at Cedric's Tavern on the estate.

Business partners and Riverbend founders Brent Manning and Brian Simpson opened their craft malt house in 2010. When I first wrote about micro-maltsters in 2011, there were only a handful in the nation, and Riverbend was the one and only operating in the Southeast. Now, there's an American Craft Malt Guild, with eighty malt house members and eighty in planning, said Brent. And Riverbend is no longer micro.

"The support from the local brewing community has been phenomenal. We work with almost every brewery in the region, and 50 to 60 percent of our product stays in WNC," Brent said.

Operating this way is not necessarily the most economical route: purchasing from small farms and malt houses costs more than buying in bulk for the breweries, even when factoring in the cost of shipping hops and malts grown and processed in the Pacific Northwest or Canada.

In the malting process, the grain is soaked, allowed to germinate and then heated to stop the germination. Color in craft beer depends on the roast of the malt. A lightly roasted malt will produce a pale beer, while a deeper roast produces a darker beer. One of the world's most persistent beer myths is that darker beers are stronger than their lighter brethren. However, the color is merely a reflection of the roast level of the grain.

One past challenge for Riverbend has been that most of the barley grown in the Southeast is the six-row variety, while many brewers prefer two-row. The difference is what you think: six-row has six rows of kernels at the top of the plant, while two-row has two. Per Brent, two-row grain is plumper, more uniform in size and easier to work with for both the maltster and the brewer.

"There has been a persistent myth that two-row barley couldn't viably be grown in the South," Brent said. "Working closely with our farming partners, we now can source locally grown, high quality two-row from which we are able to make spectacular malt."

In 2017, Brent and Brian brought in experienced local businessman Scott Hickman as CEO and co-owner. Scott helped the team raise funds for an expansion. In early 2018, Riverbend started producing malt at its new seventy-four-thousand-square-foot location in South Asheville. The expansion increases annual capacity from about 500,000 to 3 million pounds of malted grains. The malt house regularly sells malt to more than one hundred southeastern breweries, with around forty of those being regular customers. The business also supplies distilleries.

Regionally sourced and locally malted grain at Asheville's Riverbend Malt House. *Courtesy of Riverbend Malt House.*

"The distillery market is coming on very strong even though we don't have a specialty distilling malt yet. It turns out that craft distillers are interested in the same thing as craft brewers are in terms of production," Brent said. "They don't mind if the process is slow, as long as the result is flavorful."

In 2014, the Country Malt Group, which supplies malt to breweries and home brewers across America, moved its Southeast distribution warehouse from Hickory to Fletcher. The company said it did so in order to add milling capacity, but the location, across the street from one of the biggest production breweries on the East Coast, Sierra Nevada, doesn't hurt.

## YEAST

Then there's the magic ingredient, the living organism that produces the alcohol and the carbon dioxide and turns a watery vegetal mix into the lovely nectar we call beer.

Chris White, White Labs president and co-owner, spoke at a fermentation sciences class at Appalachian State University in 2012. He liked what he saw. So much so, that in early 2016, San Diego–based White Labs opened an East Coast manufacturing, packing, shipping and education facility in Asheville in a building formerly owned by the city.

"We're basically farmers. We're yeast farmers," said Lisa White, White Labs vice president and co-owner. Former spouses Lisa and Chris started the business in 1995. Today, White Labs provides yeast for fermentation businesses all over the world. In addition to San Diego and Asheville, the business has a third manufacturing operation in Copenhagen, Denmark. White Labs also has a distribution warehouse in Hong Kong, a tasting room and shipping facility in Boulder, Colorado, and a research division in Davis, California.

After Sierra Nevada and New Belgium opened expansion breweries in Western North Carolina, city and county governments began to see the multilayered economic benefits to the craft beer boom.

"When we learned about White Labs and the incredible things they've done, we started reaching out to them," said Clark Duncan, executive director of the Economic Development Coalition of Asheville & Buncombe County. "At first they maybe thought we were crazy, but that's where you want to be as an economic developer. You want to know what the business needs before they do."

Lisa commented, "We were looking for the same type of camaraderie for breweries that we have in San Diego. Asheville is a lot like San Diego was fifteen years ago. Here the ABA (Asheville Brewers Alliance) is really starting to go strong. Also they really wanted us here."

"I've had boyfriends who didn't try that hard," she added, referring to Clark and his team.

She cited the importance of having a trained workforce from regional brewing education programs as well.

The 172 South Charlotte Street building was constructed in the 1890s as stables and once housed Asheville's police department, but in recent years, it had been used for maintenance and storage.

"It was twenty-five thousand square feet of storage of old water pipes and old Bele Chere posters, and it was kind of like walking into grandma's attic," Clark said.

The city agreed to lease the building to White Labs for one dollar per year for the first five years. "Because the equipment for the inside of the building was going to be so expensive," Lisa explained. In exchange, White Labs agreed to hire sixty-five staff at a living wage within those five years. Within the first year of operation, fifty people already were employed there.

Most significant has been the cost savings on yeast, especially shipping, not only for North Carolina breweries but also for those in nearby states.

"We're a lot closer to a lot of our customers here," Lisa noted, which she said was a primary reason to open an East Coast facility.

Culturing yeast at Asheville's White Labs facility. *Courtesy of White Labs.*

"White Labs lowers the cost of doing business and also lowers the cost of innovation for the industry within this community," Clark said.

Numerous Asheville brewers now walk or drive to White Labs to pick up yeast themselves. I'm sure White Labs Kitchen & Tap, with its gastro-pub menu and taproom, has something to do with that.

White Labs also counts as a brewery, as the business touts a three-barrel pilot system. One of the more unique WNC beer education experiences is to try three or four of the same beers with each made with a different yeast strain. Even those of us who have been drinking craft beer for, ahem, decades, can learn a great deal from this experience.

## Adjuncts

Rayburn Farm in Barnardsville is mentioned again and again by WNC breweries when they discuss their beers.

Husband-and-wife Michael and Lauren Rayburn started the farm in 2014. Michael, who admits that he's not a beer drinker, first connected

with breweries via Zebulon's Mike Karnowski. It started when Mike, his wife, Gabe, and the Rayburns got together to roast local pie pumpkins for a Zebulon brew. Mike told Michael to go talk to Luke Dickinson, Wicked Weed co-owner and brewer. In 2015, Rayburn Farm got the contract to provide that brewery with basil for its popular Coolcumber Golden Ale. Business has snowballed from there.

"I just started knocking on doors and showing up at breweries and asking brewers what ingredients they wanted," Michael said.

In his second season of full-time farming, Michael sold crops to twenty-six breweries. Crops include multiple varieties of turmeric and basil, ginger, hibiscus, orange mint, garlic, pineapple sage and lots of flowers.

At present, around 75 percent of Rayburn's crops go to breweries. Secondary local businesses they grow for are ice cream and donut shops.

Other farms supplying crops directly to breweries are Hop'N Blueberry Farm of Black Mountain, Cedar Grove Blueberry Farm in Cedar Grove (the foothills area) and numerous Henderson County apple farms.

Also falling into the adjunct category are candy and chocolate purveyors, including French Broad Chocolate Factory, Postre Caramels and Mountain Air Roasting, all in Asheville, and Dynamite Roasting in Black Mountain (the latter two are coffee roasters).

## More Team Players

Numerous beer-centric businesses are located or have relocated to WNC, as it makes sense to be near a pool of customers.

Arden-based Divinity Beer Systems sells and installs draft beer systems and equipment, and its crew members are on the ground throughout WNC making sure beer is pouring as it should. In 2016, Asheville-based Land of Sky Mobile Canning sold to Iron Heart Mobile Canning based in New Hampshire. As canned beer has become more and more popular, many regional breweries are experimenting with that packaging option. Iron Heart lets brewers experiment with canning before committing to the capital outlay needed to purchase in-house equipment.

A Mountain Brew History

## The Home Brew Crew

One of WNC's longest running beer-related businesses is Asheville Brewers Supply. Started by beer pioneer Andy Dahm in 1994, the current owner is Theodore Clevenger, who started there as an employee.

In addition to brewing equipment, the shop sources local hops, spices and herbs, hot sauce, vinegar mother, seasonal apples and pumpkins and even fruit-infused Belgian Candi syrups.

Home brewing became legal in 1978. For the record, distilling without a license remains illegal in America.

There's a symbiosis between those who brew for a livelihood and those who brew as a hobby. And, of course, there's crossover. Many professional brewers started out as home brewers. Many of them still make beer at home in addition to doing so in their day jobs. On the other hand, there are home brewers who aspire to making a career out of their passion and those who are happy to stick to small-batch kitchen-based production.

Many of Theodore's home brew customers have gone on to open breweries, and they still contact him to fill in the gaps.

"They will call and say they're brewing a pilot batch and need eight pounds of lactose or a bag of specialty grains or yeast. Or they need a new regulator or coupler on the fly," he said.

The region's home brew club, appropriately called Mountain Ale & Lager Tasters (MALT), was established in 1998 by a small group of enthusiasts. MALT's early membership produced at least one professional brewer; two master level–certified beer judges and several national-level judges. (The Beer Judge Certification Program is a nonprofit that certifies and ranks U.S. beer judges.)

"It was a desert when I started out—you could get a few hops and a few malts, but there wasn't much variety of ingredients or much equipment available," said MALT founding member Dave Keller, better known in the beer community as Bat Cave Dave. "Now we have access to a tremendous variety of ingredients, and there are leaps and bounds in the quality of home brew equipment."

Alex Buerckholtz, an award-winning home brewer and a former ABS employee, opened Hops & Vines in West Asheville in 2008 as a combination bottle shop and home brew supply store. He sold the store after eight-plus years, but the new owners stopped selling home brew equipment in 2018. Fifth Season Gardening in downtown's South Slope area sells home brewing ingredients and equipment as well.

"More than 95 percent of our sales are local," Theodore said. "It's helpful that we have a strong agricultural community here. We can support other local businesses and offer local products to our brewers."

Local breweries and beer businesses often sponsor home brew events, including the Blue Ridge Brew-Off, which is one of the biggest annual home brew competitions in the Southeast. MALT runs the event, which Highland Brewing has hosted for many years.

Many local home brewers also compete at Just Economics' Just Brew It, an annual Asheville-based home brew festival.

## Beery Education

Then there's the workforce supply. Western North Carolina is now rife with brewing education programs, and many who study here end up working here as well.

Boone's Appalachian State University approved a four-year fermentation sciences degree program in 2012.

A year later, the Craft Beverage Institute of the Southeast (CBI) established the nation's first two-year degree program in brewing, distilling and fermentation. CBI is part of Asheville-Buncombe Technical College's well-respected Culinary Arts and Hospitality Management program. Former commercial brewer Jeff "Puff" Irvin is the institute's director, and the lead instructor is former Highland Brewing head brewer John Lyda.

"We have former students working at many local breweries, including Sierra Nevada, New Belgium, Hi-Wire, Wicked Weed, Burial and One World, as well as all over the country," Puff said. "My goal is to get former students everywhere, so I potentially get a free beer or cocktail wherever I go."

The program has gained renown, with students attending from all over the country and even abroad. Puff said the majority already have a four-year degree, but they come to the program because they are looking for a career change.

In addition to having on-site brewing and distilling equipment, CBI sends students to intern at local breweries.

"Brewing is something you have to learn hands-on," Puff said. "Sensory, in particular, needs to be hands-on. You can't learn how to smell or taste off-flavors from a book. I can give you a book on how to drive a car, but I'm not going to hand you my keys."

## A Mountain Brew History

Sarah Hedburg, now a brewer at Hi-Wire, when she was a fermentation sciences student at AB-Tech's Craft Beverage Institute. *Courtesy of Craft Beverage Institute.*

While CBI was the first, there are now other two-year brewing programs in North Carolina at Blue Ridge Community College and Rockingham Community College. Asheville's South College also offers a certificate in professional brewing science, which takes around six months to complete, and an associate's degree with an emphasis on the field. Local brewers and beer industry workers teach most of the classes.

## Showcasing Beer

It can be difficult to find "big beer" on tap in Asheville. Looking for a Budweiser or a Miller High Life? You may be able to find one of those in a bottle or can, but many retail accounts don't want to waste a draft line on beers that don't sell as quickly as local craft brews. That's been one of the biggest changes of the past decade and one that is rippling out throughout much of WNC.

The trend started with Barley's Pizzeria & Taproom in downtown Asheville, which hasn't sold an American domestic beer since opening in 1994. Numerous WNC craft breweries sold their first off-site keg to Barley's. Many restaurants and bars have followed the path first paved by Barley's, although few have stayed as true to it. That's one reason so many young

Brewgrass Festival owner and manager team. *Left to right*: Jimi Rentz, Danny McClinton and Eddie Dewey. *Photo by Anne Fitten Glenn.*

breweries can survive with limited self-distribution. WNC watering holes clamor for local beer, and beer buyers often sniff out new breweries faster even than beer media.

"I feel like I accomplished what I set out to do with Barley's and with Brewgrass—which was to teach people that there was something out there other than macro beer," said Barley's co-owner and Brewgrass founder Jimi Rentz.

Jimi started Asheville's Brewgrass Festival, one of the Southeast's first craft beer festivals, in 1996. It still takes place annually, typically on the third Saturday in September. In a "how times have changed" moment, Jimi recalled that in the beginning, festival organizers had trouble finding a nonprofit that would accept proceeds from an alcohol-centric event. They also had difficulty finding bluegrass bands that would play there. Finally, the Big Brothers and Big Sisters of Asheville agreed to be the festival's primary beneficiary. Over twenty-one years, that organization received more than $200,000 from the festival, said Jimi.

Beer City Festival, a joint project between Brewgrass organizers and the Asheville Brewers Alliance, takes place annually during Asheville Beer Week. Asheville Beer Week has brought tourists and attention to WNC beer

since 2012. Asheville Beer Expo, an annual educational event showcasing members of the Asheville Brewers Alliance, takes place in February. That event got its start in 2016. Many breweries also host festivals in their taprooms, from Fonta Flora's Origin of the State to Hi-Wire's Stout Bout and Burial's Burnpile Harvest Festival. Typically, these are organized to showcase specialty and one-off beers, mostly from regional breweries but sometimes from farther afield.

The Asheville Brewers Alliance started in 2009 with the mission of uniting area breweries and supporting craft beer. In recent years, the organization has grown up, adding paid staff and offering regular educational meetings for the increasing number of brewery members, from quality control to employee housing options.

## Selling Brews

Specialty bottle shops that showcase packaged craft beers have opened all over Western North Carolina in recent years—and are too numerous to list in this book. Asheville's Bruisin' Ales, which opened in 2006, was the first to sell only craft and imported beers. In addition to being a full-time entrepreneur, co-owner Julie Atallah has been a fervent beer champion for the region.

Twin Leaf Brewery founder Tim Weber remembers that Julie showed him around and introduced him to "everyone in beer" the first time he visited Asheville (including yours truly).

Asheville's Bruisin' Ales brings beer "celebrities" to town for special tastings. *Left to right*: Bruisin' Ales co-owner Julie Atallah, Stone Brewing co-founder Greg Koch and author Anne Fitten Glenn. *Photo by Jason Sandford.*

"She was *the* beer ambassador. She really put Asheville on the map. I'm pretty sure her social media savvy is why we won Beer City, USA," Tim said.

A North Carolina law change in 2012 and a clarification in 2017 allows breweries to sell to-go beer from the place of manufacture. So customers can take home bottles, cans and growlers of fresh beer from brewery taprooms. Some breweries have added in-house shops, including Wicked Weed, Burial Beer and Appalachian Mountain Brewery. At minimum, most now have to-go coolers or refrigerated cases.

## Beer Tours

Beer tours are big business these days. Asheville Brews Cruise was visionary when it opened in 2006, taking folks from Asheville to Highland Brewing and Pisgah Brewing. Several years later, Asheville Brewery Tours (ABT) opened. That business started with walking tours but now mostly runs van tours. ABT still offers a popular dog-friendly downtown walking tour. BREW-Ed offers only walking tours, typically of some of Asheville's South Slope breweries. Founded and led by Cliff Mori, a certified cicerone, these tours focus on education and history. Cicerone is the sommelier program of the beer world and offers four levels of certification.

Cliff started his tour business in 2013. "At that point, Brews Cruise and brewery tours were up and running and doing well, but I thought there might be a niche for people that wanted to learn a little more," he said. "It's lighthearted, but we're also learning." In 2016, *National Geographic Traveler* magazine listed BREW-Ed as one of "15 Food Tours Worth the Travel."

To round out the Asheville brewery tour fun, with "fun" being the key word, is LaZoom Comedy Tours. If you've spent any time in downtown Asheville, you've likely seen (and heard) a big purple bus with decorative trim or, if you're lucky, have gotten a glimpse of Sister Bad Habit, a man wearing a nun's habit and sometimes riding a unicycle. LaZoom's Bands & Beer tour takes patrons to two local breweries, but in this case, the transportation may be more entertaining than the beer. And yes, you can drink on the bus—just not on the public sidewalk. This is still the South, y'all.

While Asheville has got you covered for beer tour options, in the past few years, brewery tours have appeared in other WNC towns. Of course, they are dependent on having more than one brewery to visit without spending too much time traveling between them.

## A Mountain Brew History

Leap Frog Tours provides outlier tours to many of WNC's breweries. *Left to right*: Co-owners Ann Smith and Kim Turpin and tour guide Mark Merritt. *Courtesy of Leap Frog Tours.*

The Brewery Experience, started by another certified cicerone, Gary Glancy, offers tours in Hendersonville and Greenville, South Carolina, as well as to Sierra Nevada Brewing and Bold Rock Hard Cider.

Waynesville-based entrepreneurs Ann Smith and Kim Turpin founded Leap Frog Tours in late 2016. The company started with outlier brewery tours to Brevard, Mills River and Waynesville.

"Our goal is beer education," Ann said. "While 75 percent of our clients are tourists, we have a solid base of locals who are using us to go to breweries they've been to, but they've never visited in this way."

The company since has added tours in Hendersonville, Sylva (beer and chocolate, for the win) and Franklin. For non-beer geeks, there's also a distillery tour, a wine tour and tours of haunted sites integrating local history and legends. If you want a custom tour or need transportation for a group, Leap Frog will leap to it.

Finally, there are all the businesses that advise, support or are somehow involved, deeply or tangentially, in WNC's beer industry. The Asheville Brewers Alliance website lists more associate members than breweries these days. Beer's supporting cast ranges from attorneys and insurance agencies to accountants and web designers, to, strangely enough, a local shoe manufacturer.

## The Rise of Other Craft Spirits

Folks around here no longer need to buy illicit liquor from their plumber, although I don't judge them for doing so. Some of the best moonshine I've tasted was distilled by friends, and for some reason, several of them have day jobs wrenching pipes. Today, a number of businesses are distilling legal moonshine in WNC—in the illegal moonshine capital of the world. Additionally, regional businesses are making Appalachian-inspired craft cider, mead, whiskey and wine.

North Carolinians have been making wine, mostly from native scuppernong and muscadine grapes, for centuries. Wine was fermented at home and imbibed for its health properties more than for the buzz. One of the oldest established NC wineries is Waldensian Heritage Winery, established in 1930 in the town of Valdese in Burke County. Valdese was settled by immigrants from the Alps of Northern Italy.

America's most famous private home, Biltmore, began selling wine in 1984 made from grapes grown on the eight-thousand-acre estate. Today, Biltmore's winery is the most visited in the country, likely because the home itself attracts well over one million guests a year. Biltmore produces 150,000 cases of wine annually and distributes it to twenty states.

Andrews Brewing in Andrews started as a vineyard and winery, Calaboose Cellars, adding brewing operations later. Additionally, there are a couple of small wineries in Hendersonville and a few more in the High Country.

Distilleries are popping up like forest mushrooms throughout the region. Recent revisions in state laws controlling the production and sales of liquor paved the way for a boom in licensed distilleries. The first legal moonshine businesses opened their doors in the early 2000s. Asheville Distilling Company, which sells moonshine under the Troy & Sons brand, was the first on the scene. Asheville Distilling also produces a line of whiskeys. Other Asheville-based distilleries, including Howling Moon Distillery and Climax Moonshine, focus on making traditional white lightning, while Dalton Distillery produces rum.

Oak & Grist Distilling Company opened in Black Mountain in 2017, debuting with an all-grain gin. Asheville's Eda Rhyne Distillery opened in 2018 and produces Fernet, Amaro and Nocino, a black walnut liqueur. All contain mountain-grown and foraged botanicals. More distilleries, including H&H and Apothecary Beverage Company, with its The Chemist beverage label, recently opened in Asheville. Wilkesboro has a couple of legal distilleries now, and there's even one in Maggie Valley.

## A Mountain Brew History

Then there are the cideries and meaderies. The government classifies both liquids as wines. Cider is typically fermented apple juice, while mead is honey-fermented wine. Therefore, a retail business that has only a beer and wine license can sell both. Almost every craft brewery taproom now has a dedicated gluten-free tap of cider, ginger beer or, in a few cases, hard root beer.

Hendersonville is the top producer of apples in the state and one of the top ten growing regions in the country. Asheville's Urban Orchard Cider Company was likely the first post-Prohibition brick-and-mortar cider maker in North Carolina. When the business opened in 2013, there were only a handful of craft cideries nationwide, said Jeff Anderson, Urban Orchard creative director. In 2018, Urban Orchard opened a second production facility and taproom on Asheville's South Slope. The original location in East-West Asheville remains open.

In recent years, more and more cideries have opened regionally, including Noble Cider in Leicester, Bold Rock Hard Cider in Mills River, Flat Top Cider Works in Hendersonville and Black Mountain Ciderworks & Meadery. These cideries source all or most of their apples from Hendersonville farms. The primary reason Bold Rock opened a second cidery in Western

Urban Orchard Cider Company in West Asheville was one of the first modern-day cideries to open in North Carolina. *Courtesy of Urban Orchard Cider.*

North Carolina was access to a regional apple crop. (Its original facility is in Virginia.) The Black Mountain business is in the same business park as Pisgah Brewing and Oak & Grist Distillery, making that corner of town a veritable hub of craft alcoholic nectar.

Fox Hill Meadery in Marshall is the region's oldest commercial mead-maker, in business since 2007. Black Mountain Ciderworks & Meadery produces mead as well, obviously. Former home brewers started both businesses.

Following in the footsteps of brewers, look for more non-beer alcoholic beverage makers to stake their claims in these mountains. As Rett Murphy, co-owner of Eda Rhyne Distillery, said, "We've seen how the beer community has amazing support by our local community. If we weren't in Asheville, for a number of reasons, including the beer community, we probably wouldn't be doing this."

## The Future of Beer

Clearly, the growth of the U.S. craft beer industry has been huge during the twenty-first century. The number of operating breweries has steadily increased, with the Brewers Association reporting 6,372 American breweries in 2017, with small and independent breweries accounting for 98 percent of those. Their chief economist predicts 7,000 breweries will be in operation by the end of 2018.

In terms of production volume, the craft beer sector has seen double-digit growth. In 2017, craft brewers produced 25.4 million barrels of liquid. Small breweries and brewpubs, which make fewer than 15,000 barrels annually, supplied 76 percent of the craft brewery growth that same year.

North Carolina specific numbers are more difficult to parse. According to the North Carolina Craft Brewers Guild, there were 250 operating breweries in the state as of January 2018, compared to 122 in 2012. In 2014, there were ten thousand beer-related jobs and $1.2 billion in impact, which includes associated industries, said Andrew Lemley, former executive director of the NC Guild.

In 2016, the BA ranked North Carolina as ninth in the nation in terms of number of breweries and tenth in terms of economic impact. However, the state ranked fifth in terms of barrelage, with more than 1.2 million barrels of beer produced that year. Numbers come from reporting member breweries.

## Asheville Breweries Economic Contribution

Breweries in the four-county Asheville Metro made a major contribution to the regional economy in 2016.

**2,571 jobs**
877 jobs in brewery industry activity created or supported another 1,694 jobs in the local economy. For every 1 job, nearly 2 more jobs were supported.

**$111M labor income**
Labor income associated with brewing activity jobs accounted for $111 million, adding to local household spending power.

**$934M total output**
Total output or production was estimated at $934 million contribution. 2,571 workers were paid $111 million in Labor Income as part of companies' $365 million contribution to the Gross Regional Product in the Asheville MSA.

**$205M tax revenues**
An estimated $205 million in state, local, and federal tax revenues were contributed from transactions such as taxes on production and corporate profits. These revenues may go towards public services such as public safety, parks, education, transportation, etc.

**$55K average earnings**
Average earnings per direct job in brewery industry activity was over $55K. With indirect and induced effects included, the average was estimated at $43K.

**5 top five industries**
In the Asheville metro market, the top five industries impacted (by employment) were Breweries Manufacturing, All Other Crop Farming, Wholesale Trade, Truck Transportation, and All Other Food and Drinking Places.

**754% growth**
The primary Breweries Manufacturing Industry grew in employment by 754% 2011-2016, adding over 600 direct jobs in the region.

**35+ businesses**
A 2016 snapshot estimates at least 35 brewing businesses in the Asheville MSA.

Sponsored by: McGuire, Wood, & Bissette Law Firm
Produced by: The Asheville Area Chamber of Commerce and Economic Development Coalition for Asheville-Buncombe County

This infographic reflects the beer industry's economic contribution in the four counties of Buncombe, Haywood, Henderson and Madison. *Courtesy of McGuire, Wood & Bissette Law.*

"The state of southern beer is incredible. There has never been a better time to be a beer lover," Andrew said. "From the mountains to the coast, there are more brewers making higher quality beer than any time in our history."

Western North Carolina industry numbers are difficult to pin down, partially because of the rate of new breweries opening in the area. One of the most dramatic of those is the growth number of 754 percent in a period of five years, released in 2016.

While there is evidence of a slowdown nationwide, it doesn't seem that Western North Carolina has reached the top of the suds roller coaster yet.

"People have been speculating for years that the growth in both numbers of craft breweries and volume of liquid will inevitably slow down," Andrew said. "And though we've seen some slowing in the rate of growth, I think there's ample opportunity for more brewers and craft beer."

While rumors continue to swirl about the looming craft beer bubble, most brewers agree that breweries consistently producing quality beer will survive. There are still WNC towns actively pursuing breweries to locate to their communities.

"Quality will more and more be the driving force behind success in the market," said Chris Frosaker, former Asheville Brewers Alliance president. "Breweries that don't make good beer will not succeed, and this will become apparent in the next few years as competition increases."

Nicole Dexter, founder and co-owner of Sylva's Innovation Brewing, said, "I think we will continue to see breweries popping up all over WNC. It's a region conducive to brewing, full of beer lovers, and there are lots of pockets in the area that still have room for brewery growth."

As the industry matures, there will be more closings, mergers and acquisitions. However, with some luck, persistence and quality product, most of the breweries I've written about in this book will survive. Regardless, they are now all part of the history of Western North Carolina beer.

# TIMELINE OF WESTERN NORTH CAROLINA BEER

**Pre-historical records**
Native Americans likely brew beer using berries and corn.

**Late 1700s**
First European immigrants settle in Western North Carolina. Mostly Scots-Irish and German, they bring brewing and distilling traditions with them.

**1800s**
Southern beer recipes include ingredients such as locust pods, persimmons, spruce, ginger, corn, honey and molasses.

**1862**
North Carolina prohibits using grains to brew beer or liquor to protect food supply during Civil War. Repealed in 1866.

**1865**
State approves first "spirituous liquor" taxation law, following lead of the Internal Revenue Service, which approved a similar law a few years earlier.

**1872**
Asheville first votes against saloons, and of the four in operation, two close and two move outside city limits. Saloons reappear in the city a couple of years later.

## 1874
"Local Option" law passes, allowing North Carolina towns to go dry via popular vote. Extended to counties in 1881.

## 1870s
First mentions of commercial breweries and distilleries operating in Asheville.

## 1880–1900
Saloons thrive in Asheville and some other WNC towns.

## 1907
Asheville votes "yes" to prohibition.

## 1909
North Carolina becomes first state to ratify prohibition by popular vote, although many WNC towns and counties are already dry.

## 1915
State passes act to allow delivery of alcoholic beverages within the state.

## 1920
The Eighteenth Amendment goes into effect, making the manufacture, transport and sales of alcoholic beverages illegal nationwide.

## 1933
National prohibition repealed, although NC and SC are the only two states that refuse to ratify. NC legislators legalize sale of beer up to 3.2 percent alcohol but don't allow sales of stronger liquor until 1935.

## 1937
NC Alcohol Control Act creates State Alcohol Board creating state owned and managed liquor store system and ratifies "local option" again.

## 1947
After several votes in the '30s and '40s, Buncombe County finally becomes completely "wet." The first ABC stores open in Asheville.

## 1950s & '60s
Many WNC towns and counties hold repeal votes; most fail, leaving much of WNC dry for another twenty or thirty years.

# Timeline of Western North Carolina Beer

**1978**
President Jimmy Carter makes home brewing legal in the United States.

**1983**
North Carolina's drinking age is raised from eighteen to twenty-one.
Blowing Rock alcohol sales permits revoked for bars there.

**1985**
NC amendment makes brewpubs legal.

**1986**
Boone approves beer and wine sales.

**1992**
TUMBLEWEED RESTAURANT in Boone adds in-house brewing and soon is renamed COTTONWOOD BREWERY.

**1993**
SMOKY MOUNTAIN BREWERY opens near Waynesville, and closes two years later.
Asheville's BARLEY'S TAPROOM & PIZZERIA opens, selling only craft and imported beers.

**1994**
Oscar Wong and John McDermott start HIGHLAND BREWING in the basement of Barley's Taproom.

**1997**
The BLUE ROOSTER, Asheville's first brewpub, opens next to Barley's. It closes a year later.
BENEFIT BREWING is started by Jonas Rembert and Andy Dahm in back of Asheville's JACK OF THE WOOD pub.
Barley's co-owners Jimi Rentz and Doug Beatty found the BREWGRASS FESTIVAL in Asheville.
ASHEVILLE BREWERS SUPPLY, Asheville's first home brew supply store, opens.
MOUNTAIN ALE AND LAGER TASTERS home brew club begins meeting regularly.
TWO MOONS BREW 'N' VIEW opens with brewer Doug Riley at the helm. The next year, Mike and Leigh Rangel buy the business and change the name to ASHEVILLE PIZZA & BREWING CO.

# Timeline of Western North Carolina Beer

**1999**
Catawba Valley Brewing Co. is born in the basement of Glen Alpine antique mall.
MALT starts Blue Ridge Brew-Off home brew competition, which becomes one of the largest such events in the Southeast.

**2001**
Joe and Joan Eckert purchase Benefit Brewing and change name to Green Man Brewery.
Jonas Rembert and Andy Dahm open French Broad Brewing Co. in Biltmore Village.

**2003**
Appalachian Brewing starts up in a barn in Rosman.

**2004**
Dieter Kuhn and Sheryl Rudd open Heinzelmännchen Brewery in Sylva, producing German-style beers. The brewery closed in 2017.

**2005**
Jason Caughman and Dave Quinn open Pisgah Brewing Co. in Black Mountain, producing the area's first certified-organic beers.
Green Man Brewery moves from Jack of the Wood to the Buxton Avenue location that locals affectionately call Dirty Jack's.
North Carolina's "Pop the Cap" legislation passes, increasing allowable alcohol by volume for malt beverages from 6 to 15 percent.

**2006**
Highland Brewing moves to east Asheville and expands production.
Andy and Kelly Cubbin purchase Appalachian Brewing and change the name to Appalachian Craft Brewery. They soon move operations to Fletcher.
Bruisin' Ales, Asheville's first beer-only retail store, opens.

**2007**
Catawba Valley Brewing moves to Morganton and opens a tasting room. In 2013, it dropped the "Valley" from the name.
Hops 'n Vines, beer and wine retail and home brew shop, opens in West Asheville.

**2007–8**
Regional farmers begin experimenting with growing hops.

# Timeline of Western North Carolina Beer

## 2008
Inaugural Winter Warmer Beer Festival launches in Asheville and runs until 2017.
Wedge Brewing Co. opens in Asheville's River Arts District.

## 2009
Asheville Brewers Alliance formed.
Oyster House Brewing Co. opens inside the Lobster Trap restaurant in Asheville.
Asheville ties with Portland, Oregon, for first place in the first Beer City, USA poll, put on by Brewers Association president Charlie Papazian.
Bill Drew and Jonathan Cort open Craggie Brewing Co. in Asheville. The brewery closed in 2013.

## 2010
Lexington Avenue Brewery opens a gastropub/brewery in Asheville.
Biltmore Brewing Co. contracts with Highland Brewing.
Green Man Brewery purchased by Dennis and Wendy Thies and expanded.
Nantahala Brewing Co. in Bryson City opens.
After Asheville wins the Beer City, USA title outright, Asheville Brewers Alliance and Brewgrass organizers put on the first Beer City Festival in Pack Square Park downtown.
Just Economics of WNC holds the first "Just Brew It" home brew festival.

## 2011
Appalachian Craft Brewery moves operations to Hendersonville, opens a tasting room, changes name to Southern Appalachian Brewery.
Asheville wins Beer City, USA title again.
Riverbend Malt House opens in Asheville, malting North Carolina–grown grains for local breweries.
The Thirsty Monk Beer Bar adds a brewery to its South Asheville location.
The first local canned beers roll off the line at Asheville Brewing Company.
Frog Level Brewing Co. starts selling its beer in Waynesville.

## 2012
Headwaters Brewing Co. opens in Waynesville. The name changed to BearWaters Brewing in 2013.
Brevard Brewing Co. opens in Brevard.
Oskar Blues Brewing Co. of Longmont, Colorado, opens an East Coast brewery in Brevard.
Asheville wins Beer City, USA title again.

# Timeline of Western North Carolina Beer

Inaugural ASHEVILLE BEER WEEK, a ten-day celebration of craft beer, is held.
TIPPING POINT TAVERN in Waynesville starts brewing. The restaurant and brewery closed in 2017.
ALTAMONT BREWING CO. in West Asheville starts brewing. The brewery closed in 2017, selling to new ownership to become UPCOUNTRY BREWING.
BLUE MOUNTAIN PIZZA AND BREWPUB opens in Weaverville.
HOWARD BREWING starts brewing in Lenoir. The brewery closes in 2017.
WICKED WEED BREWING opens a brewpub in downtown Asheville.

## 2013
ANDREWS BREWING COMPANY opens in Andrews.
APPALACHIAN MOUNTAIN BREWERY opens in Boone.
BLOWING ROCK BREWING COMPANY begins brewing.
BURIAL BEER begins brewing and opens taproom on Asheville's South Slope.
FLAT TOP MOUNTAIN BREWING starts brewing and opens taproom in Banner Elk.
FONTA FLORA BREWERY opens brewery and taproom in Morganton.
INNOVATION BREWING opens brewery and taproom in Sylva.
LOOKOUT BREWING COMPANY opens near downtown Black Mountain.

## 2014
BEECH MOUNTAIN BREWING COMPANY, owned by Beech Mountain Ski Resort, opens brewery and taproom.
LOST PROVINCE BREWING CO. starts brewing and opens taproom and restaurant in Boone.
ONE WORLD BREWING opens brewing facility and taproom in downtown Asheville.
SATULAH MOUNTAIN BREWING COMPANY opens brewery and taproom in Highlands.
TWIN LEAF BREWERY begins brewing on Asheville's South Slope.

## 2015
BOOJUM BREWING COMPANY begins brewing and opens taproom and restaurant in downtown Waynesville.
BOONESHINE BREWING COMPANY starts brewing next to Basil's Fresh Pasta and Deli in Boone.
LAZY HIKER BREWING CO. opens brewery and taproom in Franklin.
MILLS RIVER BREWERY opens a brewpub with taproom in Arden.
SANCTUARY BREWING COMPANY starts brewing in Hendersonville and opens a taproom to help support animal sanctuary in Flat Rock.
SIERRA NEVADA BREWING opens its East Coast brewing, packaging and distribution facility in Mills River.
SWEETEN CREEK BREWING opens brewery and sandwich shop in Asheville.

# Timeline of Western North Carolina Beer

## 2016

Bhramari Brewing Company begins beer production and opens taproom and restaurant in Asheville.

Blue Ghost Brewing Company begins brewing and opens taproom in Fletcher.

Currahee Brewing Company opens brewery and taproom in Franklin.

Ecusta Brewing opens a small brewery with taproom in downtown Brevard and a taproom at the edge of the Pisgah Forest. The downtown location closed after about a year.

Hickory Nut Gorge Brewery opens a small brewery and taproom in Chimney Rock.

Hoppy Trout Brewing Company opens a small-batch brewery in Andrews.

Mad Co. Brewing starts brewing small batches with taproom in Marshall.

Mountain Layers Brewing Company opens brewery with taproom in Bryson City.

New Belgium Brewing Company opens East Coast production facility in Asheville.

Whistle Hop Brewing Company uses repurposed train cars for its brewery and taproom in Fairview.

Zebulon Artisan Ales begins brewing and opens small taproom in Weaverville.

## 2017

Altamont Brewing sells to new ownership. Brewery reopens as UpCountry Brewing.

Archetype Brewing opens a production brewery and taproom in West Asheville.

Balsam Falls Brewing Co. opens a brewery and taproom in Sylva.

BearWaters Brewing Co. moves to Canton, expanding production and opening a larger taproom.

Catawba Brewing Company opens taproom and production facility in Charlotte, NC, and purchases Palmetto Brewery in Charleston, SC.

Eluvium Brewing Company opens brewery and taproom in Weaverville.

French Broad River Brewery gets new ownership in Asheville.

Ginger's Revenge Craft Brewery opens brewery and taproom in Asheville.

Habitat Brewing Company opens a small batch brewery and taproom in Asheville.

Hillman Beer opens near Asheville's Biltmore Village with brewery production and on-site restaurant.

Homeplace Beer opens brewery and taproom in Burnsville.

Peaks & Creeks Brewing Company opens brewery and taproom in the Brevard LumberYard arts district.

## Timeline of Western North Carolina Beer

The THIRSTY MONK purchases a brewery in Denver, Colorado and a beer bar in Portland, Oregon.
TURGUA BREWING COMPANY opens a brewery and taproom on a Fairview farm.
WHITE LABS KITCHEN AND TAP opens yeast production facility in Asheville.
WICKED WEED BREWING purchased by AB-InBev.
ZILLICOAH BEER CO. opens brewery and taproom in Woodfin.
MICA TOWN BREWING opens brewery and taproom in Marion.

### 2018
ALL SEVENS BREWHOUSE opens inside Westville Pub in West Asheville.
BLACK MOUNTAIN BREWING opens brewery and taproom in Black Mountain.
BREWERY CURSUS KEME opens old world brewery and beer garden in Asheville.
BURIAL BEER opens production brewery and craft beer bar near Biltmore Village.
EURISKO BEER COMPANY opens brewery and taproom in Asheville.
FERMENTED NONSENSE opens small-batch brewery in Arden.
INNOVATION BREWING opens second facility and taproom in Dillsboro.
NEW 7 CLANS BREWING starts contract brewing at BearWaters Brewing.
ONE WORLD BREWING opens second production facility and taproom in West Asheville.
SIDEWAYS FARM AND BREWERY opens in Etowah.
WHITESIDE BREWING opens brewpub in Cashiers.

# WESTERN NORTH CAROLINA BREWERIES

**T**his list includes Western North Carolina breweries operating as of the summer of 2018, organized alphabetically by town or community.

As I write elsewhere in this book, breweries seem to open in WNC frequently, and I apologize if I've missed one or three. I've listed a few below that opened after I completed this manuscript or are in planning, such as Fermented Nonsense and DSSOLVR. A few of the breweries listed here are located in the foothills, and I didn't profile those, but they are still very much worth visiting if you are nearby, as are the breweries in Hickory and Winston-Salem. Because of a word-count restraint, I had to stop somewhere.

If you want up-to-the-minute brewery, beer bar and beer retailer information, look online.

Craft beer folks tend to eschew traditional advertising, although many of them are proficient at social media. So follow your favorite breweries on Instagram, Twitter, Facebook and even Snapchat. As far as I'm concerned, there's no such thing as too many #beerporn photos, so I follow breweries from all over the world on Instagram. My social media accounts are all under Brewgasm. Follow me if you like photos and tales about beer (obviously), food, history, bikes and dogs.

# Western North Carolina Breweries

## Andrews

**Andrews Brewing Company**, 565 Aquone Road
Circa 2013. Taproom with outdoor space and beautiful mountain views. Production brewery downtown.

**Hoppy Trout Brewing Company**, 911 Main Street
Circa 2016. Small-batch brewpub with Sicilian-style brick pizza oven.

## Asheville

**All Sevens Brewhouse**, 777 Haywood Road
Circa 2018. Brewery added in expansion of West Asheville's iconic Westville Pub. Classic pub fare, including in-house baked breads.

**Archetype Brewing**, 265 Haywood Road
Circa 2017. Spacious taproom and production brewery with outdoor space in West Asheville.

**Asheville Brewing Company**, 77 Coxe Avenue and 675 Merrimon Avenue
Circa 1998. Taprooms in two locations. South Slope production brewery with additional pilot system and brewpub serving pizza and pub fare. Original taproom, pizzeria and second run movie theater in North Asheville.

**Bhramari Brewing Company**, 101 South Lexington Avenue
Circa 2016. Production brewery, taproom and restaurant with outside space and parking.

**Brewery Cursus Keme**, 155 Thompson Street
Circa 2018. Old world–style brewery and beer garden.

**Burial Beer Co.**, 40 Collier Avenue and 16 Shady Oak Drive
Circa 2013. Brewery and taproom with permanent food truck and large outdoor area on South Slope. Production brewery with taproom featuring a variety of American craft beers near Biltmore Village.

# Western North Carolina Breweries

Catawba Brewing Company, 32 Banks Avenue and 63 Brook Street
Circa 1999. Taproom with pilot system, rotating food trucks, and venue space on South Slope. Smaller taproom near Biltmore Village. Original production brewery and taproom in Morganton, and large production brewery and taproom in Charlotte. Purchased Charleston's Palmetto Brewing Company in 2017.

DSSOLVR, 63 North Lexington Avenue
Production brewery and taproom opening in 2018.

Eurisko Beer Company, 255 Short Coxe Avenue
Circa 2018. Production brewery and taproom at the far end of Asheville's South Slope.

Farenheit Pizza & Brewhouse, 17 Lee Street
Circa 2018. Pizzeria with on-site small-batch brewing.

Fermented Nonsense, 100 Julian Shoals Drive
Circa 2018. Small-batch brewery in back office of Craft Centric Taproom & Bottle Shop.

French Broad River Brewery, 101 Fairview Road
Circa 2001. Taproom and regular live music. New ownership as of 2017.

Ginger's Revenge Craft Brewery, 829 Riverside Drive
Circa 2017. Taproom and brewery producing gluten-free ginger beers and regularly featured guest beer taps from local breweries.

Green Man Brewery, 23–27 Buxton Avenue
Circa 1997. Taproom with outside patio (Dirty Jack's) and tasting room in brew house next door (Green Mansion).

Habitat Brewing Tavern & Commons, 174 Broadway Street
Circa 2017. Small batch brewery and taproom with emphasis on community events.

Highland Brewing Company, 12 Old Charlotte Highway
Circa 1994. Production brewery and taproom with live music on weekends. Rooftop taproom and rental venue. Biltmore Brewing beers are brewed here.

HILLMAN BEER, 25 Sweeten Creek Road
Circa 2017. Production brewery and taproom with on-site restaurant and outdoor space.

HI-WIRE BREWING, 197 Hilliard Avenue (South Slope) and 2A Huntsman Place (Big Top, Biltmore Village)
Circa 2013. Taprooms in two locations. Original South Slope taproom and sour and wild ale production facility. Biltmore Village production brewery and taproom with permanent food truck. Tap room in Durham.

LEXINGTON AVENUE BREWING, 39 North Lexington Avenue
Circa 2010. Production facility and taproom with full gastropub and covered patio.

MILLS RIVER BREWERY, 330 Rockwood Road
Circa 2015. Brewpub with taproom in Arden. Production brewery and taproom in Mills River.

NEW BELGIUM BREWING COMPANY, 21 Craven Street
Circa 2016 (in WNC). East Coast production facility for Colorado-based brewery. Taproom, large outdoor space and rotating food trucks.

ONE WORLD BREWING, 10 Patton Avenue and 520 Haywood Road
Circa 2014. Underground production facility and taproom downtown. production facility and taproom in West Asheville.

OYSTER HOUSE BREWING COMPANY, 625 Haywood Road
Circa 2009. Small batch production facility and full restaurant with fresh oysters in West Asheville.

SWEETEN CREEK BREWING, 1127 Sweeten Creek Road
Circa 2015. Brewery, taproom, and gourmet sandwich shop with a large outdoor space.

THIRSTY MONK PUB & BREWERY, 92 Patton Avenue, 2 Town Square Boulevard, 20 Gala Drive
Circa 2011. Multiple locations. Downtown includes Belgian beer bar, American beer bar with a bar menu and cocktail bar. Biltmore Park location offers taproom and bar menu. Brother Joe's Coffee Pub has taproom and

light cafe menu. Also own brewery in Denver, Colorado, and beer bar in Portland, Oregon.

12 Bones South Brewery, 2350 Hendersonville Road
Barbecue restaurant adding new location with on-site brewing operations in 2018.

Twin Leaf Brewery, 144 Coxe Avenue
Circa 2014. Production facility and taproom on South Slope with outside seating.

Upcountry Brewing Company, 1042 Haywood Road
Circa 2017. Taproom with outside seating, bar menu and regular live music. Former location of Altamont Brewing Company, now closed.

Wedge Brewing Company, 37 Paynes Way, Suite 001 and 5 Foundy Street
Circa 2008. Two locations, both have production facilities, taprooms and outside seating. Local rotating food trucks. Venue rental space at Wedge at Foundation.

White Labs Kitchen and Tap, 172 South Charlotte Street
Circa 2017. East coast expansion facility for yeast production. Taproom and restaurant on-site, with some beer brewed in-house and in collaboration with regional breweries.

Wicked Weed Brewing Pub/Wicked Weed Funkatorium/Wicked Weed Funkhouse, 91 Biltmore Avenue and 147 Coxe Avenue
Circa 2012. Biltmore Avenue brewpub with restaurant and downstairs taproom. South Slope location houses barrel-aged and sour beer operations, as well as tasting room and bottle shop. Production brewery in Enka-Candler to add taproom. All owned by AB-InBev as of 2017.

# Banner Elk

Flat Top Mountain Brewery, 567 Main Street
Circa 2013. Production brewery and taproom with food options.

# Western North Carolina Breweries

## Black Mountain

Black Mountain Brewing, 131 Broadway Avenue
Circa 2018. Production brewery and taproom.

Lookout Brewing Company, 103 South Ridgeway Avenue
Circa 2013. Production brewery and taproom. Occasional events and music.

Pisgah Brewing Company, 150 Eastside Drive
Circa 2005. Production brewery and taproom with inside and outside stages featuring frequent live music. Regular rotating food trucks.

## Blowing Rock

Blowing Rock Brewing Company, 152 Sunset Drive
Circa 2013. Production brewery and taproom with full restaurant and inn (Blowing Rock Ale House & Inn). Second production brewery/taproom/restaurant in Hickory, NC (American Honor Ale House & Brewery).

## Boone

Appalachian Mountain Brewery & Cidery, 163 Boone Creek Drive
Circa 2013. Taproom with small production system, heavily involved in sustainability. Member of Craft Brew Alliance, in which AB-InBev has stake. Publicly traded company.

Beech Mountain Brewing Company, 1007 Beech Mountain Parkway
Circa 2014. Brewery and taproom owned by Beech Mountain Ski Resort. Open to public.

Booneshine Brewing Company, 465 Industrial Park Drive
Circa 2015. Brewery started next to Basil's Fresh Pasta and Deli. Moving into new production facility with taproom and restaurant.

Lost Province Brewing Co., 130 North Depot Street
Circa 2014. Brewery and restaurant with full menu, including wood-fired pizza, regular music and events.

## Western North Carolina Breweries

## Brevard

Brevard Brewing Company, 63 East Main Street
Circa 2012. Production facility and taproom with regular live music.

Ecusta Brewing, 49 Pisgah Hwy #3
Circa 2016. Brewery and taproom at the edge of Pisgah Forest.

Oskar Blues Brewery, 342 Mountain Industrial Drive
Circa 2012 (in WNC). East Coast production facility for Colorado-based brewery. Large brewing facility, taproom with outdoor space, regular music and permanent food truck.

Peaks & Creeks Brewing Company, 212 King Street, Suite B
Circa 2017. Brewery and taproom in the Brevard Lumberyard arts district. Founded by owner of Waynesville's Tipping Point Brewery, now closed.

## Bryson City

Mountain Layers Brewing Company, 90 Everett Street
Circa 2016. Brewery, taproom and rooftop deck, offering snacks and food trucks on the weekends.

Nantahala Brewing Company, 61 Depot Street and 116 Ramseur Street (Bryson City), 747 Haywood Road (Asheville)
Circa 2010. Production brewery and taproom on Depot Street offers regular live music. Ramseur Street location has full restaurant, along with tastings and event space rental. Taproom in West Asheville.

## Burnsville

Homeplace Beer Co., 6 South Main Street
Circa 2017. Production brewery and taproom offering small bites and wood-fired pizza.

# Western North Carolina Breweries

## Canton

BearWaters Brewing Co., 101 Park Street
Circa 2012 in Waynesville. Moved brewery to Canton in 2017. Large taproom with pet-friendly outside space. Pigeon River Grille onsite.

## Cashiers

Whiteside Brewing Co., 128 Highway 107 North
Circa 2018. Brewpub with significant outdoor space and accommodations available at Laurelwood Inn.

## Chimney Rock

Hickory Nut Gorge Brewery, 461 Main Street
Circa 2016. Small brewery and taproom with decks overlooking the Rocky Broad River. Small food menu and regular live music.

## Etowah

Sideways Farm & Brewery, 62 Eade Road
Circa 2018. Farm to pint production brewery and taproom.

## Fairview

Turgua Brewing Company, 27 Firefly Hollow Drive
Circa 2017. Farm-to-kettle style brewery and taproom with some ingredients for beer grown on-site.

Whistle Hop Brewing Company, 1288 Charlotte Highway
Circa 2016. Brewery and taproom in repurposed train cars. Rotating food trucks and regular live music.

# Western North Carolina Breweries

## Fletcher

Blue Ghost Brewing Company, 125 Underwood Road
Circa 2016. Brewery and taproom with permanent food truck, Hungry Ghost. Regular live music and outdoor space.

## Franklin

Currahee Brewing Company, 100 Lakeside Drive
Circa 2016. Large brewery and taproom with outdoor biergarten overlooking the Little Tennessee River.

Lazy Hiker Brewing Co., 188 West Main Street
Circa 2015. Brewery and taproom with weekend music and events. Permanent food truck.

## Granite Falls

Granite Falls Brewing Company, 47 Duke Street
Production brewery and full restaurant in historic bottling works building.

## Hayesville

Hayesville Brewing Company, 1568 US-64
Circa 2018. Small-batch brewpub.

## Hendersonville

Dry Falls Brewing Company, 425 Kanuga Road
Production brewery under construction.

Guidon Brewing Company, 415 Eighth Street East
Circa 2018. Small-batch brewery.

# Western North Carolina Breweries

Sanctuary Brewing Company, 147 First Avenue East
Circa 2015. Brewery and taproom offering small bites and regular events including trivia and pet adoptions.

Southern Appalachian Brewery, 822 Locust Street
Circa 2003. Family and pet-friendly taproom with outside seating, regular live music and food trucks.

Triskelion Brewing Company, 669 Maple Street
Circa 2017. Production brewery and taproom.

## Highlands

Satulah Mountain Brewing Company, 454 Carolina Way
Circa 2014. Family and pet-friendly taproom, no food offerings. Open limited days.

## Lenoir

Loe's Brewing Company, 1048 Harper Avenue
Circa 2010. Brewpub in downtown with outdoor seating.

## Marion

Mica Town Brewing Company, 25 Brown Drive
Circa 2017. Brewery and taproom with game room.

## Marshall

Mad Co. Brewing, 45 North Main Street
Circa 2016. Small-batch brewery and taproom with pool tables, regular live music and a large deck on the French Broad River.

## Mills River

Sierra Nevada Brewing Company, 100 Sierra Nevada Way
Circa 2015 (in WNC). East Coast brewing and packaging facility for California-based brewery. Restaurant and taproom with outdoor space. Indoor and outdoor music venues.

## Morganton

Catawba Brewing Company, 212 South Green Street
Circa 1999. Original taproom and production facility in Morganton (listed under Asheville as well).

Fonta Flora Brewery and Fonta Flora at Whippoorwill, 317 North Green Street and 6751 NC-126 in Nebo
Circa 2013. Eclectic brewery and taproom offering a small snack menu. Regular music and events. Production brewery and taproom in Nebo.

## Murphy

Valley River Brewery & Eatery, 71 Tennessee Street
Circa 2016. Small-batch brewery in Murphy and brewpub in Haysville. Wood-fired pizza at both locations.

## Plumtree

Blind Squirrel Brewery, 4716 South US Hwy 19E
Circa 2012. Small-batch seasonal brewery. Taproom outpost in Burnsville closed in 2017.

## Rutherfordton

Yellow Sun Brewing Co., 127 Trade Street
Circa 2018. Small-batch brewery and pizzeria.

## Sparta

Laconia Ale Works, 433 North Main Street
Circa 2018. Taproom and production brewery by owners of Marshall's Mad Co. Brewing.

## Sylva

Balsam Falls Brewing Co., 506 West Main Street
Circa 2017. Taproom and brewery. Wide variety of locally-inspired beers.

Innovation Brewing and Innovation Station, 414 West Main Street and 40 Depot Street in Dillsboro
Circa 2013. Production brewery and taproom with permanent food truck. Wood-fired pizza restaurant next door. Second taproom, pilot system and facility for wild and sour program in Dillsboro.

## Waynesville

Boojum Brewing Company, 50 North Main Street and 357 Dayton Drive
Circa 2015. Taproom with full food menu, large deck and outside bar downtown. Production brewery just outside of town.

Frog Level Brewing Co., 56 Commerce Street
Circa 2011. Dog-friendly brewery and taproom with outside deck overlooking Richland Creek.

## Weaverville

Blue Mountain Pizza and Brew Pub, 55 North Main Street
Circa 2012. Pizzeria with small-batch brewing on-site. Live music daily.

Eluvium Brewing Company, 11 Florida Avenue
Circa 2017. Brewery and taproom with rotating food trucks.

# Western North Carolina Breweries

Zebulon Artisan Ales, 8 Merchants Alley
Circa 2016. Brewery and taproom open Fridays and Saturdays. Single-batch beers, with no beer brewed the same way twice.

## West Jefferson

Boondocks Brewing Taproom and Restaurant and Boondocks Brew Haus, 108 South Jefferson Avenue and 302 South Jefferson Avenue
Circa 2012. Large taproom and full restaurant with a large outside seating area. Regular live music and events.

## Woodfin

Zillicoah Beer Co., 870 Riverside Drive
Circa 2017. Spacious taproom with lots of outdoor space on the French Broad River. Specializing in wild and sour beers.

## Contract breweries

Biltmore Brewing Company, Asheville, contracts with Highland Brewing.
Sapphire Mountain Brewing Company, Sapphire, contracts with Thomas Creek Brewery.
7 Clans Brewing Company, Qualla Boundary, contracts with BearWaters Brewing.

## Cideries/Meaderies

Appalachian Mountain Brewery & Cidery, Boone
Ben's Tune-up/Ben's Beer (Sake Maker), Asheville
Black Mountain Ciderworks & Meadery, Black Mountain
Bold Rock Hard Cider, Mills River
Daidala Ciders, Asheville
Flat Rock Ciderworks, Hendersonville
Fox Hill Meadery, Marshall
Molley Chomper Hard Cider, Lansing

# Western North Carolina Breweries

Noble Cider, Asheville
Urban Orchard Cider Company, Asheville

## Distilleries

Adam Dalton Distillery, Asheville
Asheville Distilling Company, Asheville
Blue Ridge Distilling Company, Golden Valley
Carolina Distillery, Lenoir
The Chemist Distillery, Asheville
Eda Rhyne Distillery, Asheville
Elevated Mountain Distilling Company, Maggie Valley
H&H Distillery, Fairview
Howling Moon Distillery, Asheville
Oak & Grist Distillery, Black Mountain
Tryon Backdoor Distillery, Tryon

# BIBLIOGRAPHY

Much of the material for this book comes from personal interviews. As I've worked in and written about the beer business for a long time (often doing both at the same time), I've collected stories, random facts and some tall tales, usually while drinking beer. As this is a history book, I've tried to include only the verifiable tall tales.

I pulled some content from my own published articles as well as from those of many others listed in this bibliography. I owe a debt of gratitude to all the researchers and writers I leaned on for background and source material.

So much has been digitized in the past few years. Keyword searches are much more efficient than perusing microfiche (not to mention locating it and loading it into the machine). I'm happy to say that those finicky microfiche scrollers may soon be relegated to library basements. Newspapers.com has made historical research a great deal easier.

Even so, as I often tell my kids, not everything is online, and I still spent hours in the stacks at various libraries perusing actual books and articles printed on paper. Thanks, as always, to the libraries that protect—yet happily share—old books, maps and papers, some of which exist only in a few places and may or may not ever make their way online.

## Bibliography

### Books

Arthur, John Preston. *Western North Carolina: A History (From 1730 to 1913)*. Raleigh, NC: Edwards & Broughton Printing Company, 1914.

Blackmun, Ora. *Western North Carolina: Its Mountains and Its People to 1880*. Boone, NC: Appalachian Consortium Press, 1977.

*The Confederate Receipt Book: A Compilation of Over One Hundred Receipts, Adapted to the Times.* Richmond, VA: West and Johnston, 1863.

Davison, J.P. *Asheville City Directory and Gazetteer of Buncombe County*. Richmond, VA: Baughman Brothers, 1883.

Fulenweider, Harry W. *Asheville City Directory and Business Reflex*. Charleston, SC: Walker, Evans & Cogswell, 1890.

Glenn, Anne Fitten. *Asheville Brewing: An Intoxicating History of Mountain Brewing*. Charleston, SC: The History Press, 2012.

Hardy, Michael C. *North Carolina in the Civil War*. Charleston, SC: The History Press, 2011.

Kephart, Horace. *Our Southern Highlanders*. New York: MacMillan, 1913.

Myers, Erik Lars, and Sarah H. Ficke. *North Carolina Craft Beer & Breweries*. 2nd ed. Winston-Salem, NC: John F. Blair, 2016.

Nelson, Louise K. *Historic Waynesville*. Self-published, 1999.

Ogle, Maureen. *Ambitious Brew: The Story of American Beer*. Orlando, FL: Harcourt Books, 2006.

Okrent, Daniel. *Last Call: The Rise and Fall of Prohibition*. New York: Scribner, 2010.

Pierce, Daniel S. *Corn from a Jar: Moonshining in the Great Smoky Mountains*. Gatlinburg, TN: Great Smoky Mountains Association, 2013.

Postell, Lesa W. *Appalachian Traditions: Mountain Ways of Canning, Pickling, & Drying*. Whittier, NC: Ammons Communications, 1999.

Powell, William S., ed. *Encyclopedia of North Carolina*. Chapel Hill: University of North Carolina Press, 2006.

Starnes, Richard D. *Creating the Land of the Sky: Tourism and Society in Western North Carolina*, Tuscaloosa: University of Alabama Press, 2005.

Terrell, Bob. *The Will Harris Murders*. Alexander, NC: Land of Sky Books, 1997.

### Newspapers.com Articles

*Asheville (NC) Citizen-Times*. "Adolph Freck Dies from His Injury." June 30, 1900.
———. "The Alligator Bar." November 20, 1887.

# Bibliography

———. "Beer Sales Increase as Quality Is Made Better." July 16, 1933.
———. "Drys Apparently Stymied by Legislature." March 13, 1949.
———. "Go to Bob Jones…" April 22, 1886.
———. "In and Around Asheville." May 24, 1890.
———. "In the Bonanza Company." January 9, 1896.
———. "The Liquor Dealers Banqueted." August 23, 1895.
———. "Sol Edel's Suicide." April 1, 1898.
———. "Something New." September 3, 1887.
———. "A Twelve Footer Coming." November 1, 1887.
*Asheville (NC) Weekly Citizen.* "A Daring Robbery." February 20, 1879.
———. "Hildebrand Buck Beer." August 8, 1878.
———. "Lager Beer." December 16, 1875.
———. "Ordinances of the Town of Asheville." May 13, 1875.
———. "Pure Lager Beer." January 22, 1880.
———. "A Revenue Raid Through the West." February 26, 1880.
———. "That Beer." June 20, 1878.
*Charlotte (NC) News.* "Asheville's New Brewery." February 7, 1903.
*Franklin (NC) Press.* "Captured a Blind Tiger Mill." December 28, 1904.
*Goldsboro (NC) Messenger.* "Summer Drinks." August 7, 1873.
*Highlander Macon County and Western North Carolina Advertiser.* "New Trades for Women." July 23, 1886.
*Lenoir (NC) Topic.* "Local News." July 9, 1890.
*North Carolina Citizen.* "Asheville." January 4, 1872.
*Press and Sun-Bulletin* (Binghamton, NY). "North Carolina Reverts to Old Bone Dry Law." December 6, 1933.
*Watauga Democrat* (Boone, NC). E.F. Jones, letter to the editor. July 13, 1893.
*Western Carolinian* (Salisbury, NC). "Domestic Beer, Porter." August 19, 1828.
———. "Hops, Wanted." May 18, 1874.

## Newspaper, Magazine and Online Articles

Axtell, Nathaniel. "Cheers, Say Transylvania Retailers after Alcohol Sales Ok'd." *Hendersonville Times-News*, November 6, 2014. www.blueridgenow.com/news/20141106/cheers-say-transylvania-retailers-after-alcohol-sales-okd.
Barrett, Mark. "Changing NC Alcohol Laws Not as Simple as ABC." *Asheville Citizen-Times*, April 16, 2015. www.citizen-times.com/story/news/local/2015/04/16/changing-nc-alcohol-laws-simple-abc/25898203.

# Bibliography

Baughman, Kinney. "The Tumbleweed Report." *Newsletter of the Ann Arbor Brewer's Guild* 8, no. 11 (November 1994). http://aabg.org/newsletters/pre1999/AABG9411.html.

Bloom, Laura Begley. "Quit Your Job: 7 Places in the U.S. So Cheap You Can Afford to Be an Entrepreneur." *Forbes*, September 6, 2017. www.forbes.com/sites/laurabegleybloom/2017/09/06/quit-your-job-7-places-in-the-u-s-so-cheap-you-can-afford-to-be-an-entrepreneur/#637ddc4d533f.

Bodrie, Kat. "Crafting History—Historic W-S Breweries." *Winston-Salem Monthly*, April 3, 2018. www.journalnow.com/winstonsalemmonthly/crafting-history-two-historic-w-s-breweries.

Burgess, Joel. "How Asheville's Big Beer Deal Fell Flat." *Asheville Citizen-Times*, April 18, 2016. www.citizen-times.com/story/news/local/2016/04/16/how-ashevilles-big-beer-deal-fell-flat/82888810.

Conley, Mike. "Marion Voters Ease Restrictions on Beer Sales." *McDowell News*, November 8, 2017. www.mcdowellnews.com/news/marion-voters-ease-restrictions-on-beer-sales.

Contributors. "Drinking Wars: A Wet Decade." *Carolina Corner*. www.carolinacorner.com/attractions/drinking-wars-wet-decade.htm.

"Craft Brewer Defined." Brewers Association. www.brewersassociation.org/statistics/craft-brewer-defined.

Douglas, Scott. "Beer Scout: Familiar Faces Launch DSSOLVR." *Mountain Xpress*, March 28, 2018. https://mountainx.com/food/beer-scout-dssolvr-brings-a-taste-of-the-surreal-to-downtown-asheville.

Ellison, Quintin. "A Dry County? Hardly. Booze Abounds in Jackson Thanks to Creative State Laws." *Smoky Mountain News*, August 10, 2011. www.smokymountainnews.com/news/item/4736-a-dry-county?-hardly-booze-abounds-in-jackson-thanks-to-creative-state-laws.

Glenn, Anne Fitten. "Appalachian Craft Spirits." *Edible Asheville* (Fall 2017).

———. "Beer from the Ground Up." *Edible Asheville* (Summer 2016).

———. "Bitter Gamble." *Edible Asheville* (Fall 2016).

———. "Dry No More: How Legal Alcohol Is Changing Small Towns." *Edible Asheville* (Spring 2018).

———. "What's in A Name: Beer Branding, from Label Design to Legal Hurdles." *Edible Asheville* (Spring 2017).

Hughes, C.J. "How Craft Breweries Are Helping to Revive Local Economies." *New York Times*, February 27, 2018. www.nytimes.com/2018/02/27/business/craft-breweries-local-economy.html.

# Bibliography

Kays, Holly. "Some Alcohol Permits Could Now Be Allowed in Cherokee." *Smoky Mountain News*, July 1, 2015. www.smokymountainnews.com/news/item/15947-some-alcohol-permits-could-now-be-allowed-in-cherokee.

Kiss, Tony. "Profile in Beer: Sierra Nevada's Ken Grossman Stays Busy." *Asheville Citizen-Times*, December 14, 2015. www.citizen-times.com/story/news/local/2015/12/14/profile-beer-sierra-nevadas-ken-grossman-stays-busy/76666374.

Kucharski, Sara. "Franklin Ok's Alcohol Sales." *Smoky Mountain News*, August 2, 2006. www.smokymountainnews.com/news/item/13222-franklin-ok-s-alcohol-sales.

Loftus, Margaret. "15 Food Tours Worth the Travel." *Traveler Magazine*. www.nationalgeographic.com/travel/travel-interests/food-and-drink/best-food-tours-around-world.

Lunsford, Mackensy. "French Broad River Brewery Expands, Displacing Toy Boat Community Arts Space." *Asheville Citizen-Times*, December 7, 2017. www.citizen-times.com/story/news/local/2017/12/07/french-broad-river-brewing-expands-displacing-toy-boat-community-arts-space/908824001.

———. "12 Bones South to Move, Reopen New Restaurant/Brewery in S. Asheville." *Asheville Citizen-Times*, March 12, 2018. www.citizen-times.com/story/news/local/2018/03/21/12-bones-south-close-reopen-new-restaurant-and-brewery-south-asheville/445042002.

Osment, Timothy M. "Railroads in Western North Carolina." *Economy*. https://digitalheritage.org/2010/08/railroads-in-western-north-carolina.

Roach, Dylan. "These 5 Beer Makers Own More than Half the World's Beer." *Business Insider*, February 9, 2016. www.businessinsider.com/biggest-beer-companies-in-the-world-2016-1.

Walter, Rebecca. "Basic Brewery Shuts Its Doors in Hendersonville." *Hendersonville Times-News*, September 16, 2017. www.blueridgenow.com/news/20170916/basic-brewery-shuts-its-doors-in-hendersonville.

Wheelan, Frank. "How Beer Came to Bethlehem." *Morning Call*, August 16, 1987. http://articles.mcall.com/1987-08-16/news/2589568_1_moravian-bethlehem-beer-brew.

Wikipedia. "List of Dry Communities by U.S. State." Accessed April 10, 2018, https://en.wikipedia.org/wiki/List_of_dry_communities_by_U.S._state#North_Carolina.

Wood, Jesse. "Lost Province Brews Up Cottonwood 'Tribute' Beer in Honor of Boone's First Brewery." *High Country Press*, June 27, 2017. www.hcpress.com/front-page/lost-province-brews-cottonwood-tribute-beer-honor-boones-first-brewery.html.

# INDEX

## A

ABC Commission 43
ABC store 42, 43, 45, 99, 220
Ackley, David 186
Adam Dalton Distillery 193, 214
Addis, Jen and Matt 188
ALE 43
Allegheny County 105, 136
Allen, Derek 96
Alligator Bar, the 34, 35
All Sevens Brewing 195, 196
Altamont Brewing 184, 190, 191
American Craft Malt Guild 202
American Honor Ale House 131, 232
Anan, Steven 184, 185, 186
Anderson, Jeff 215
Andrews 163, 166, 214
Andrews Brewing Company 165, 166, 214
Anheuser-Busch InBev 53, 54, 55, 87, 135, 173
Appalachian Mountain Brewery 54, 131, 133, 134, 135, 136, 212, 222
Appalachian State University 130, 133, 203, 208

Appalachian Trail 126, 150
Archetype Brewing Company 184, 185, 186
Arden 51, 110, 172, 173, 206
Ashburn, Leah Wong 55, 56, 57
Ashe County 136, 140, 141
Asheville Beer Expo 211
Asheville Beer Week 68, 210
Asheville Brewers Alliance 17, 54, 87, 94, 204, 210, 211
Asheville Brewers Supply 66, 207, 221
Asheville Brewery Tours 212
Asheville Brewing Company 17, 60, 61, 62, 223
Asheville Brews Cruise 212
Asheville Convention and Visitors Bureau 93
Asheville Distilling Company 214
Asheville Regional Airport 109, 110
Asheville Tourists 26
Atallah, Julie 211
Avery County 126, 129
Ayers, Becky 144, 145
Ayers, Jonathan 53, 144, 145

# Index

## B

Baker, Aaron 88
Baker, Ben and Kelsie 157, 158
Balsam Falls Brewing Company 161, 162
Banner Elk 124, 126, 128, 133
Barley's Pizzeria & Taproom 55, 56, 209, 210
Barnardsville 205
Basic Brewery 124, 142
Baughman, Kinney 47, 48, 49, 50, 137
BearWaters Brewing Company 81, 82, 83, 156, 163
Beech Mountain Brewing Company 130, 133, 138, 139
Beer City Festival 210
Bell's Brewery 158
Benefit Brewing 58, 59, 65
Bennewitz, Uli 49
Ben's Tune-Up 124, 125
Bhramari Brewing Company 183, 184
Bialik, Barry 78, 79, 80, 147
Biltmore 79, 80, 175, 178, 202, 214
Black Mountain 70, 71, 112, 113
Black Mountain Ciderworks & Meadery 71, 216
Black Star Line Brewing Company 124, 142
Blind Squirrel Brewery 129, 130
Blowing Rock 16, 32, 126, 130, 131
Blowing Rock Brewing Company 131, 132
Blue Ghost Brewing 109, 110, 201
Blue Mountain Pizza and Brew Pub 99, 100
Blue Ridge Brew-Off 208
Blue Ridge Community College 145, 209
Blue Ridge Mountains 162
Blue Ridge Parkway 163
Blue Rooster Restaurant and Brewpub 57, 58
Boera, Todd 119, 120, 121, 122
Bold Rock Hard Cider 109, 213, 215, 216
Boojum Brewing Company 157, 158
Boondocks Brewing 140, 141
Boone 16, 33, 44, 45, 46, 126, 130, 131, 133, 134, 135, 136, 137
Boone, Daniel 24
Booneshine Brewing Company 133, 136, 137, 138
Bower, Chris 27
Bowman, Jon 123, 147, 148, 157
Brevard 16, 25, 40, 83
Brevard Brewing Company 83, 84, 85
BREW-Ed 212
Brewers Association 87, 122, 200, 216
Brewery Cursus Keme 65, 196, 197
Brewgrass Festival 210
Brew Hub 135
Brown, Gary 140, 141
Bruisin' Ales 211
Bryson City 77, 78, 96, 156, 162, 163, 164, 165
Bryson, Corey and Laurie 161
Budweiser of Asheville 85, 158, 184, 191
Buerckholtz, Alex 207
Buncombe County 22, 40, 70, 93, 94, 193, 204
Buncombe Turnpike 25
Burial Beer Company 65, 174, 175, 176, 211, 212
Burke County 23, 62, 63, 119, 121
Burnsville 96, 126, 127, 129
Buxton Hall Barbecue 64

## C

Cagle, Joey 99, 100
Calaboose Cellars 165, 214
Caldwell County 140
Camp Patton 30
Candler 173, 201
Canton 82, 83, 95, 156
Carlson, Eric and Judy 165, 166

# Index

Casanova, Brad  184, 185
Casey, Paul and Sarah  59, 65, 66
Cashiers  142, 152, 153, 154, 201
Catawba Brewing Company  46, 62, 63, 64, 65, 119, 127
Caughman, Jason  70
Causey, Emily  118
Chambers, Josh  146
Champion Paper  95
Charnack, Adam  176, 177
Chassner, Jeremy  97
Chassner, Jonathan  75, 76, 97, 98
Cherokee  147, 151, 156, 162, 163
Cherokee County  163, 164, 165, 166
Chimney Rock  16, 115
cicerone  212, 213
Cigar City Brewing  87
Civil War  130
Clay County  163
Clevenger, Theodore  207
Coatney, Carson  137, 138
Cochran, John  184, 190, 191, 192
Coggins, Collette  163
Conway, Bart  47
Costin, Ryan  138
Cottonwood Brewery  46, 49, 50, 123, 133, 134
Cottonwood Grille and Brewery  47, 48, 50, 51
Coughlin, Sean  83, 200
Country Malt Group  203
Craft Beverage Institute  56, 208
Craft Brew Alliance  54, 135
Craggie Brewing Company  123, 176
Crosby Hop Farm  200
Cubbin, Andy and Kelly  69, 70
Currahee Brewing Company  151, 152

## D

Dahm, Andy  58, 59, 65, 66, 207
Dayco  51, 95, 96
Deaver Brewery  29, 30
DeBruhl, Miranda  94

Deschutes Brewery  94
Desenne, Philip  107
Dews, Bob  123, 152
Dews, Lisé  152
Dexter, Chip  159, 160
Dexter, Nicole  159, 160, 199, 218
Diaz, Jim  186
Dickinson, Luke  172, 206
Dickinson, Walt  172
Dillard, John  183
Dillsboro  160
Dills Falls  162
Dinan, Joe  142, 143, 144
Divinity Beer Systems  206
Dry County Brewing Company  119, 124
Duncan, Clark  92
DuPont Corporation  95, 147
DuPont State Forest  87, 110

## E

Eagles Nest Hotel  157
EchoView Farm  201
Eckert, Joe and Joan  59
Ecusta Brewing Company  146, 147
Ecusta Corporation  95, 147
Eda Rhyne Distillery  214, 216
Edwards, Brandon  104
Elliott, Clayton  60
Eluvium Brewing Company  102, 103, 104
Eurisko Beer Company  193, 194
Evers, Beau  200

## F

Fairview  25, 97, 106, 107, 109
Flat Top Brewing  124, 128
Flat Top Cider Works  215
Flat Top Mountain Brewery  124, 128, 129
Fletcher  97, 109, 203
Fonta Flora Brewery  119, 120, 121, 122, 174, 211

# INDEX

Foothills Brewing  46, 50
Fort San Juan  24
Fox Hill Meadery  216
Franklin  21, 22, 142, 149, 150, 151, 213
Freck, Adolph  31
Freeman, Talia  138
French Broad Brewery  59, 64, 125
French Broad River Brewery  47, 65, 66, 67, 193
Fretwell, Marc and Merri  114, 115, 116
Frog Level Brewing Company  156, 157, 165
Frosaker, Chris  176, 177

## G

Garcia, John  113, 114
Gibson, Chad  181
ginger beer  24, 25, 186, 187, 188, 215
Ginger's Revenge Craft Brewery  186, 187
Glancy, Gary  213
Good Hops Brewing  113
Gormley, Tim  174
Graham County  22, 43, 163, 164
Great American Beer Festival  49, 73, 83, 135, 151, 193
Great Smoky Mountain Railroad  77, 160
Great Smoky Mountains Expressway  156
Great Smoky Mountains National Park  77, 156, 164
Green Man Brewery  46, 47, 58, 59, 60, 100, 125
Grossman, Brian  16, 88, 97
Grossman, Ken  86, 88
Guthy, Denise and Rick  172
Guthy, Ryan  171, 172, 173, 174

## H

Habitat Brewing Company Tavern & Commons  188, 189, 190
Hall, Cristina  186
H&K Hops Farm  80
Hans Rees & Sons  72
Harrah's Cherokee Casino Resort  162
Harrah's Cherokee Valley River Casino  162, 169
Harris, Will  38
Harris, Zac  193, 194
Haysville  163, 164, 168, 169, 170
Haysville Brewing Company  168
Haywood County  46, 80, 81, 96, 123, 157
Heinlein, Dale  154
Heinzelmännchen Brewery  123, 153, 159, 161
Henderson County  206
Hendersonville  124, 142, 143, 144, 145, 213, 214, 215
Herdklotz, Tim  137, 138
Hertz, Julia  53
Hickman, Scott  203
Hickory Nut Gorge Brewery  114, 115, 116
Highland Brewing Company  46, 49, 53, 55, 56, 57, 177, 181, 195, 202, 208, 212
Highlands  32, 142, 152, 154, 155
Hillegass, Dirk  195
Hillman Beer  65, 192, 193
Hillman, Brad  192, 193
Hillman, Brandi  192, 193
Hillman, Greig  192, 193
Hi-Wire Brewing  97, 123, 127, 176, 177, 178, 211
Holmes, Thomas  27
Homeplace Beer Company  126, 127, 128
Hoppy Trout Brewing Company  166, 167

# Index

hops  27, 28, 47, 56, 71, 80, 114, 186, 199, 200, 201
Horner, Jeffrey  196
Horn, Zach  109, 110
Howard Brewing  124, 140

## I

Ingle, Thornton  32, 130
Innovation Brewing Company  158, 159, 160
Iron Heart Mobile Canning  150, 206
Irvin, Jeff  208
Ivory Tower Education Brewery  135, 136

## J

Jackson County  45, 78
Jensen, Jody and Lisa  168
Jester King  173
Joara  23
Jordan, Kim  89
Just Brew It  208
Justice, Erica and Joey  181, 182, 183

## K

Karnowski, Mike  59, 100, 101, 102, 206
Katechis, Dale  87
Kear, Gordon  123, 190
Kelischek, Nathan  133
Keller, Dave  207
Kephart, Horace  25, 40, 45, 165
Kiss, Tony  88, 92, 122
Klingel, Billy  73, 75
Kuhn, Dieter  123, 153

## L

Laconia Ale Works  105, 106
Lake James  118, 119
Lake Lure  115
Langheinrich, Pete  62
Laurelwood Inn  152
LaZoom Comedy Tours  212
Lazy Hiker Brewing Company  149, 150
Leap Frog Tours  213
Lemley, Andrew  216
Levin, Matt  193, 194
Lewis, Shea  102, 103
Lexington Avenue Brewing Company  75, 76
Linville Gorge  118, 121
Loe's Brewing Company  140
Lookout Brewing Company  113, 114
Lost Province Brewing Company  50, 133
Lyda, John  56, 58, 92, 208

## M

Macon County  142, 151, 154
Mad Co. Brewing Company  65, 104, 105
Madison County  104, 105, 115
malt  107, 120, 187, 202, 203, 207
malted grain  187, 199, 202, 203
Manning, Brent  202
Marion  16, 63, 65, 96, 112, 117, 118
Marsden, Dawn  169
Marsden, Mike  77, 169
Marshall  96, 216
Mason, Andy  50, 136
Mason, Lynne  136
Mason, Zack  193, 194
McCarthy, PJ  110
McDermott, John  49, 56, 58
McDowell County  115, 117
Melissas, Carl  73
Mica Town Brewing Company  118, 119
Miceli, Gina and Tom  106, 107
MillerCoors  54, 55, 190
Mills River Brewery  109, 110, 111
Mitchell County  126, 140
Morganton  23, 24, 63, 64, 112, 118, 121

# Index

Mori, Cliff 212
Mountain Ale & Lager Tasters (MALT) 207, 208
Mountain Layers Brewing 164, 165
Mount Mitchell 126
Muller, W.O. 28, 29
Murphy, Ken 149
Murphy, Rett 216

## N

Nantahala Brewing Company 77, 78
Nebo 121
Nestler, Elizabeth 60
New Belgium Brewing Company 16, 65, 86, 87, 89, 90, 91
Nichols, James and Kim 116, 117
Noble Cider 215
Norris, Graham 150
North Carolina Craft Brewers Guild 216
Nu Wray Inn 127

## O

Oak & Grist Distilling Company 71, 214, 216
Oder, Leigh 60
Old Fort 95
One World Brewing 178, 179, 184
Oskar Blues Brewery 16, 17, 54, 86, 87, 88
Owle-Crisp, Morgan 163
Oyster House Brewing Company 184

## P

Palmetto Brewery 62
Parks, John 97, 98, 178
Parks, Ryan 131, 132
Payne, John 73
P.B. Scott's 130, 131
Peaks & Creeks Brewing Company 124, 147, 148, 149

Penn, Norm 78
Pettit, Mark 164, 165
Pickard, Gabe 100, 101, 102
Pierce, Daniel S. 38, 95
Pierson, Ben 76
Pisgah Brewing Company 70, 71, 72, 113, 127, 212, 216
Pisgah Forest 87, 146, 149
Plumtree 129
Polk County 123
Postlethwaite, Joanna 78
Prochaska, Rich 51, 123
Pyatt, Billy 62, 63, 64, 65, 159
Pyatt, Jetta 62, 63, 64
Pyatt, Scott 62, 63, 64, 127

## Q

Qualla Boundary 147, 162, 163
Quinn, Dave 70

## R

Ralston, Mark and Yumiko 124, 128
Rangel, Mike 60, 61
Rayburn Farm 104, 181, 205
Rayburn, Lauren and Michael 205
Reed Mine 103
Reible, Kelsey 154
Reiser, Doug 174, 199
Reiser, Jess 174
Rembert, Jonas 58, 59, 65
Rentz, Jimi 210
Rice, Todd 131
Richardson, Don 50, 137
Richardson, Jay 90
Riley, Doug 60
River Arts District 72, 90
Riverbend Malt House 107, 120, 202, 203
Robbinsville 37
Robert Portner Brewing Company 34
Rockingham Community College 209
Rodeck, Tom 166

# INDEX

Rosman 69
Rowland, Joe 77, 92, 94, 96
Ruff'ton Brewhouse 116, 123
Rutherford County 112, 115
Rutherfordton 115, 116, 123

## S

Salisbury 27
Sanctuary Brewing 142, 143, 144
Sandefur, Kevin 82, 83
Sapphire Mountain Brewing Company 154
Satulah Mountain Brewing Company 154, 155
Schaller, Tim 72, 73
Schroeder, JT 151
Schutz, Jay and Lisa 178, 179
Sernack, Gary 183
7 Clans Brewing 162, 163
Sierra Nevada Brewing Company 16
Silver, Frankie 126, 127
Silver, John 126, 127, 128
Simpkins, Allison 183, 184
Simpson, Brian 202
Single Brothers Brewery & Distillery 27
Smith, Ann 213
Smith, Drew 195
Smoky Mountain Brewery 18, 46, 156
Sneak E Squirrel Brewing 124
Snyder, Jason 118, 119
Sons of Temperance 98
Soukut, Joey 110
South College 209
Southern Appalachian Brewery 69, 70, 142, 143
South Slope 59, 60, 64, 124, 172, 174, 176, 180, 181, 183, 193, 207, 212, 215
Southwestern Community College 165
Sparta 105, 106, 126, 140
Spiegelman, Sean and Stephanie 133, 135
Spradling, Kristin 166

Spruce Pine 118, 119, 124, 140
Sticky Indian Hops Farm 201
Stuart, John 59
Swain County 163, 165
Sweeten Creek Brewing 181, 182
Sylva 77, 103, 123, 124, 156, 159, 161, 162, 193, 213, 218

## T

Terrapin Brewing 190
terroir 101, 199
Theodore, Laura 144
Thies, Dennis and Wendy 59
Thirsty Monk Pub and Brewery, the 78, 79, 80, 147
Tipping Point Tavern & Brewery 123, 147, 148, 156
Transylvania County 85
Travis, Randy 102
Triskelion Brewing Company 142, 144, 145, 146
Tumbleweed Grille 133, 137
Turgua Brewing Company 107, 108, 109
Turpin, Kim 213
12 Bones 72, 181
Twin Leaf Brewery 180, 181
Two Moons Brew & View 56, 58, 60

## U

United Dry Forces 45
UpCountry Brewing Company 123
Urban Orchard Cider 215

## V

Valley River Brewery 168, 169, 170
Vanhoose, Mike 99, 100
Varner, Jon 102, 103
Victory Brewing Company 81

253

# INDEX

## W

Waldensian Heritage Winery  214
Walker, Jeff  131
Watauga County  133, 136, 140
water  8, 21, 25, 27, 199, 200
Waynesville  18, 51, 79, 80, 81, 82, 83, 95, 96, 156, 157
Weaverville  97, 98, 99, 100, 101, 103
Weber, Erik  109
Weber, J.  109
Weber, Tim  180, 211
Wedge Brewing Company  72, 73
West Jefferson  126, 129, 140
Westville Pub  184, 195
Wharton, Benton  70
Whistle Hop Brewing Company  106, 107
White, Chris  203
White Labs  17, 94, 204, 205
White, Lisa  204
Whiteside Brewing Company  123, 152, 153, 154
Whiteside Mountain  154
Wicked Weed Brewing Company  53, 54, 143, 171, 172
Widmer Brothers Brewery  135
Wilkesboro  24, 27, 214
Williams, Clark  80
Williams, Kyle  83
Wilson, Aaron  66
Winding Creek Brewing Company  123
Wong, Oscar  49, 55, 56, 57, 92
Woodfin  76, 97, 98
World Beer Cup  62

## Y

Yancey County  126, 127
Yates, Taylor  151
yeast  17, 25, 32, 94, 97, 101, 107, 146, 199, 203, 205
Yellow Sun Brewing Company  115, 116, 117

## Z

Zebulon Artisan Ales  100, 101, 102, 206
Zieber, Chris  133, 134, 135
Zillicoah Beer  58, 65, 76, 97, 98
Zimmer, Bill  146

# ABOUT THE AUTHOR

**A**nne Fitten Glenn first learned about craft beer in the early 1990s, when she worked with George Stranahan, founder of Flying Dog Brewery, near Aspen, Colorado. Her most memorable experience there was having notorious writer Hunter S. Thompson yell at her because she'd left the cover off George's hot tub while housesitting for him (and throwing a big party). Hunter was naked, and Anne Fitten was holding a Doggie Style Pale Ale.

*Photo by Sean McNeal.*

AF (it's a double first name, and yes, many call her by her initials) grew up in Atlanta and attended the University of Georgia. After graduate school there, she worked in London, England, where she discovered pub-brewed cask beer. She moved to Western North Carolina in 1997, and after having babies, teaching college and working with nonprofits, she started writing about beer and the beer business. She debuted the Brews News column for *Mountain Xpress* and wrote that weekly for five years. The History Press published her first beer book, *Asheville Beer: An Intoxicating History of Mountain Brewing*, in September 2012.

AF worked as Oskar Blues Brewery's East Coast marketing and public relations director for almost three years. She was able to be part of that brewery's growth from a mostly empty warehouse to an eighty-five-thousand-barrel production, packaging and shipping facility. Now, AF

# About the Author

consults to breweries, mostly in communications and public relations. Her primary local client is Asheville Brewing Company, the town's third-oldest brewery.

An award-winning writer, AF regularly writes about beer (and sometimes food). She pens a regular Mountain Brews article for *Edible Asheville*, and she's written for numerous other publications, including *All About Beer*, *Asheville Citizen-Times*, *Smoky Mountain Living*, *WNC Magazine*, *Explore Asheville* and *CraftBeer.com*.

AF developed and teaches a Beer 101 class for both beertenders and beer lovers. She regularly speaks at conferences and special events about the world's favorite alcoholic beverage. She's a member of the North American Guild of Beer Writers, Pink Boots Society and North Carolina Writers' Network. She served on the Asheville Brewers Alliance Board of Directors for almost five years and was a founding organizer of Asheville Beer Week.

She and her family live in Asheville within walking or biking distance of an ever-expanding number of craft breweries.